Drawings by
MICHELANGELO

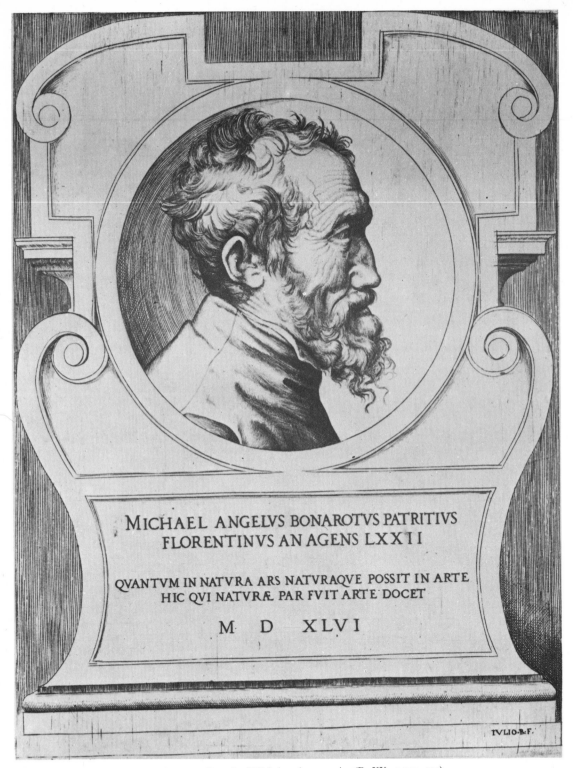

Giulio Bonasone, Portrait of Michelangelo, engraving (B. XV, p.170, 345)

Drawings by
MICHELANGELO

in the collection of
Her Majesty the Queen at Windsor Castle,
The Ashmolean Museum,
The British Museum
and other English collections

An exhibition held in
The Department of Prints and Drawings
in the British Museum

6th February to 27th April 1975

GERE

Published for
THE TRUSTEES OF THE BRITISH MUSEUM
by British Museum Publications Limited

© 1975, The Trustees of The British Museum
Second impression 1975
ISBN 0 7141 0743 3 *Cased*
 0 7141 0742 5 *Paper*
Published by British Museum Publications Ltd
6 Bedford Square, London WC1B 3RA
Designed by Brian Paine
Set in Monophoto Ehrhardt 453 by
Tradespools Ltd, Frome, Somerset and
printed in Great Britain by
Balding & Mansell Ltd, London and Wisbech

CONTENTS

INTRODUCTION

As a sculptor, Michelangelo is represented in this country by a single major work—one of only five outside Italy—the early marble *tondo*, the *Madonna Taddei*, at Burlington House; and as a painter, by the early unfinished *Entombment* (and possibly also by the *Virgin and child with the Infant Baptist and Angels*) in the National Gallery. Of drawings by him, on the other hand, we possess an incomparable wealth, and it seemed that the best way of celebrating the five-hundredth anniversary of his birth on 6 March 1475 would be to bring together in one exhibition all the drawings by him in British collections: to show, alongside the eighty-five in the British Museum, the fifty-three in the Ashmolean Museum in Oxford, the twenty-two in the Royal Library at Windsor and seventeen from other collections. In addition, we are privileged to exhibit, for the first time in this country, the magnificent sheet of studies for the *Libyan Sibyl* in the Metropolitan Museum, New York.

The study of an artist's drawings admits us to his most intimate thoughts and enhances our appreciation of his finished works by enabling us to follow the development of his ideas and to trace the stages by which the final result was achieved. Those in this exhibition, from every phase but the very earliest of Michelangelo's long career from the first years of the sixteenth century down perhaps to the year of his death in 1564, include studies for almost all his major commissions: for the famous cartoon of the *Bathers* which he made in Florence in 1504–6, for the Sistine Ceiling (1508–12) and for the Medici Chapel (1520–33), for which there is a unique series of studies illustrating the successive solutions to the problem of placing the Medici tombs; most of the known surviving drawings made for his friend and protégé Sebastiano del Piombo; studies for his last paintings, the *Last Judgement* in the Sistine Chapel and the Cappella Paolina frescoes; and a few connected with some of his late architectural projects, St Peter's, the Palazzo Farnese, and the Sforza Chapel in S. Maria Maggiore. But the value of Michelangelo's drawings is not simply that they throw light on a series of creative processes of particular complexity. Many of them are in themselves works of art of incomparable beauty, for Michelangelo was not only unique among artists in his threefold supremacy as sculptor, painter and architect, but was also the greatest exponent of the Florentine pictorial tradition which saw the representation of the nude figure in action as the artist's essential aim. Nor are the drawings here exhibited all preparatory studies: they include an unrivalled group of the 'presentation drawings' made as finished works as gifts for particular friends, in which his rendering of the human figure reaches a level of unsurpassed perfection; and another group, no less remarkable, of the religious subjects drawn in the very last years of his life in which he perfected a uniquely personal style using the figure to express a mystical vision of extraordinary pathos and intensity.

This country possesses about two-fifths of the surviving drawings by Michelangelo, and of the finest an even higher proportion. Many of the drawings in other collections—in the Casa Buonarroti for example—are slight sketches or mere plans or diagrams, whereas the majority of those in England must have been acquired for their aesthetic appeal. The two collectors chiefly responsible for so greatly enriching the nation's artistic wealth were George III, for whom the twenty-two

drawings in the Royal Library were purchased in Italy in the later eighteenth century, and Sir Thomas Lawrence, the great portrait painter and President of the Royal Academy, who took advantage of the upheavals on the Continent caused by the Napoleonic War, which led to the dispersal of so many ancestral treasures, to amass the finest collection of drawings by the Old Masters ever brought together by a single individual. All the drawings in the Ashmolean Museum here shown, forty-eight of those in the British Museum, and at least three of those in other collections come from this source (they can be distinguished by the small 'TL' stamped blind in the lower left-hand corner of the sheet). Most of them came indirectly from the Buonarroti family in Florence, the descendants of Michelangelo's nephew Leonardo, who began to disperse their treasures after the French invasion of Italy in 1796. The drawings then disposed of were acquired by the painter J.-B.-J. Wicar, who was in the advantageous position of being Commissioner in charge of the official looting of pictures in Italy; from him many passed to Lawrence through the hands either of his friend and adviser the *marchand–amateur* William Young Ottley or of the dealer Samuel Woodburn.

The fate of the Lawrence Collection is well known. It is sufficient here to say that all his attempts to preserve it intact after his death, by directing his executors to offer it to the nation at a price even then absurdly below its real value, were frustrated by official apathy, so that the collection eventually passed back into the hands of Woodburn as Lawrence's principal creditor. Woodburn's efforts to dispose of it, even piecemeal, met with little success, and it was not until 1845 that the University of Oxford was reluctantly persuaded to accept, as a gift paid for by public subscription (more than half of which came from a single individual, the second Earl of Eldon), most, but by no means all, of the drawings by Raphael and Michelangelo which were regarded as the cream of the collection.

At that time the British Museum possessed only one drawing by Michelangelo himself—the *Virgin and Child* (no. 140 in the present exhibition), which had passed from the collections of P.-J. Mariette and the marquis de Lagoy in France to that of Richard Payne Knight, who bequeathed it with the rest of his collection in 1824—but in 1859 the foundations of the collection were laid by the purchase in Florence of thirty-six drawings from the Cavaliere Michele Buonarroti. To these in the following year were added a further twelve from the Lawrence Collection, which were among the residue sold after Woodburn's death. Others from the same source were acquired later in the century through bequest and purchase, five coming with the Henry Vaughan Bequest in 1887 and no fewer than twenty-two with the purchase of the Malcolm Collection in 1895.

The third great English collection of Michelangelo drawings, that at Windsor, has a different history. They were acquired for George III in Italy at some time in the second half of the eighteenth century. Their immediate source is not recorded, but it is unlikely that they ever formed part of the Buonarroti possessions. Five of the 'presentation drawings' are known to have belonged to Cardinal Alessandro Farnese, who died in 1590. It may be that some or all of the rest likewise came from the Farnese family.

Of these three collections of drawings by Michelangelo, those of the Royal Library and the British Museum were catalogued by the late Johannes Wilde in 1949 and 1953, and that of the Ashmolean Museum by Sir Karl Parker in 1956. The Morellian hypercriticism of the later nineteenth and earlier twentieth centuries had removed a number of important drawings from Michelangelo's *oeuvre*, either attributing them to Sebastiano del Piombo or dismissing them as copies because they did not fit into an *a priori* conception of Michelangelo's style. Wilde, by vindicating with scrupulous caution the earlier traditional view, produced a more convincing and better-balanced conception of Michelangelo as a draughtsman.

The present catalogue is based on that of the exhibition held at the British Museum in 1953, in which Wilde's views, not only on the Windsor and British Museum drawings but also on those in the Ashmolean Museum and elsewhere, were summarized in a highly concentrated form which presupposed a considerable degree of expert knowledge on the part of the reader. Though the present catalogue does not claim to be any less summary, individual entries have been expanded as seemed necessary and arranged in a more consistent chronological order, and are divided into sections provided with short prefatory notes giving the essential background information. Since this is primarily a catalogue of an exhibition, discussion of a double-sided drawing (of which there are many) is limited to the side exhibited, the other being referred to only if it has some bearing on this.

A summary exhibition catalogue would be overburdened by references to all the abundant critical literature, but complete references are given to four publications that have appeared since the fundamental catalogues of the three principal English collections: Dussler's *corpus* of drawings (1959), which gives complete bibliographies up to that year, and Hartt's (1971)—the two might stand as types respectively of the ultra-cautious and ultra-speculative approach to the subject; Paolo Portoghesi's and Bruno Zevi's *Michelangiolo Architetto* (1964); and the fifth and last volume of de Tolnay's monograph (1960). Any other literature published after 1959 that seemed positively helpful is also referred to, but we have not thought it necessary to balance the arguments for and against every unverifiable hypothesis that has been put forward about the purpose or dating of a drawing; in the main we have been content to follow Wilde, whose particular contribution to the study of Michelangelo lies in his essentially factual and common-sense approach.

The present exhibition is not identical with that held in 1953. One drawing (1953, no. 76) could not be borrowed, two (1953, nos. 26 and 131) have been omitted as being of doubtful authenticity; and a photograph of the 'Holkham *grisaille*'—the copy by Aristotile da San Gallo of the *Bathers* group in the lost *Battle of Cascina* cartoon, in the collection of the Earl of Leicester at Holkham Hall—is shown instead of the original painting (1953, no. 7). On the other hand, nine drawings by Michelangelo himself have been added, the two most important being the famous sheet of studies for the *Libyan Sibyl* in the Metropolitan Museum (no. 20), certainly the finest of all the surviving studies for the Sistine Ceiling, and the study of *Christ at the Column* in the British Museum (no.

38), which Wilde in 1953 still ascribed to Sebastiano del Piombo, but which he later agreed was by Michelangelo.

Others are the very late black chalk study of a standing Christ in the Fitzwilliam Museum in Cambridge (no. 160), which was added to the 1953 exhibition at the last moment, too late to be included in the catalogue; the design for the double tomb of the Medici Popes, at Christ Church (no. 57); two *écorché* studies in pen and ink, at Windsor (nos. 83 and 84); two drawings acquired since 1953 by Count Seilern (nos. 33 and 116), who has also added to his collection nos. 40 and 104 in the 1953 catalogue; and the sheet of studies for the *Last Judgement* recently discovered in the Methuen Collection at Corsham (no. 134).

Five drawings, which though not from Michelangelo's own hand are of particular interest in the context of the exhibition, have also been added: the old copy of a figure in the lost *Bathers* group (no. 11), the copy by Giulio Clovio of the lost final study for the Borgherini Chapel *Flagellation* (no. 39), the old copy of the lost 'presentation drawing' of the *Rape of Ganymede* (no. 124), all three from the Royal Library; the copy of the lost *Count of Canossa* from the British Museum (no 115); and from the Ashmolean Museum the studio repetition of the final design for the unexecuted tomb of the *Magnifici* in the Medici Chapel (no. 52).

The Trustees wish to express their thanks to those who have so generously contributed to this exhibition: to Her Majesty the Queen for graciously lending all twenty-two of the Michelangelo drawings in the Royal Library together with the three copies referred to above; to the Visitors of the Ashmolean Museum, Oxford, for equally consenting to lend all of theirs; to the Trustees of the Metropolitan Museum, New York, the Syndics of the Fitzwilliam Museum, Cambridge, and the Governing Body of Christ Church, Oxford; to the Executors of the Hon. Robert Gathorne-Hardy and those private owners who have so generously allowed themselves to be temporarily deprived of their treasures, Count Antoine Seilern, Mr Brinsley Ford and the Hon. John Methuen.

Thanks are also due to Mr Robert Mackworth-Young, Her Majesty's Librarian at Windsor; Dr Humphrey Sutherland, the Curator of the Pictures at Christ Church; Mr David Piper, Director of the Ashmolean Museum, and Dr Kenneth Garlick, Keeper of the Department of Western Art; Professor Michael Jaffé, Director of the Fitzwilliam Museum; and Mr Jacob Bean, Curator of Drawings at the Metropolitan Museum.

The revision of the catalogue was undertaken jointly by myself and Mr Nicholas Turner, Assistant Keeper in the Department. We would like to express our gratitude for assistance of various kinds to Mr Hugh Macandrew of the Ashmolean Museum, and to Mr James Byam Shaw in allowing us to consult the MS. of his forthcoming catalogue of the Christ Church collection; and above all to Mr Michael Hirst for invaluable advice and criticism.

J. A. GERE

SOME DATES OF SIGNIFICANCE IN THE LIFE OF MICHELANGELO

1475 March 6. Birth at Caprese near Sansepolcro.

1488 April 1. Apprentice for three years to Domenico and David Ghirlandaio. Towards the end of the year (?) transferred to Bertoldo's newly opened school in the Medici garden at S. Marco.

1492 April 8. Death of Lorenzo de' Medici.

1496 June 25. Arrival in Rome.

1498 August 27. Contract for the *Pietà* in S. Peter's.

1501 May (?). Return to Florence.
August 16. Contract for the marble *David*.

1503 April 24. Contract for statues of the twelve apostles for the cathedral of Florence.

1504 March. The marble *David* finished.
November/December. Began work on the full-size cartoon for the *Battle of Cascina*.

1505 Spring. Summoned to Rome by Julius II and commissioned to execute his tomb.

1506 April 17. Returned secretly to Florence.
End of November. Called to Bologna by the Pope to execute his statue in bronze.

1508 End of February. Return to Florence.
Spring. Called to Rome by the Pope and commissioned to decorate the ceiling of the Sistine chapel.

1510 Beginning of September. Termination of half the frescoes, followed by a long break in the work.

1512 October 31. Unveiling of the ceiling.

1513 February 21. Death of Julius II.
March 11. Election of Leo X.
May 6. New contract, with the executors of the Pope, for the monument of Julius II.

1516 July 8. Third contract for the Julius monument. Michelangelo returned to Florence.
December. Commissioned by Leo X to build the façade of S. Lorenzo in Florence.

1520 March 10. The responsibility for quarrying and delivering the marble for the façade of S. Lorenzo taken away from Michelangelo.
November. Began planning the Medici chapel.

1521 December 1. Death of Leo X.

1523 November 19. Election of Clement VII.

1524 January. Intensive work in the Medici chapel began. Commission to build the library of S. Lorenzo.

1527 May 6. The Sack of Rome.
May 17. The Medici left Florence.

1528 Autumn to 1529 Summer. Active part in preparations for the defence of Florence taken by Michelangelo.

1530 August 12. Capitulation of Florence.
October/November. Resumed work in the Medici chapel.

1532 April 29. Fourth contract for the Julius monument.
August. Arrival in Rome for a long visit. Towards the end of the year his friendship with Tommaso de' Cavalieri began.

1534 August/September (?). In Florence for the last time.
September 25. Death of Clement VII.
October 13. Election of Paul III.

1536 November. Began the fresco of the *Last Judgement*.

1536 or end of 1538. His friendship with Vittoria Colonna began.

1541 October 31. Unveiling of the *Last Judgement*.

1542 August 20. Fifth contract for the Julius monument.
Autumn. Began the decoration of the Pauline chapel.

1545 February. Termination of the Julius monument.

1546 October. Took over the building of S. Peter's and of the Palazzo Farnese.

1547 February 25. Death of Vittoria Colonna.

1549 November 10. Death of Paul III.

1550 The frescoes in the Pauline chapel finished.

1559–60 Nudities in the *Last Judgement* painted over by order of Paul IV.

1564 February 18.
Death of Michelangelo.

LIST OF WORKS REFERRED TO IN ABBREVIATED FORM

Barocchi: Paola Barocchi, *Michelangelo e la sua Scuola. I Disegni di Casa Buonarroti e degli Uffizi*, 2 vols., Florence, 1962.

B.B.: Bernard Berenson, *I Disegni dei Pittori Fiorentini*, revised and amplified edition, 3 vols., Milan, 1961.

Dussler: Luitpold Dussler, *Die Zeichnungen des Michelangelo. Kritischer Katalog*, Berlin, 1959.

Frey: Karl Frey, *Die Handzeichnungen Michelagniolos Buonarroti*, 3 vols., Berlin, 1909–11.

Hartt: Frederick Hartt, *The Drawings of Michelangelo*, London, 1971.

Parker: K. T. Parker, *Catalogue of the Collection of Drawings in the Ashmolean Museum. Vol. II. The Italian Schools*, Oxford, 1956.

Popham–Wilde: A. E. Popham and Johannes Wilde, *The Italian Drawings of the XV and XVI centuries in the collection of His Majesty the King at Windsor Castle*, London, 1949.

Portoghesi–Zevi: Paolo Portoghesi and Bruno Zevi, *Michelangiolo Architetto*, Turin, 1964.

Pouncey-Gere: Philip Pouncey and J. A. Gere, *Italian Drawings in the Department of Prints and Drawings in the British Museum. Raphael and his Circle*, London, 1962.

Ramsden: E. H. Ramsden, *The Letters of Michelangelo*, 2 vols., Stanford, 1963.

Schilling–Blunt: Edmund Schilling and Anthony Blunt, *The German Drawings in the Collection of H.M. the Queen at Windsor and Supplements to the Catalogues of Italian and French Drawings*, London, 1971.

Thode: Henry Thode, *Michelangelo, Kritische Untersuchungen über seine Werke*, 3 vols., Berlin, 1908–13.

Tolnay: Charles de Tolnay, *Michelangelo*, 5 vols., Princeton, 1943–60.

Wilde: Johannes Wilde, *Italian Drawings in the Department of Prints and Drawings in the British Museum. Michelangelo and his Studio*, London, 1953.

Where Wilde's opinion is quoted on drawings other than those in the British Museum or at Windsor, the reader may assume that it is to be found in the catalogue of the Exhibition held at the British Museum in April–June 1953.

I THE SECOND FLORENTINE PERIOD
1501–5

Michelangelo was trained in Florence. The earliest surviving drawings by him, datable *c.* 1490, are probably the series of pen-and-ink copies (Louvre, Munich, and Albertina) of figures in frescoes by Giotto and Masaccio. The drawings of a Philosopher (no. 1) resembles them in technique, and the influence of these earlier masters is clearly reflected in the still *quattrocentesque* and monumental conception of the figure; Wilde, however, saw this particular drawing as somewhat more developed stylistically and dated it soon after Michelangelo's return from Rome in 1501, when he had already completed the *Pietà* for St Peter's. In the five years that he then spent in Florence—one of the most inspired and prolific periods of his entire career—he produced the marble *David* (Accademia, Florence), the marble group of the *Virgin and Child* for the church of Notre-Dame in Bruges (see no. 6), two circular marble reliefs of the *Virgin and Child*—the Taddei and Pitti *tondi* (Royal Academy and Bargello), and the marble figures of the Piccolomini Altar in Siena Cathedral. He also painted the Doni *tondo* of the *Holy Family* (Uffizi) and in 1504 began the cartoon of the *Battle of Cascina*, for a painting intended as a *pendant* to Leonardo da Vinci's *Battle of Anghiari* on the other half of one of the long walls of the Sala del Gran Consiglio in the Palazzo Vecchio. Only one section of the cartoon seems to have been completed, the group generally known as the *Bathers*, which illustrates the incident in the recorded history of the battle of a party of Florentine soldiers surprised by the approach of the enemy while bathing in the Arno. The cartoon was enormously influential. Frequently copied, it was eventually destroyed (*c.* 1515), according to Vasari, by the very artists who drew from it. The slender figures of the *Cascina*, often posed in attitudes of extreme contortion, influenced the first generation of Florentine Mannerists, who were prompted to take even greater liberties in the arrangement of the model and the placing of the human figure. The appearance of the *Bathers* group is preserved in a *grisaille* painting by Aristotile da San Gallo in the collection of the Earl of Leicester at Holkham Hall. This copy, painted in 1542 from a (lost) drawing made by Aristotile in his youth, is inherently truthful and an invaluable document, though its style needs some correction by reference to Michelangelo's own studies for the figures (e.g. no. 4) and to the earlier copy of the central figure in the composition (no. 11). (Nos. 6 and 8 may also have been made in the same connexion.) Wilde pointed out that the *Bathers* would have filled rather less than half the total width of the space (probably on the left-hand side of it) intended for the *Battle of Cascina* composition, the rest of which would presumably have been occupied by a representation of the actual battle. The rough sketches of battle-scenes datable around this period (nos. 3, 5, 7, 9 and 10) were no doubt made in this connexion.

Michelangelo seems to have chosen the *Bathers* episode simply as a pretext for representing the nude figure in as many poses as possible. 'The cartoon, while it survived, replaced [Masaccio's] Brancacci Chapel as the academy of art, and its matter, in effect, consists of what we call "academies" . . . In this incompletely classical, unsynthetic emphasis on formalism and virtuosity Michelangelo anticipates the mentality of the post-classical generation which, indeed, the cartoon later helped to form' (S. Freedberg).

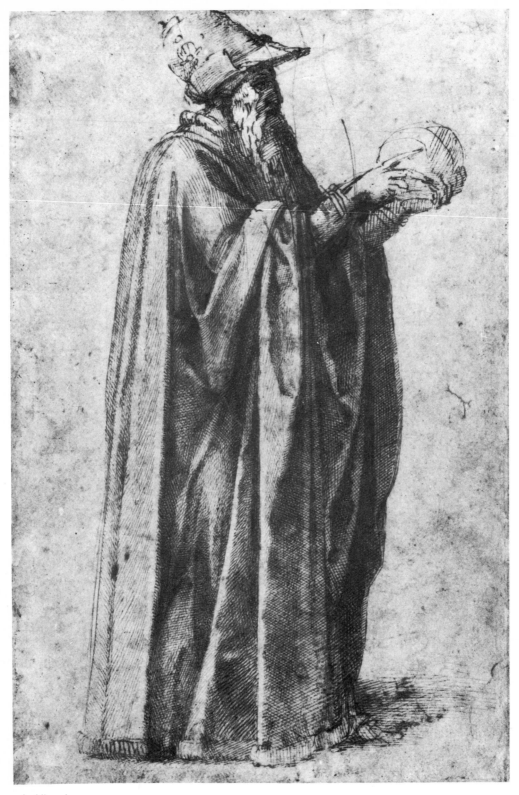

1 A philosopher

Nos. 1–13: DRAWINGS FOR
THE *BATTLE OF CASCINA*
AND THE *BRUGES MADONNA*

1 A philosopher

British Museum (Wilde 1)

Pen and two different shades of ink.

33·1 × 21·5 cm.

Lit.: Dussler 171; Hartt 21

About 1501–3. The hat is derived from the one
worn by the Byzantine Emperor, John Palaeo-
logus, who visited Italy in 1438–9. It denotes that
the figure is intended to be a Greek, and occurs
in many fifteenth-century representations of
Aristotle. The object in his hands is a skull (cf.
the somewhat similar figure sketched by Dürer
on a sheet in the Albertina, Winkler 87).

2 Head of a satyr

2 Head of a satyr

British Museum (Wilde 2)

Lit.: Dussler 327; Hartt 157

Pen and two different shades of ink. 13 × 13 cm.

About 1504.

3 Battle-scene: two standing figures

British Museum (Wilde 3)

Pen and ink. 18·6 × 18·3 cm.

Lit.: Dussler 170; Hartt 22

About 1503–4. The battle-scene, inspired by
Leonardo da Vinci's *Battle of Anghiari*, is
probably connected with the *Battle of Cascina*.
The standing figures could be studies for one of
the twelve statues of Apostles which Michelangelo
contracted on 24 April 1503 to make for the
cathedral in Florence.

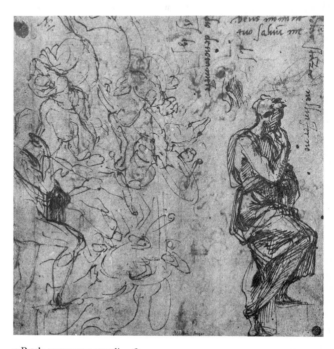

3 Battle-scene: two standing figures

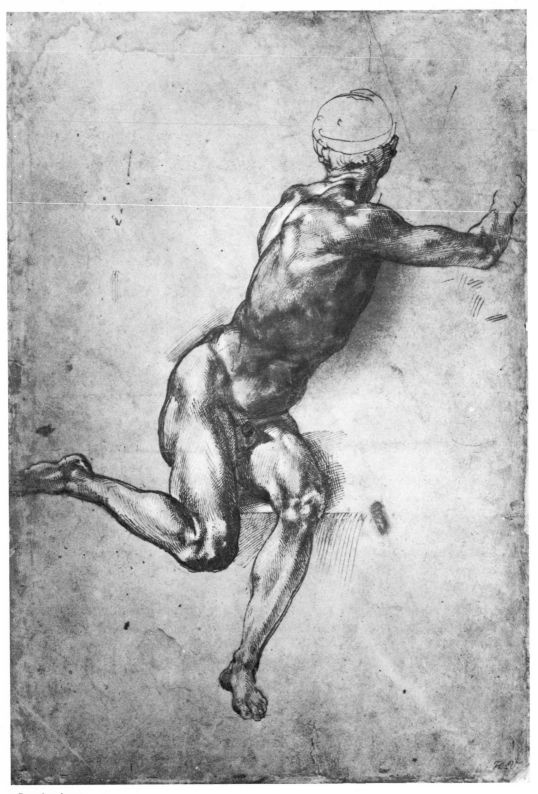

4 Seated nude man

4 Seated nude man turning away

British Museum (Wilde 6)

Pen and brush in two different coloured inks, heightened with white. 42·1 × 28·7 cm.

Lit.: Dussler 324; Hartt 41

About 1504–5. Study for a figure in the foremost row of the *Bathers*.

5 A horseman: a horse: a man's back: a man's right shoulder and arm: and other sketches

Ashmolean Museum (Parker 295)

Pen and ink, lead-point and black chalk. 19·1 × 25·9 cm.

Lit.: Dussler 603; Hartt 34

About 1503–4. Probably connected with the *Battle of Cascina*. Berenson rejected the chalk studies but accepted those in pen. Wilde, who accepted the whole sheet (1953), followed him in connecting it with the *Battle of Cascina*. Parker argued that the handwriting of the inscription more closely resembles that of Michelangelo's younger contemporary, the Florentine sculptor Raffaello da Montelupo (*c.* 1505–66/7). He doubted Michelangelo's authorship of the chalk studies, and made the ingenious suggestion that if the sheet is turned upside down the horse can be seen as a copy of one of the falling horses in the *Fall of Phaethon* (datable *c.* 1533: see no. 126) by a left-handed draughtsman—which Montelupo on occasion was. On the other hand, he admits that the pen-and-ink sketch of a horseman is 'surprisingly free and brilliant' for Montelupo.

6 Group of three nude men: the Virgin and Child

British Museum (Wilde 5)

Black chalk, and pen and ink over lead-point. 31·5 × 27·8 cm.

Lit.: Dussler 162; Hartt 27

The *Virgin and Child* is a study for the marble groups in Bruges, which was completed in 1506. Brinckmann (*Michelangelo-Zeichnungen*, Munich, 1925, no. 9), followed by Wilde and Dussler, dismissed the interpretation of the group of nude

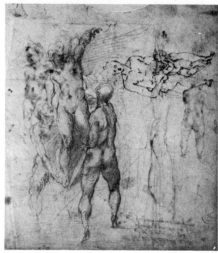

6 Three nude men: Virgin and Child

men as 'two performing acrobats' supporting a third standing on a cloth between them. He ingeniously explained the group as a study for the *Bathers*: one man sitting on the bank with his right leg hanging over the edge, drying his left foot which is drawn up on the bank; a second standing on the bank pointing to his left; and a third running towards the bank drawing his sword. But the other interpretation is supported by a drawing of the same three figures in the Louvre (718; Tolnay, i, fig. 283; B.B. 1598, 3rd edn, fig. 552) which shows unmistakably that the man at the back is supporting in his clasped hand the right leg of the central figure, whose other leg is held up by the third figure. The Louvre drawing is accepted by Berenson but rejected by Wilde (who did however accept the studies on the *verso* of the sheet). But even if it were a copy it must be a faithful one, for the action of the figures is too intelligently and convincingly rendered for the drawing to be explained as a copyist's misunderstanding of the group on the British Museum sheet.

The study for the *Bruges Madonna* dates the sheet in the period of the *Battle of Cascina*. The group of three men may be connected with that composition, though not necessarily with the *Bathers* section of it. Berenson pointed out that the motif of two men holding up a third occurs in the drawing of the *Worship of the Brazen Serpent* (no. 105). There can be no direct connexion, since no. 105 can hardly be earlier than the late 1520s; but it seems by no means impossible that Michelangelo after an interval of years might have adapted a discarded motif originally intended for a not dissimilar subject.

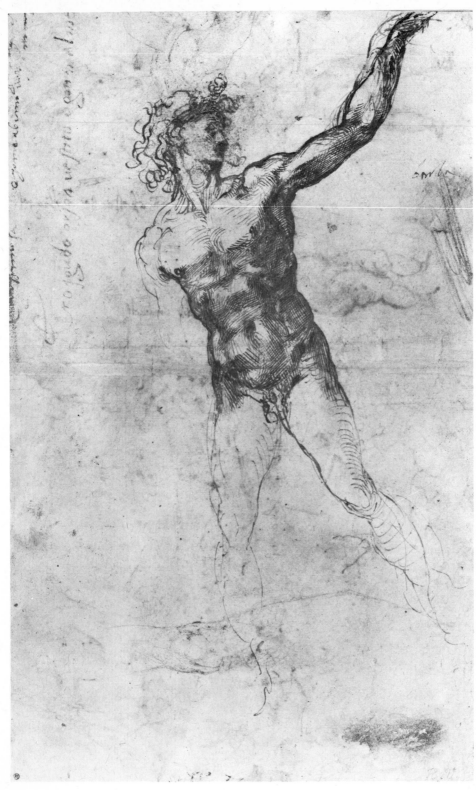

8 A youth beckoning

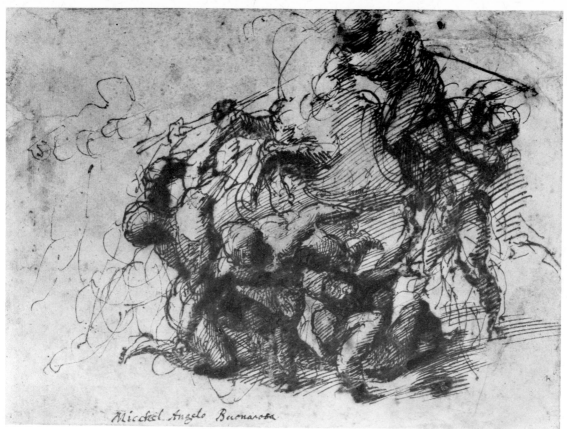

9 A battle-scene

7 Studies of horses: a battle-scene

Ashmolean Museum (Parker 293)

Pen and ink. 40·3 × 26·1 cm.

Lit.: Dussler 191; Hartt 30

The small sketch at the bottom of the sheet is for the same scene as those on nos. 3 and 9. All three are no doubt connected with the *Battle of Cascina*. The static poses of the larger-scale horses hardly suggest a connexion with this spirited composition, unless these are studies made from the life in preparation for representing horses in movement.

On the *verso*, showing through on the other side, are five drafts of poems in Michelangelo's hand.

8 A youth beckoning

British Museum (Wilde 4)

Pen and brown ink. 37·5 × 23 cm.

Lit.: Dussler 169; Hartt 4

Datable from its style *c.* 1503–4 and possibly connected with the *Battle of Cascina*. The pose, derived from the *Apollo Belvedere*, resembles that of the central figure in the group on no. 6.

9 A battle-scene: horsemen attacking foot-soldiers

Ashmolean Museum (Parker 294)

Pen and ink. 17·9 × 25·1 cm.

Lit.: Dussler 190; Hartt 31; C. de Tolnay, *Commentari*, xxiii (1972), p. 70

Probably connected with the *Battle of Cascina*, the outcome of which, according to historical sources, was decided by an attack of the Florentine cavalry against the Pisan infantry.

The subject is clearly a skirmish between a horseman and a number of foot-soldiers, and not the Expulsion of Heliodorus from the Temple, as Tolnay suggests. Nor is there any evidence that this subject was ever proposed for one of the circular reliefs on the façade of S. Lorenzo, with which he is inclined to connect the drawing.

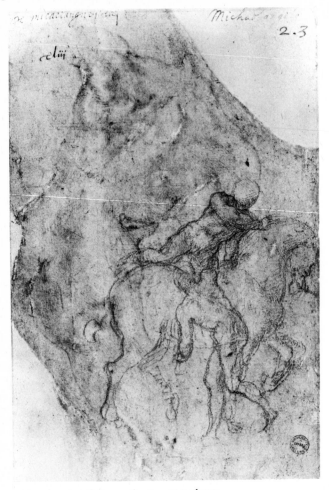

10 A nude man assisting another to mount a horse

10 A nude man assisting another to mount a horse

Ashmolean Museum (Parker 296 *verso*)

Black chalk. 26·2 × 17·3 cm.

Lit.: Dussler 344; Hartt 32

No doubt a study for a group in the *Battle of Cascina*. A pen-and-ink drawing of a nude man on the other side of the sheet is in a pose close to that of the standing figure but for the position of the left leg; it is also close, in reverse, to that of the figure wielding a pole in the centre of the back row of the *Bathers*.

11 Head and shoulders of a bearded man (after Michelangelo)

Windsor (Popham–Wilde 448)

Red chalk. 16·5 × 18·2 cm.

An old copy of the figure in the centre of the *Bathers* group. This was evidently made directly from the original, and tells us more about the actual appearance and style of the cartoon than does the painted copy of the whole group by Aristotile da San Gallo, which was not executed until 1542 when the cartoon itself had long since been destroyed.

12 Virgin and Child with St Anne

Ashmolean Museum (Parker 291)

Pen and ink. 25·2 × 16·8 cm.

Lit.: Dussler 193; Hartt 9

The composition seems clearly to be inspired by Leonardo da Vinci. It differs both from his National Gallery (ex-Burlington House) cartoon of the *Virgin and Child with St Anne* and from the Louvre painting; but another cartoon of the same subject by him, now lost, was on public exhibition in Florence in the spring of 1501, at the time when Michelangelo returned from Rome.

13 Studies of a man's back, knee and shoulders

Ashmolean Museum (Parker 292 *verso*)

Pen and ink, partly over black chalk.
19·2 × 23·4 cm.

Lit.: Dussler 192; Hartt 18

About 1501-3. Two heads drawn on the *verso* are close variants of heads on no. 12 *verso*. The two sheets may have formed part of the same sketchbook.

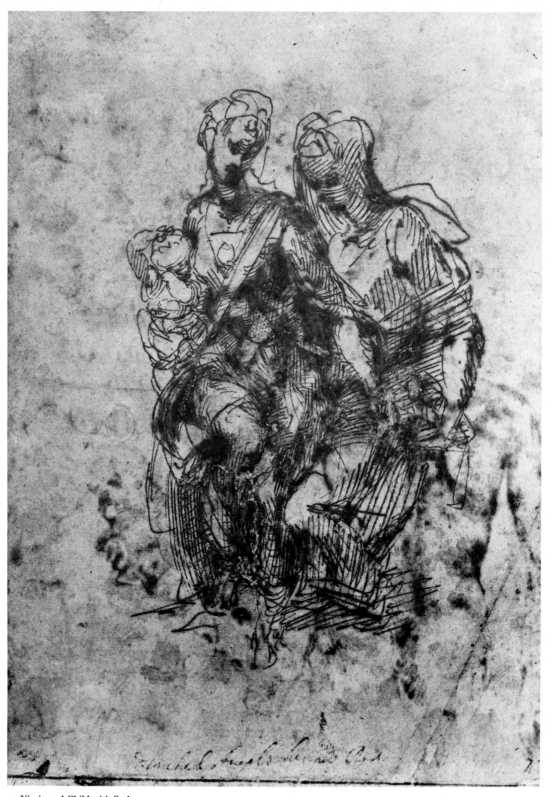

12 Virgin and Child with St Anne

II THE SECOND ROMAN PERIOD
1505–16

In March 1505 Michelangelo was called back from Florence to Rome by Julius II and commissioned to design a tomb for the Pope to be placed in St Peter's. The contentious nature of the early relationship between Julius II and Michelangelo may be explained in part by the forced diversion of the latter's political allegiances. Florence in the early years of the sixteenth century was a democratic state with a political climate which was undoubtedly congenial to Michelangelo; in contrast, Rome was governed by the authoritarian regime of Julius II, and this militant and expansionist rule did not conform as readily to his political ideals. Furthermore Julius II's invitation had caused Michelangelo to abandon abruptly the commission to decorate the choir chapels of Florence cathedral with statues of the twelve Apostles, a project to which he had devoted his energies immediately prior to his departure from the city. Condivi, Michelangelo's friend and early biographer, describes the Julius tomb commission as a 'tragedy'. It was indeed to overshadow Michelangelo's life for the next forty years; its history is a series of compromises by which the scheme was revised and progressively reduced in an attempt to reconcile the anxiety of Julius's family for its completion with the differing and more urgent requirements of his successors, Leo X, Clement VII and Paul III, and even those of Julius himself. The first proposal was for a very large (about 36 by 24 ft) rectangular free-standing structure embellished with bronze reliefs and more than forty life-size or larger marble statues, containing an oval tomb-chamber for the sarcophagus. Round the outside were to be statues in niches separated by figures of bound captives (the 'Slaves'), and the whole was to be crowned by a cornice above which were to be four large figures, one of them of Moses, surrounding a smaller second storey decorated with bronze reliefs of scenes from the Pope's life and surmounted by two statues of angels. This is not the place for a detailed analysis of the successive modifications which this plan underwent in 1513, 1516, 1525, 1532 and 1542 (they are lucidly summarized on pp. 25 ff. of Sir John Pope-Hennessy's *Italian High Renaissance and Baroque Sculpture*, 1963); it is sufficient to say that the monument eventually erected in 1542–5, not in St Peter's, but in the church of S. Pietro in Vincoli, bears little relation to Michelangelo's original conception. It is a wall-tomb (as had already been proposed in the 1516 revision) combining the front of the lower storey of the 1513 revision (see no. 36) with the upper storey as proposed in 1516. The *Moses*, begun probably in 1513 and intended for a position in the upper register where it would have been seen from below and from the left, is unhappily placed in the central niche of the lower storey. In the niches on either side are figures of *Rachel* and *Leah* (typifying the *Contemplative Life* and the *Active Life*), one probably part of the 1532 project, the other associable with the final stage. The figures in the three upper niches, the *Virgin and Child*, a *Prophet*, and a *Sibyl*, were carried out by Raffaello da Montelupo after models by Michelangelo, also probably made for the 1532 project. Inverted volutes were substituted for the 'Slaves', which in the 1513 plan were to have been placed on the bases in front of the *Herms* in the lower storey. Very few of the many drawings that Michelangelo must have made for the tomb have survived (see nos. 33 to 36), but some account of the project is essential in view of the important part it played in his life.

'The tragedy of the tomb was not simply a tragedy of compromise, a great artistic concept trimmed by fate or by expediency; it was the tragedy of a work rooted in deep artistic convictions that was completed by a man to whom artistic considerations were in themselves no longer of great consequence. In 1542, . . . the Inquisition was introduced in Italy, the Council of Trent had already been convened, and the Counter-Reformation, which had cast its shadow over the preceding decade, was fully launched. In the life of Michelangelo reason was expelled, and dark contemplation took its place . . . Between the latest of the statues carved for the 1516 tomb, the *Victory*, and the new statues carved for the monument of 1542, there intervene the visionary images of the *Last Judgement*, in which painting is treated as a vehicle for the transmission of mystical experience. The bottom of the Julius monument is not just a union of figures of different dates, but the meeting point of two irreconcilable attitudes to sculpture' (Pope-Hennessy, op. cit., p. 37).

Michelangelo's work on the tomb was interrupted in the spring of 1508 by the Pope's order that he should decorate the ceiling of the Sistine Chapel. Working with extraordinary speed and concentration he completed more than half of this enormous task between February 1509 and the end of August 1510, and the entire ceiling by the end of October 1512. Almost all the related drawings are studies for separate figures, but no. 14 is of particular interest in being a rough sketch for the first and very much simpler scheme in which the figurative part, as we know from Michelangelo's own account, was to have been confined to a series of figures of enthroned Apostles in the spandrels of the vault, while the centre of the ceiling was to be covered with 'ornament of the usual kind'. As the drawing shows, this was a formal pattern of geometric elements. Michelangelo goes on to say that he told the Pope that 'the Apostles by themselves would make a poor effect, in my opinion. He asked me why, and I answered "because they too were poor". He then told me to do it in the way I thought best.' His mind must still have been filled with ideas for the tomb, and it has often been observed that these seem to have found expression in his revised scheme for the ceiling, likewise mostly made up of single figures in a complex architectural framework: the colossal Prophets and Sibyls in the spandrels, flanked by plinths decorated with illusionistic sculpture, can be seen as equivalents of the great seated statues of Moses and others which were planned for the upper storey of the tomb; the *ignudi* as equivalents of the '*Slaves*'; and the scenes in the centre of the vault and in the spandrels as equivalents of the bronze reliefs.

The iconographic scheme of the ceiling was devised in relation to that of the two earlier series of frescoes, painted in 1481–3 by Botticelli, Ghirlandaio and others on the side walls of the chapel. These illustrate the history of mankind under the Law of the Old Covenant, as revealed to Moses, and under the New Covenant as revealed by Christ. The ceiling illustrates the history of mankind before the Old Covenant. The scenes in the centre represent the Creation and the Fall of Man, followed by the destruction of mankind in the Flood and its salvation in the persons of Noah and his family, ending with the *Drunkenness of Noah* which typifies the perpetually unregenerate nature of humanity. The four scenes in the corner spandrels, *David and Goliath, Judith and Holofernes,*

the *Crucifixion of Haman* and the *Worship of the Brazen Serpent*, are four of God's mercies to the Israelites which foreshadow the Redemption, which is foreseen by the Prophets and Sibyls. In the lunettes and on the subsidiary triangular vaults of the window embrasures are the Ancestors of Christ, typifying the mass of humanity still sunk in darkness.

One of the most conspicuous elements in this complex iconographic scheme, the nude figures of youths flanking the Genesis scenes in the centre of the ceiling, have never been satisfactorily explained, though in recent years several ingenious suggestions have been made. It is difficult to believe that their function was purely decorative, as some writers (e.g. Symonds) have supposed. Condivi, Michelangelo's friend and biographer, simply refers to them as '*certi ignudi*'.

Since its completion, the Sistine ceiling has prompted the very greatest admiration. Reynolds, writing in his *Discourses* in the later half of the eighteenth century, praised Michelangelo's achievement, regarding it as a manifestation of sublime power:

'. . . I would ask any man qualified to judge of such works, whether he can look with indifference at the personification of the Supreme Being in the center of the Cappella Sestina, or the figures of the Sybils which surround that chapel . . . and whether the same sensations are not excited by those works, as what he may remember to have felt from the most sublime passages of Homer?'

The ceiling further displayed the very highest level of attainment in the representation of figures in action. These Reynolds described not as mere everyday mortals but as beings of a higher order: '. . . his ideas are vast and sublime; his people are a superior order of beings; there is nothing about them, nothing in the air of their actions or their attitudes, or the style and cast of their limbs or features, that reminds us of their belonging to our own species . . .'

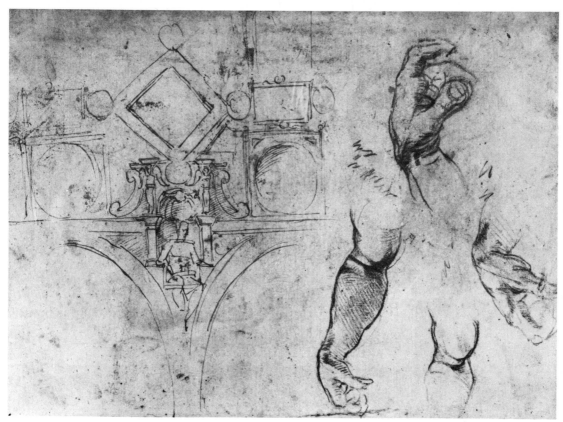

14 Scheme for the decoration of the Sistine ceiling

Nos. 14–36: DRAWINGS FOR THE SISTINE CEILING, THE RISEN CHRIST AND THE TOMB OF JULIUS II

14 Scheme for the decoration of the Sistine Ceiling: studies of arms

British Museum (Wilde 7)

Pen and ink over lead point: black chalk. 27·5 × 38·6 cm.

Lit.: Dussler 163; Portoghesi–Zevi pp. 110 f.; Hartt 62

A sketch of the first scheme for the decoration of the ceiling, in which the figurative element was to have been confined to figures of the twelve Apostles, and the rest of the space filled with conventional patterning. The arms are probably for a figure on the ceiling which was not carried out, and were presumably drawn later. Another drawing showing a design for the first scheme of the ceiling is in the Institute of Arts, Detroit (27.2).

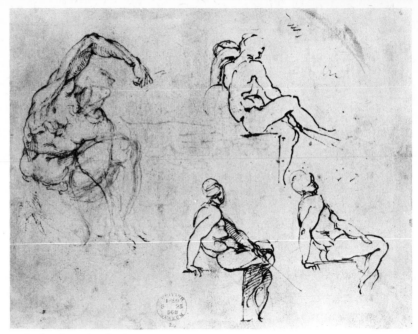

15 Studies of seated nude men

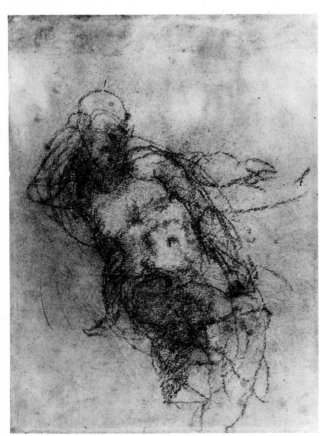

16 Nude figure, seated

15 Studies of seated nude men

British Museum (Wilde 8 *verso*)

Pen and ink. 24·5 × 18·8 cm.

Lit.: Dussler 164; Hartt 96

About 1508–9. Studies for the *ignudi*, though there is no exact correspondence between them and any of the figures as finally executed.

16 Nude figure, seated

British Museum (Wilde 9)

Black chalk. 27·8 × 21·8 cm.

Lit.: Dussler 314; Hartt 93

About 1508–9. Probably an early study for the *ignudo* above and to the right of the *Delphic Sibyl*.

17 Study for the drapery of the Erythraean Sibyl

British Museum (Wilde 10)

Black chalk and pen and dark brown ink over a brush-drawing in brown. 38·7 × 26 cm.

Lit.: Dussler 566; Hartt 84

A drapery study made according to the traditional Florentine method, as used by Leonardo and Fra Bartolommeo and described by Vasari in his life of Leonardo, from a small clay model of the figure on which draperies soaked in liquid clay were arranged in the required folds and left to harden.

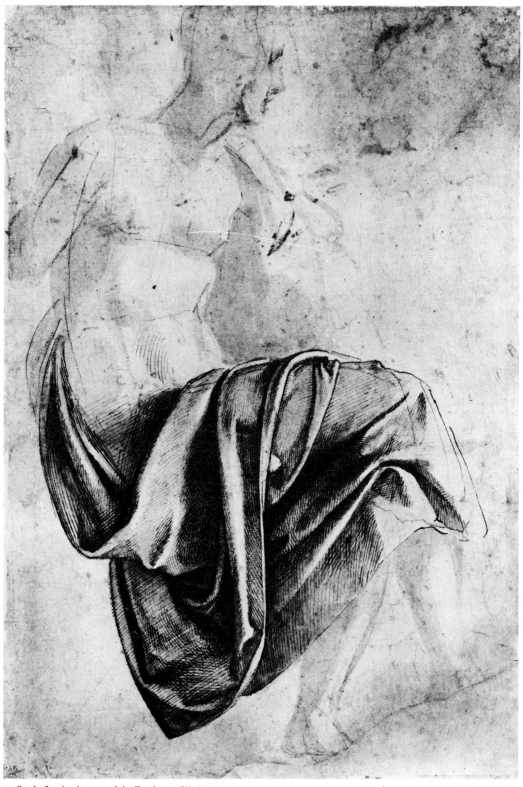

17 Study for the drapery of the Erythaean Sibyl

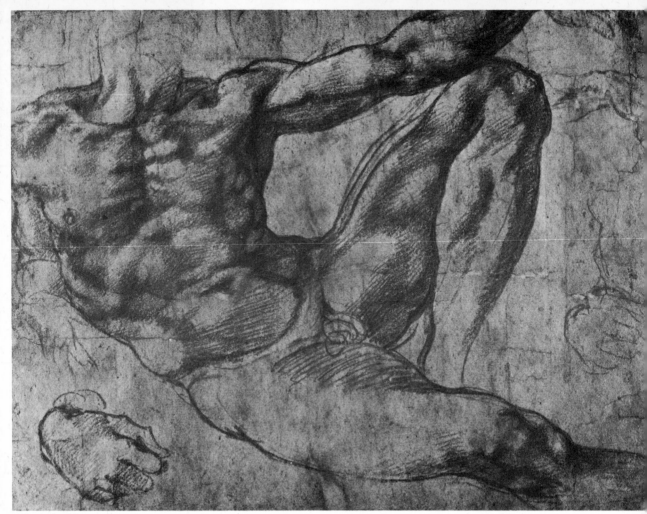

18 Study for Adam

18 Study for Adam

British Museum (Wilde 11)

Red chalk. 19·3 × 25·9 cm.

Lit.: Dussler 580; Hartt 77

For the figure in the *Creation of Adam*. This is an example of the type of working drawing which Michelangelo made from the model in preparation for work on the Sistine Ceiling. The pose of Adam as painted in the fresco is substantially that of the present sheet. The execution of the *Creation of Adam* belongs to the second phase of decoration, begun about 1511.

19 Studies for the Sistine Ceiling and for the tomb of Julius II.

Ashmolean Museum (Parker 297)

Red chalk and pen and ink. 28·5 × 19·4 cm.

Lit.: Dussler 194; Hartt 89

The principal sketch on the sheet is for the boy to the left of the *Libyan Sibyl*, for whose right hand there is also a study. Other studies for this Sibyl are on no. 20, which might have formed part of the same sketchbook, or even of the same sheet.

The small figures in pen are for the '*Slaves*' which were to have decorated the tomb of Julius II. The second from the left resembles in all essentials the *Rebellious Slave* (Louvre). The cornice top left, drawn in the same ink and presumably at the same time, is no doubt also connected with the tomb.

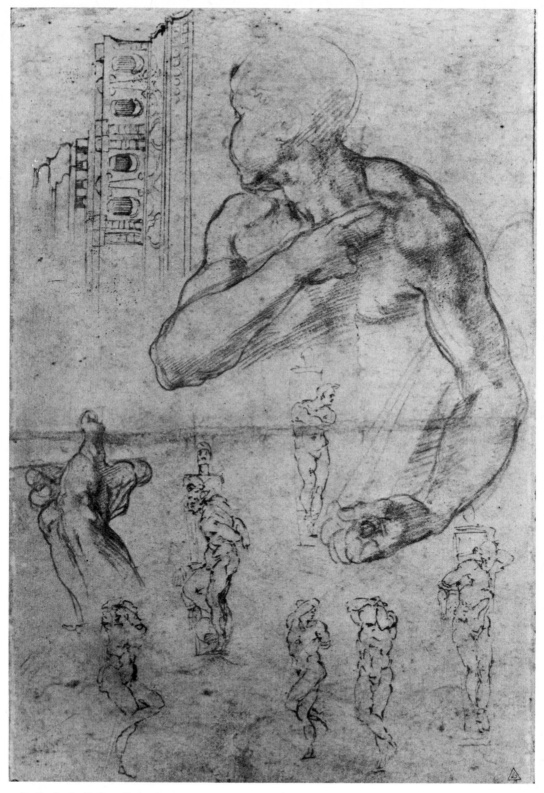

19 Studies for the Sistine ceiling and tomb of Julius II

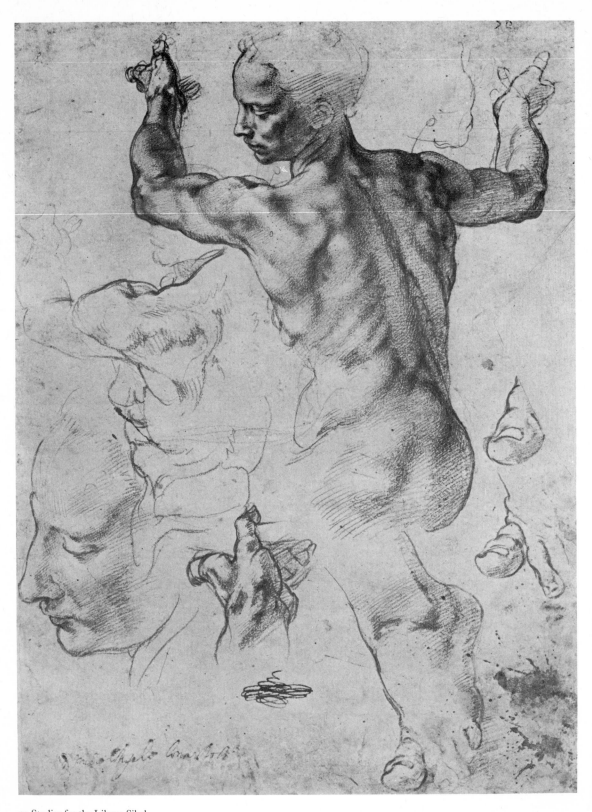

20 Studies for the Libyan Sibyl

20 Studies for the Libyan Sibyl

Metropolitan Museum, New York (24.197.2)

Red chalk. 29 × 21·5 cm.

Lit.: Dussler 339; Hartt 87

A study from the life, drawn from a nude male model, with separate studies of the head, the left shoulder, the right hand and the left foot. In the figure as painted the right forearm is held slightly higher so that the thumb is level with the top of the head, and the left hand slightly lower, so that it is level with the eye, with the forearm more sharply foreshortened. The correspondence is otherwise exact. The gesture of the arms and hands is explained by the fact that the figure is holding a large open book. No. 19 is clearly connected with this drawing: the two may have come from the same sketchbook or have even formed part of the same sheet.

21 Two studies of legs

British Museum (Wilde 14)

Red chalk. 21·4 × 16·1 cm.

Lit.: Dussler 304; Hartt 246

About 1511–12. Studies for the left leg of the *ignudo* above and to the left of *Jeremiah*, and (drawn with the sheet turned upside down) for the left foot of the *Crucifixion of Haman*.

22 Two studies of a crucified man

British Museum (Wilde 12)

Pen and ink over stylus. 24·9 × 16 cm.

Lit.: Dussler 313; Hartt 165

Probably preliminary sketches for the *Crucifixion of Haman*.

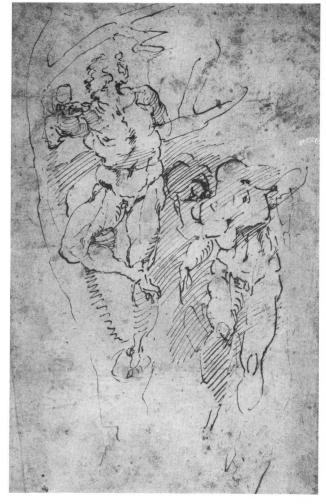

22 Two studies of a crucified man

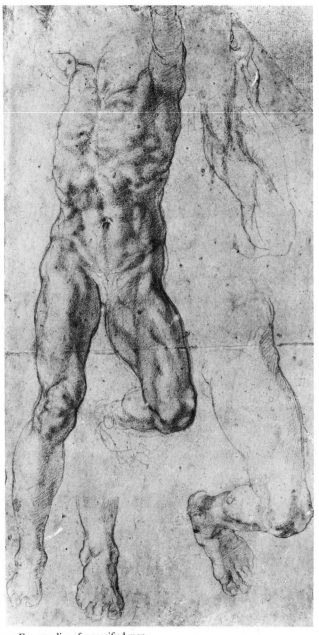

23 Four studies of a crucified man

23 Four studies of a crucified man

British Museum (Wilde 13)

Red chalk. 40·6 × 20·7 cm.

Lit.: Dussler 569; Hartt 90

Studies for the *Crucifixion of Haman* in one of the corner-spandrels at the altar-end of the Sistine Chapel. These were among the last parts of the ceiling to be decorated. See also no. 22.

24–31 Eight leaves from a sketchbook, each measuring about 14 cm. by 14·2/14·6 cm., with small sketches in pen and ink and in black chalk, mostly connected with the Ancestors of Christ in the lunettes

Ashmolean Museum (Parker 299–306)

Lit.: M. Hirst, *Burlington Magazine*, cv (1963), p. 169, note 3.

24 (Parker 299)

Lit.: Dussler 604; Hartt 121

Inscribed in Michelangelo's hand: *di qui[n] dici di sette[m]bre.*

25 (Parker 300)

Lit.: Dussler 605; Hartt 119

26 (Parker 301)

Lit.: Dussler 606

Inscribed, in a hand not Michelangelo's: *M A Silvio in roma falconi damagliano/ silvio di messere . . . Damagliano in roma.*

27 (Parker 302)

Lit.: Dussler 607; Hartt 123

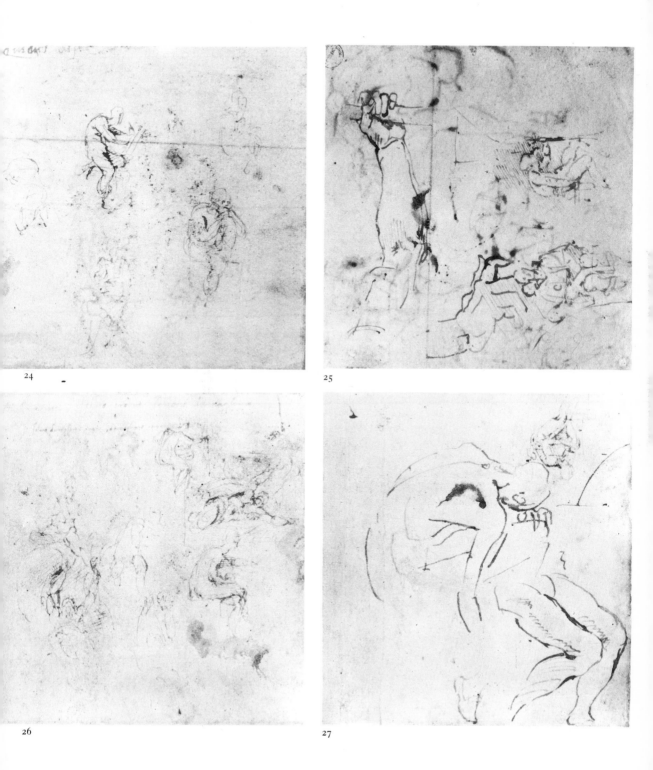

24

25

26

27

28 (Parker 303)

Lit.: Dussler 608; Hartt 120

Inscribed in Michelangelo's hand: *Dagli bere*.

29 (Parker 304)

Lit.: Dussler 609

30 (Parker 305)

Lit.: Dussler 610; Hartt 115

31 (Parker 306)

Lit.: Dussler 611; Hartt 112

1511–12. These eight small leaves, evidently from the same sketchbook, were formerly joined together to make two sheets of four leaves each. They are so reproduced by Frey and were so exhibited in 1953 (nos. 19 and 22). Critical opinion about them has varied. Berenson rejected them totally and suggested, on the strength of the inscription on no. 26, that they might be by the Silvio Falcone da Magliano who is recorded as having been one of Michelangelo's assistants in Rome between 1514 and 1517. Tolnay accepted only the standing nude man in black chalk on no. 24 *verso*. Parker, while admitting that there are grounds for doubt, found certain features of the sketches inexplicable except on the hypothesis that they are 'substantially due to the master's own hand'. Hirst stated more emphatically the case for Michelangelo's total authorship, pointing out, against the theory that the sketches are the work of a copyist, that some of the figure motifs do not occur on the ceiling; that some of those that do, occur here in different contexts, so that the hypothetical copyist would have been capable of adjusting and rearranging Michelangelo's ideas; and that all those that can be identified with figures actually executed relate to the second phase of the decoration.

The great majority of these sketches are connected with the Ancestors of Christ (the *Antenati*) in the lunettes, though on no. 26 are what appear to be studies for *God the Father separating Light and Darkness* in the centre of the vault. The black chalk sketch on no. 29 of a bowed old man with a wallet at his waist, leaning on a stick and preceded by a dog, appears to be an exception. Robinson connected it with the essentially similar motif, according to Vasari suggested by Michelangelo himself, on the reverse of Leone Leoni's portrait medal of Michelangelo executed in 1560 (see no. 203). Parker denies that there can be any connexion, and it is certainly true the sketch must have preceded the medal by nearly half a century; but the general similarity is undeniable, and it may well be that the idea was germinating in Michelangelo's mind over this long period. In the context of the other studies on the sheets one might expect this figure to be connected with the Sistine Ceiling. Wilde, indeed, apropos of the medal (1953, no. 175), describes the motif as having been transformed in the sketch into one of the *Antenati*. The only one of the Ancestors who at all resembles this figure, not in pose but in general type, is *Boaz* (Tolnay, ii, fig. 166) who is represented as a haggard old man leaning on a stick. Like most of the other Ancestors, *Boaz* is seated with his back to the arch of the central window; but one, the wife of *Naason* (Tolnay, ibid., fig. 171), is standing with her back to the curve of the lunette as the old man in the sketch would have to do if he were intended as an Ancestor.

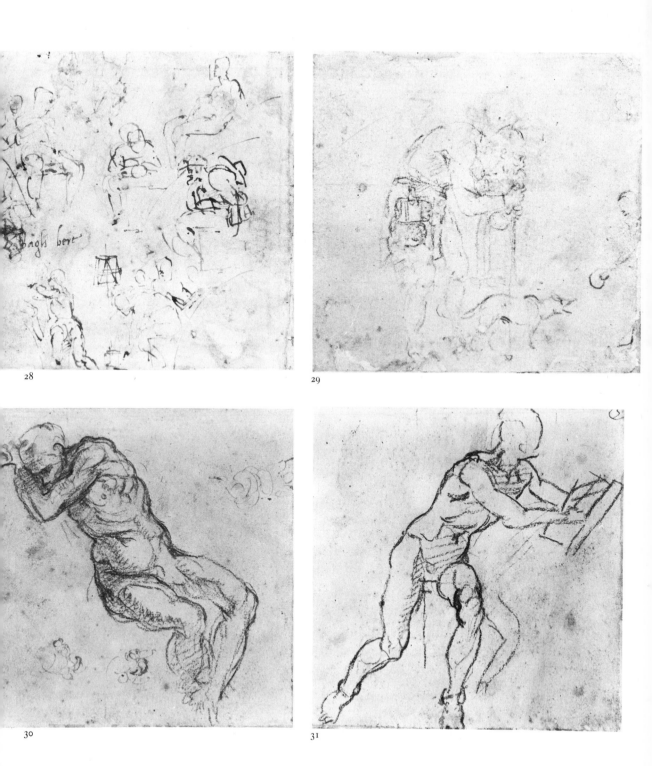

28

29

30

31

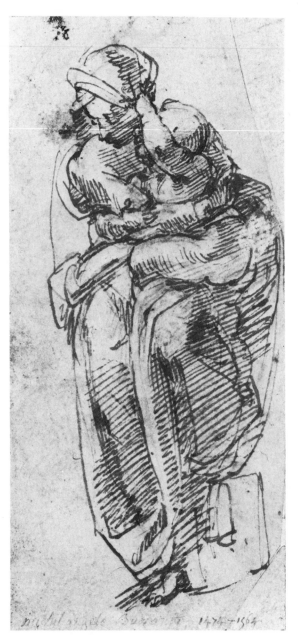

32 The Risen Christ

Brinsley Ford, Esq.

Pen and ink and black and red chalk.

24·7 × 21 cm.

Lit.: Dussler 182; Hartt 296

About 1515. A study for the marble statue of the *Risen Christ* commissioned on 14 June 1514 by Metello Vari. Michelangelo began work on the figure but abandoned it in 1516 because a flaw in the marble appeared which disfigured the face. The statue now in S. Maria sopra Minerva in Rome is a replica completed by Michelangelo in 1520 with some help from assistants.

See no. 188.

33 The Virgin and Child

33 The Virgin and Child

Count Antoine Seilern

Pen and brown ink over red chalk. 16·5 × 7·5 cm.

There seems no reason to doubt the traditional attribution to Michelangelo of this recently discovered drawing. Michael Hirst dates it *c.* 1516 and suggests that it might have been connected with the statue of the Virgin and Child which was at that stage proposed for the tomb of Julius II.

34 A male torso

British Museum (Wilde 47)

Black chalk. 22·6 × 16·2 cm.

Lit.: Dussler 317; Hartt 292

Study for the principal figure in the group of *Victory* (now in the Palazzo Vecchio, Florence). For this aspect of the figure see Tolnay, iv, pl. 30. Vasari (vii, p. 66) mentions this group with other statues for the tomb of Julius II and implies that it was made in that connexion. The fact that the figure wears oak-leaves in his hair, which were the heraldic emblem of the Pope's family, the Della Rovere, reinforces this possibility. Wilde infers that it was intended for one of the niches in the lower storey of the tomb, and dates it 1527–30 (*Michelangelo's "Victory"*, Charlton Lecture, Oxford, 1954).

35 Right leg and shoulder

Ashmolean Museum (Parker 314)

Red chalk. 22·1 × 16·8 cm.

Lit.: Dussler 340; Hartt 294

About 1520. Probably made in connexion with the bearded '*Slave*' in the Accademia in Florence which was to decorate the tomb of Julius II.

34 A male torso

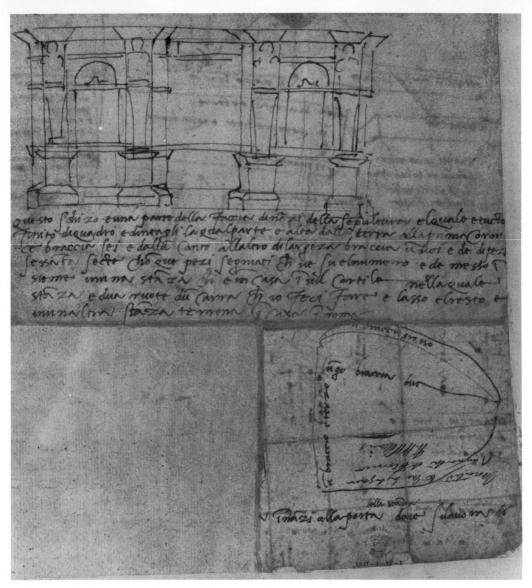

36 Elevation of the lower storey of the tomb of Julius II

36 Elevation of the lower storey of the tomb of Julius II

British Museum (Wilde 23)

Pen and ink. 26 × 23·8 cm.

Lit.: Dussler 152; Portoghesi–Zevi, p. 78; Hartt 126

A roughly drawn elevation of the lower storey of the tomb, as executed (apart from the herms) under Michelangelo's direction by the sculptor Antonio da Pontassieve according to the revised contract of 1513. This forms the lower part of the structure finally erected in S. Pietro in Vincoli between 1542 and 1545. The herms are roughly sketched in the drawing to explain the structure but were not executed until the final phase, when volutes were placed on the bases in front of them instead of the '*Slaves*' which Michelangelo considered unsuitable for the tomb in its reduced form.

The drawing was made in the early part of 1518 for the benefit of Michelangelo's friend Leonardo il Sellaio, who was looking after his house in Rome, to help him verify the contents of the studio. On the *verso* is a diagram of the measurements and approximate shapes of eleven component parts of the structure.

III DRAWINGS MADE FOR
SEBASTIANO DEL PIOMBO

Some three years after Michelangelo's return to Rome his ascendancy was threatened by the advent of Raphael, who had likewise been called there by Julius II. Raphael was commissioned to decorate the Vatican *stanze*, located in the building adjoining the Sistine Chapel, with frescoes, which on their completion were to rival Michelangelo's ceiling. The two men were temperamentally incompatible and never on friendly terms, so that the artistic world of Rome tended to be split into two factions. Michelangelo differed from Raphael in being essentially a solitary genius. Raphael's lucidly analytic intelligence enabled him to delegate as much work as possible to a highly organized team of talented younger artists. Michelangelo's thought was incommunicable; and though the scale of his commissions obliged him to make use of assistants, they were only employed in a menial and subordinate capacity. He had, however, a number of independent followers who admired him and to whom he was willing to give practical assistance by providing drawings for their own projects. In this way he was able vicariously to express ideas that would have otherwise been stifled by the pressure of more urgent commissions. The first, and most important, of these followers was Sebastiano Luciani, known as Sebastiano del Piombo (*c.* 1485–1547), who had been a pupil of Giorgione in Venice. In 1511 he moved to Rome where he soon became one of Michelangelo's most devoted followers. In 1516 he received, on Michelangelo's recommendation, two important commissions: for the decoration of the Borgherini Chapel in the church of S. Pietro in Montorio and for a large altarpiece of the *Raising of Lazarus* (National Gallery, London) commissioned by Cardinal Giulio de' Medici for his cathedral at Narbonne. Simultaneously, and for the same place, the Cardinal commissioned from Raphael an equally large altarpiece of the *Transfiguration*. In this direct confrontation Michelangelo was naturally anxious to support Sebastiano, and according to Vasari assisted him over both commissions: the altarpiece of the Borgherini Chapel, the *Flagellation of Christ*, was based on a '*piccolo disegno*' provided by Michelangelo, and the *Raising of Lazarus* was painted '*sotto ordine e disegno in alcune parti di Michelangelo*'. The early sketch for the composition of the *Flagellation* (no. 37), the larger study for the figure of Christ (no. 38) and the three studies for the group of Lazarus and his supporters (nos. 40 and 41: the third is at Bayonne) were all traditionally attributed to Michelangelo, and all but one of them (no. 38) are known to have been in the possession of his descendants, the Buonarroti family in Florence. Nevertheless, from the late nineteenth century onwards there has been a persistent tendency among critics to attribute them to Sebastiano. The apparent absence of drawings by Michelangelo himself connected with these joint projects is accounted for by the improbable hypothesis that he merely sent Sebastiano studies of single figures already made in connexion with other works and left him to make what use of them he could. The fundamental weakness of this theory—well described by Kenneth Clark as 'one of the heroic curiosities of connoisseurship'—namely, the stylistic incompatibility between the drawings connected with the *Flagellation* and the *Raising of Lazarus* and those drawings unquestionably attributable to Sebastiano on the strength of their connexion with paintings in which Michelangelo had no share, was first pointed out by Oskar Fischel (*Old Master Drawings*, xiv

(1939–40), pp. 21 ff.). Wilde in his 1953 catalogue restored all these drawings but no. 38 to Michel-angelo, together with a number of others including some in the present exhibition (nos. 78, 87, 118, 141 and 159), which had also been re-attributed to Sebastiano. No. 38 he left with Sebastiano, an opinion which he later revised. This return to the traditional view now seems entirely con-vincing.

The *Resurrection* studies (nos. 42–7) are included under this heading, though their connexion with Sebastiano is conjectural.

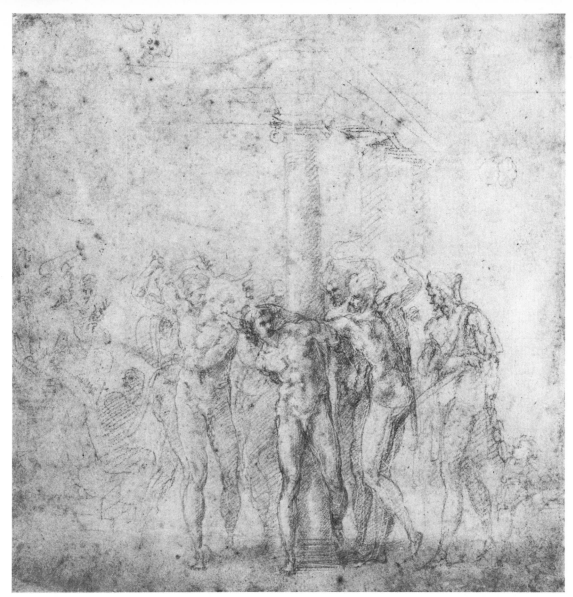

37 The Flagellation

Nos. 37–47: STUDIES FOR THE *FLAGELLATION OF CHRIST* AND THE *RAISING OF LAZARUS*; STUDIES FOR A *RESURRECTION*

37 The Flagellation

British Museum (Wilde 15)

Red chalk. 23·5 × 23·6 cm.

Lit.: Dussler 570

A preliminary design for the composition of the painting in the Borgherini Chapel, S. Pietro in Montorio, Rome. Comparison with the finished work shows that Michelangelo eventually con-

centrated the composition by enlarging the scale of the figures in relation to the total area, by reducing the number of executioners from five to four and by eliminating the bystander with the child in the foreground and the group of Pilate and his attendants in the left background. He also reversed the pose of Christ and changed the direction of the lighting from left to right in order to conform with the natural lighting in the church.

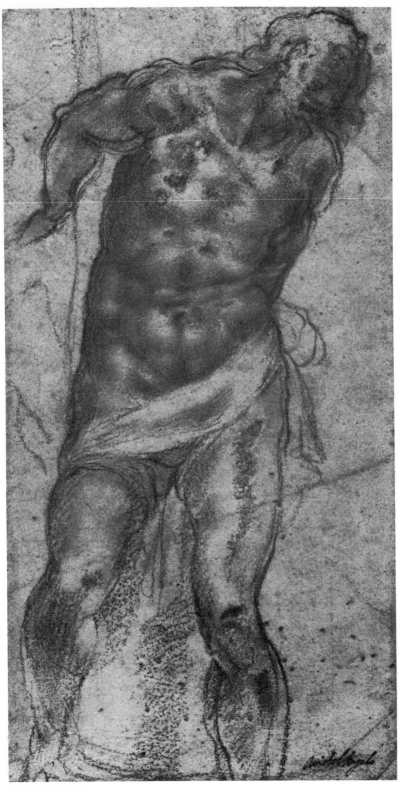

38 Christ at the Column

38 Christ at the Column

British Museum (Pouncey-Gere 276)

Black chalk, with some stumping, over stylus underdrawing. Heightened with white.

27·5 × 14.3 cm.

Lit.: Hartt 129

The traditional attribution to Michelangelo of this study for the principal figure in the Borgherini Chapel *Flagellation* was discarded by Sir J. C. Robinson in his catalogue of the Malcolm Collection (1876) in favour of one to Sebastiano. This view has been accepted without question by ever later critic, including even Wilde (pp. 28 f.), all influenced no doubt by Vasari's statement that from Michelangelo's '*piccolo disegno*' (see above) Sebastiano made '*per suo commodo alcun' altri maggiori*'. Wilde subsequently accepted Pouncey's and Gere's opinion that this drawing too is by Michelangelo. For a dissenting opinion see S. J. Freedberg, *Art Bulletin*, xlv (1963), pp. 253 ff.

39 The Flagellation (after Michelangelo)

Windsor (Popham–Wilde 451)

Red chalk over black chalk underdrawing.
20 × 18·2 cm.

Inscribed on the verso: *Julio Clovio da M. Angelo Bon.*[t].

Wilde was the first to recognize that this drawing by the miniaturist Giulio Clovio, an admirer, collector and copyist of Michelangelo's drawings, must be a faithful copy of the lost '*piccolo disegno*' which Michelangelo sent to Sebastiano to help him with the painting in the Borgherini Chapel.

40 The risen Lazarus, supported by two figures

British Museum (Wilde 16)

Red chalk. 25·2 × 11·9 cm.

Lit.: Dussler 562
See no. 41.

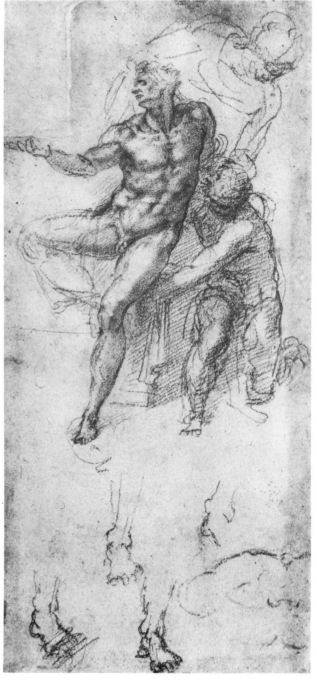

40 The risen Lazarus, supported by two figures

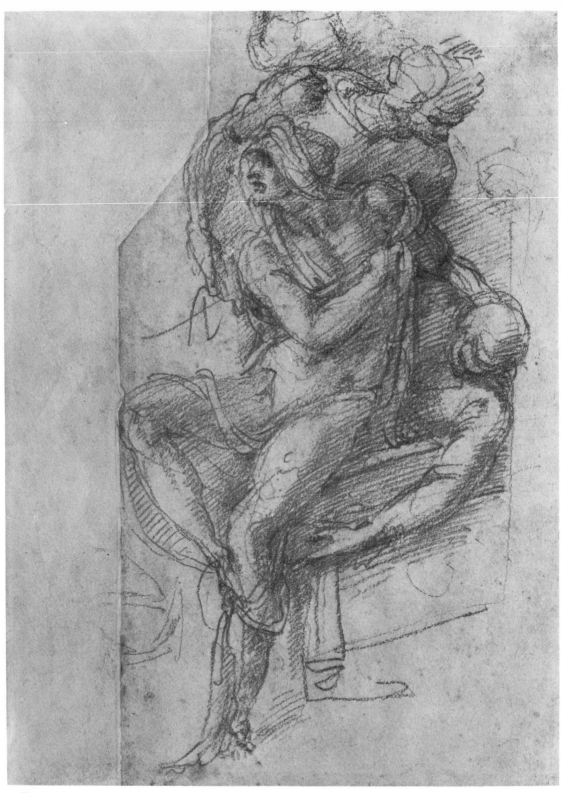

41 The risen Lazarus, supported by two figures

41 The risen Lazarus, supported by two figures

British Museum (Wilde 17)

Red chalk. 25·1 × 14.5 cm.

Lit.: Dussler 561

At the top, drawn with the sheet the other way up, is a partly cut-away sketch on a smaller scale for the upper part of the body of Lazarus. Nos. 40 and 41, and a third drawing at Bayonne (Bean cat. no. 65; B.B. 2474c) are studies by Michelangelo (see above p. 39) for Sebastiano del Piombo's altarpiece of the *Raising of Lazarus*, commissioned in 1516 and completed in 1519, now in the National Gallery. Of these sketches, the first seems to have been the partly cut away one on no. 41, followed by the two on the Bayonne sheet, then no. 40 and finally the principal study on no. 41. The vertical framing-line on the right of the last corresponds with the right edge of the panel and shows that the design of the whole composition had by then been determined.

The group in the painting is a combination of nos. 40 and 41: Lazarus and the figure standing behind him are as in no. 41, the kneeling figure on the right as in no. 40.

Wilde believes that Michelangelo may also have supplied the design for the figure of Christ. The truth of Vasari's statement that the composition was only partly due to Michelangelo is borne out by the existence of a study by Sebastiano for the woman standing immediately behind Lazarus (Frankfurt; L. Dussler, *Sebastiano del Piombo*, Basel, 1942, pl. 101).

42 The Resurrection

British Museum (Wilde 52)

Black chalk. 32·6 × 28·6 cm.

Lit.: Dussler 168; Tolnay, v, p. 179, no. 165; Hart 350

Altogether fourteen studies for a Risen Christ for a composition of the *Resurrection* are known, together with a copy of a lost fifteenth. They are datable on external evidence *c*. 1532–3 (see under Wilde 54 for a complete list and a discussion of the dating). Many of them are very carefully finished, and it seems clear that the project in connexion with which they were made was one to which Michelangelo devoted particular trouble. Curiously enough, there is no reference to it in either of the contemporary biographies by Condivi and Vasari. Various suggestions have been put forward. Wilde was reduced to the conclusion that the more highly finished drawings might have been intended for presentation, and that the others were studies for these. Tolnay (v, pp. 19 f.) connects them with a *Resurrection* which, he believes, was at one stage, shortly before the *Last Judgement* was begun, proposed for the altar-wall of the Sistine Chapel; but though this possibility cannot be entirely excluded, the evidence for it is very tenuous. The suggestion made by A. Perrig (*Zeitschrift für Kunstgeschichte*, xxiii (1960), pp. 19 ff.), that no. 47 represents not the Risen Christ but Christ in Limbo, and that it or a similar drawing was sent in 1532 to Sebastiano del Piombo to help him with his painting of that subject in the Prado, also deserves consideration. But what seems on the whole to be the most convincing solution so far put forward was made by Michael Hirst (*Journal of the Warburg and Courtauld Institutes*, xxiv (1961), pp. 178 ff.), who discovered the existence of a contract, dated 1 August 1530, by which Sebastiano del Piombo agreed to paint an altarpiece of the *Resurrection* for the Chigi Chapel in S. Maria della Pace. He suggests that Michelangelo, who is known to have supplied Sebastiano with drawings for other projects in the early 1530s, made the *Resurrection* drawings to help him with this commission. The fact that Sebastiano's altarpiece was never

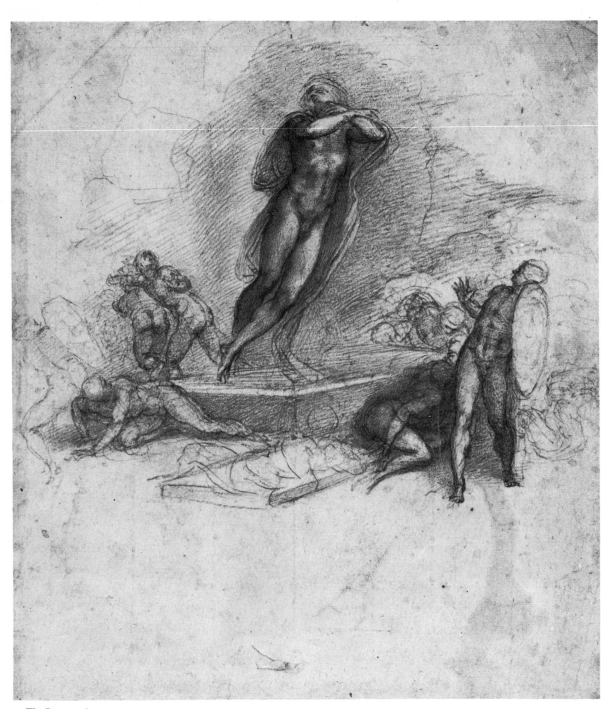

42 The Resurrection

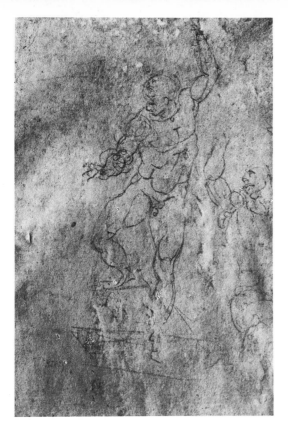

123 verso The Risen Christ

executed would explain the absence of any
reference to a *Resurrection* by Michelangelo's
contemporary biographers, and this explanation
of the drawings might also account for the
exceptional pains that Michelangelo obviously
took over the composition: in the Chigi Chapel
his protégé would have been in direct competition
with Raphael, one of whose masterpieces, the
Sibyls and Prophets, is painted in fresco on the
wall surrounding the altar-niche.

43 The Risen Christ

Ashmolean Museum (Parker 311 *verso*)

Black chalk. 27·3 × 15·6 cm.

Lit.: Dussler 199; Portoghesi–Zevi, p. 376 (*recto*);
Hartt 347

On the other side of the sheet is a ground-plan
for the relic chamber in S. Lorenzo, designed by
Michelangelo in about 1532. Another of the
Resurrection studies is on the *verso* of the presenta-
tion drawing of Tityus (no. 123) and is developed
from a partial tracing of it. The *Tityus* can be
dated from external evidence towards the end of
1532.

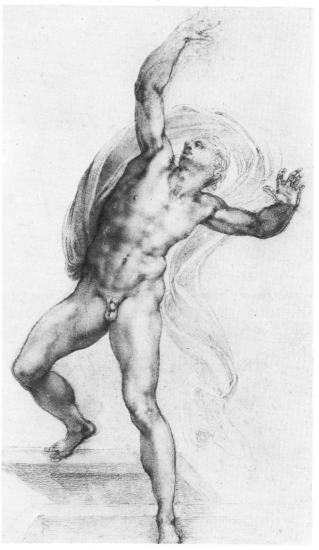

44 The Risen Christ

44 The Risen Christ

Windsor (Popham–Wilde 428)

Black chalk. 37·3 × 22·1 cm.

Lit.: Dussler 363; Tolnay, v, p. 180, no. 167;
Hartt 125

See no. 42.

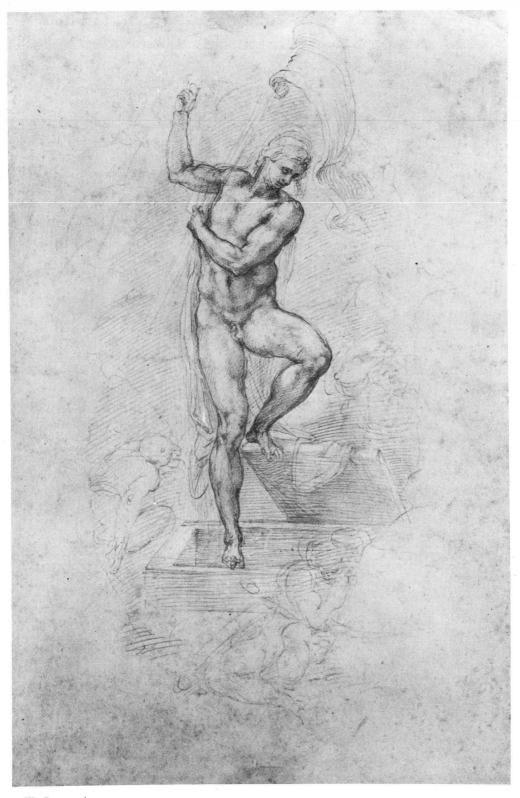

45 The Resurrection

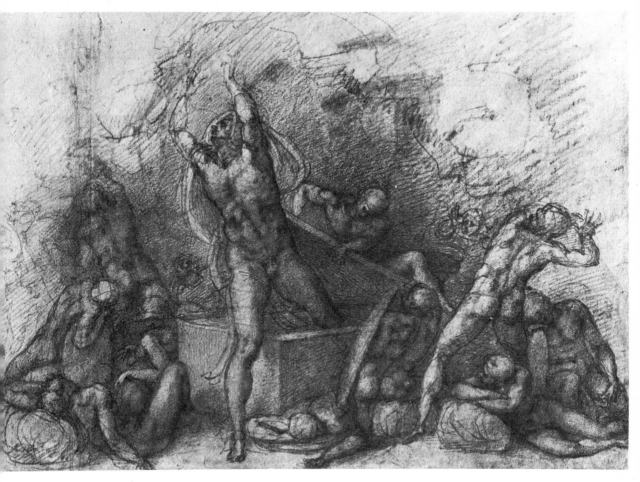

46 The Resurrection

45 The Resurrection

British Museum (Wilde 53)

Black chalk. 40·6 × 27·1 cm.

Lit.: Dussler 326; Tolnay, v, p. 179, no. 165; Hartt 132

See no. 42.

46 The Resurrection

Windsor (Popham–Wilde 427)

Black chalk (the red chalk is offset from another sheet). 24 × 34·7 cm.

Lit.: Dussler 239; Hartt 256

See no. 42.

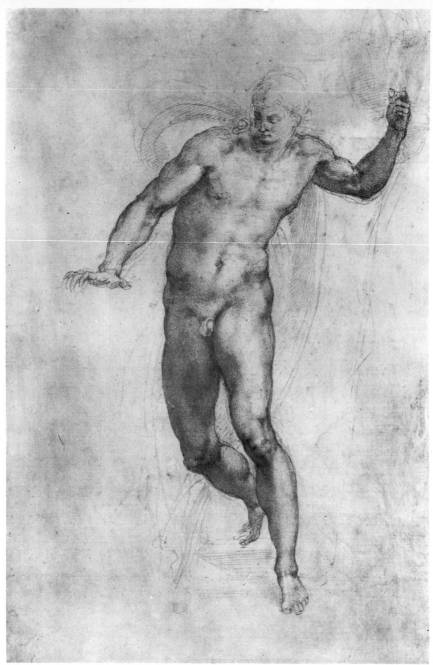

47 The Risen Christ

47 The Risen Christ

British Museum (Wilde 54)

Black chalk. 41·4 × 27·4 cm.

Lit.: Dussler 328; Tolnay, v, p. 179, no. 166;
Hartt 183

See no. 42.

IV THE THIRD FLORENTINE PERIOD
1516–34

During his last years in Florence Michelangelo was chiefly occupied with commissions from the two Medici Popes, Leo X (1513–21) and Clement VII (1523–34), the former Cardinal Giulio de' Medici, connected with S. Lorenzo, the Medici family church. In 1516 he was commissioned by Leo to make a design for the façade, but this came to nothing, and was cancelled in 1520 in favour of Cardinal Giulio's proposal that a funerary chapel (the 'New Sacristy') should be attached to the right transept of the church. The decision to construct the chapel was prompted by the deaths, in 1516 and 1519 respectively, of the Pope's brother, Giuliano de' Medici, Duke of Nemours, and his nephew Lorenzo, Duke of Urbino. These (the 'Capitani') were to be commemorated in the chapel along with the two 'Magnifici', the Pope's father, Lorenzo the Magnificent, and the latter's brother Giuliano, the father of Cardinal Giulio.

The drawings here exhibited (nos. 48 to 51) illustrate the successive phases of Michelangelo's plan for the placing of the four tombs. The first (no. 48) proposed to embody all four in a solid free-standing structure in the centre of the chapel, but the Cardinal objected that such a structure, to be seen properly, would be on too small a scale. Michelangelo then proposed to put the tombs against the walls. At first he intended to put them in pairs against the side-walls, either in the form of a double tomb in the centre of the wall (no. 49) or as single tombs against the side sections of each wall (no. 49 verso). No. 50 comes close to the final solution, with the single tombs of the Capitani in the centre of each side-wall, and a double one for the Magnifici on the end wall. This last (nos. 51 and 52) was never carried out. It would have faced the altar, which is placed in a niche in the opposite wall with its back turned towards the chapel; and though separated from the altar by the whole width of the chapel, it would have been in effect the altar-wall and as such was to have embodied statues of the Virgin and the patron saints of the Medici family, Cosmas and Damian, figures which are roughly but unmistakably indicated in no. 51.

The construction of the chapel was begun in 1520, and the marble figures of the *Times of Day* which recline in pairs on the sarcophagus lids of the two *Capitani* and which are the most conspicuous sculpture in the chapel, were begun in 1524. Work was interrupted by the political upheavals that followed the Sack of Rome in 1527 and was not resumed until 1530. In September 1534, after a short period of strained relations with his employer Clement VII, Michelangelo left Florence for good. Of the sculptures already executed for the chapel, only the *Capitani* were in place in their niches; the *Times of Day* were lying about the floor and were erected later by assistants. The *Magnifici* and papal tombs were never even begun and the chapel remains a fragment. Even though incomplete, it shows Michelangelo's attempt to solve the problem of the amalgamation of figurative sculpture with architecture. This is successfully achieved: the soft, pliable forms of the white marble figures are juxtaposed in dynamic relationship with the austere architectural membering.

Various iconographic interpretations of the chapel have been offered. One which has found favour explains the figurative and architectural scheme in Neoplatonic terms. The chapel represents

the universe subdivided into different hierarchical spheres: the zone of the River-Gods (not executed; clay model in Accademia, Florence) is that of Hades; the Allegories and the tomb effigies show earthly existence; the lunettes and the cupola signify the heavens. A simpler explanation is offered by Michelangelo's biographers Condivi and Vasari, both of whom believed the allegorical significance of the chapel was to be found in the meaning of the four figures of the *Times of Day*; these showed that human existence is transient and governed by time.

During the pontificate of Clement VII Michelangelo was involved in three further projects for S. Lorenzo. One that was under discussion between 1524 and 1526, but came to nothing, was the proposal to place Clement's tomb and that of Leo X in the church (see nos. 53–7). Another, commissioned in 1532, was for a small chapel to contain Lorenzo the Magnificent's collection of Relics (a plan for this one is on the *verso* of no. 43). The most important, dating from the early years of Clement's pontificate, was for the library, the Biblioteca Laurenziana, which occupies the whole of the west side of the cloister of the church (see nos. 66–7). Michelangelo designed the library proper and also the entrance vestibule (the '*Ricetto*'). His abstract and unfunctional treatment of the classical vocabulary of architecture was to have a fundamental influence on the irrational and anti-classical style that developed in Florence in the later part of the century.

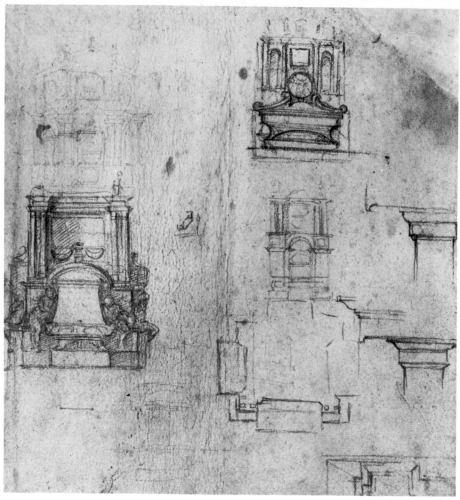

48 Design for the Medici tombs

Nos. 48–67: DRAWINGS FOR THE MEDICI CHAPEL AND THE BIBLIOTECA LAURENZIANA, S. LORENZO, FLORENCE

48 Design for the Medici tombs

British Museum (Wilde 25)

Black chalk. 22 × 20·9 cm.

Lit.: Dussler 155; Portoghesi-Zevi, p. 150; Hartt 212

1520. One of Michelangelo's first plans for the Medici tombs, according to which the four sarcophagi, of the two *Capitani* and two *Magnifici*, were to be embodied in a free-standing monument in the middle of the chapel. Four solutions are sketched on this sheet: (i) an octagonal structure with alternate long and short sides, the long sides containing rectangular recesses flanked by coupled pilasters and surmounted by segmental pediments, the short sides niches surmounted by triangular pediments; (ii) a square structure, with in the centre of the lower storey a sarcophagus resting on a projecting plinth and extending to a cornice surmounted by a segmental pediment; in the upper register is an oblong panel framed by pairs of coupled pilasters; (iii) a square structure with the sarcophagus on a step, its lid formed by inverted volutes; the upper register consists of three bays separated by pilasters; (iv) a square structure with in the centre a round-headed niche containing the sarcophagus and cutting into the pedestal of the upper storey.

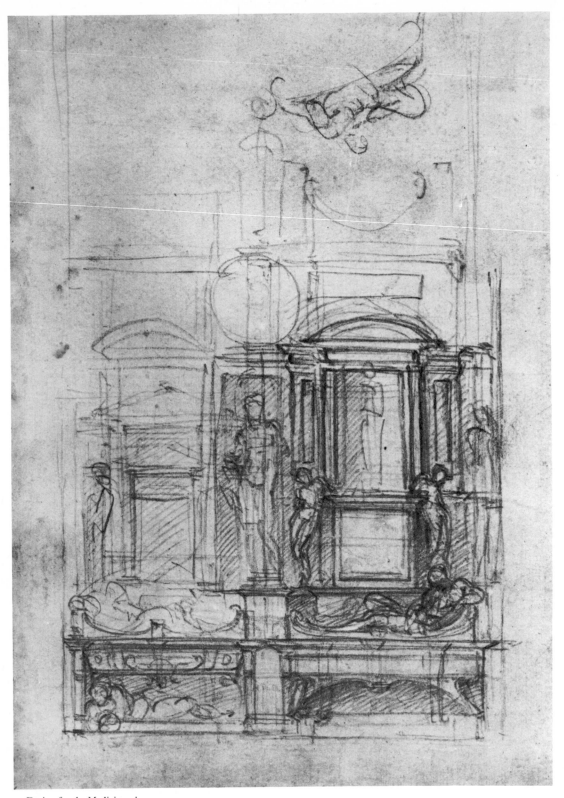

49 Design for the Medici tombs

49 Design for the Medici tombs

British Museum (Wilde 26)

Black chalk. 26·4 × 18·8 cm.

Dussler 150; Portoghesi–Zevi, p. 149; Hartt 217

An intermediate stage in Michelangelo's plan, which was to have the four tombs in pairs in the centre of each side-wall of the chapel. On the *verso* is a study for a single wall-tomb, narrower in proportion than those eventually erected in the central section of each side-wall. This is presumably connected with the earlier idea of having four single tombs, one on each side section of the side-walls.

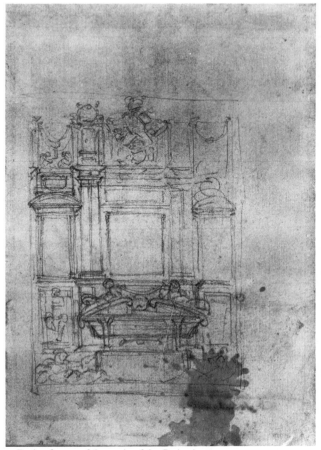

50 Design for one of the tombs of the Capitani

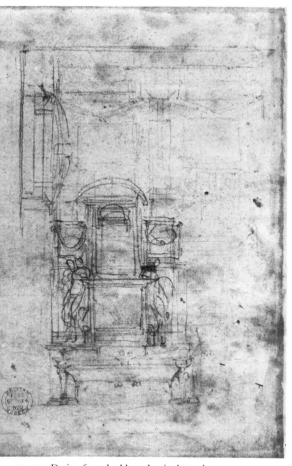

49 *verso* Design for a double and a single tomb

50 Design for one of the tombs of the Capitani

British Museum (Wilde 27)

Black chalk. 29·7 × 21 cm.

Lit.: Dussler 151; Portoghesi–Zevi, p. 151; Hartt 220

1521. Close to the final plan for the Medici chapel; the single tombs of the two *Capitani* were placed in the central sections of the side-walls, and the double tomb of the *Magnifici* was to have been in the central bay of the entrance wall.

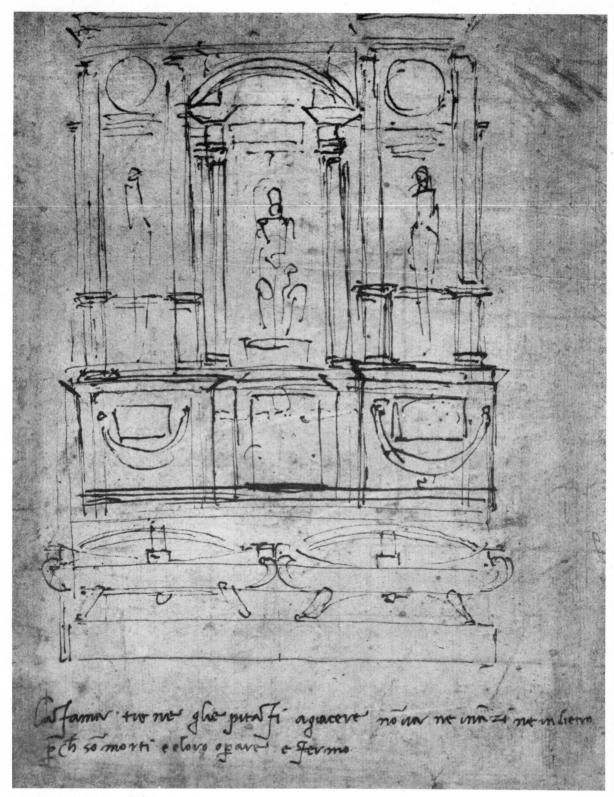

51 Design for the double tomb of the *Magnifici*

51 Design for the double tomb of the Magnifici

British Museum (Wilde 28)

Pen and ink. 21 × 16·2 cm.

Lit.: Dussler 153; Portoghesi–Zevi, p. 153; Hartt 224

On both sides are sketches for the double tomb of the *Magnifici* which in the final plan was to have occupied the central bay of the entrance wall of the chapel.

Inscribed, in Michelangelo's hand: *la fama tiene gli epitafi a giacere no(n) va ne ina(n)zi ne indietro | p(er)ch(e) so(n) morti e eloro op(er)are e fermo* ("Frame holds the epitaphs in position; it goes neither forward nor backward for they are dead and their work is finished").

See no. 52.

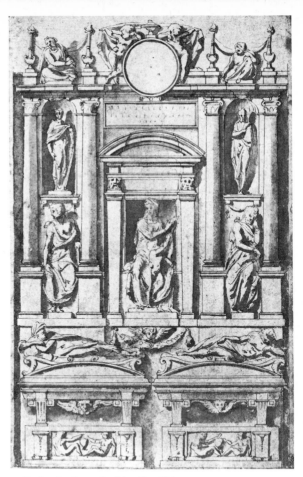

52 Design for the tomb of the *Magnifici*

52 Design for the tomb of the Magnifici (Studio of Michelangelo?)

Ashmolean Museum (Parker 349)

Pen and brown wash over black chalk, with extensive use of ruler and compasses.
38·4 × 24·4 cm.

One of several repetitions (others in Louvre, Vienna, Munich etc.) which Tolnay (iii, p. 40) at first dismissed as 'free paraphrases of Michelangelo's idea'. Later, however (*Gazette des Beaux-Arts*, series 6, lxxiii (1969), p. 73) he accepted the Albertina version, which seemed to him the best, as a product of Michelangelo's studio faithfully preserving what may be presumed to be his final design for the double tomb of the *Magnifici*. P. Joannides (*Burlington Magazine*, cxiv (1972), pp. 542 ff.) published the version in the Louvre, which he considered to be from Michelangelo's own hand. The Ashmolean version is of good quality and seems at least to be a product of the studio, as Parker believes.

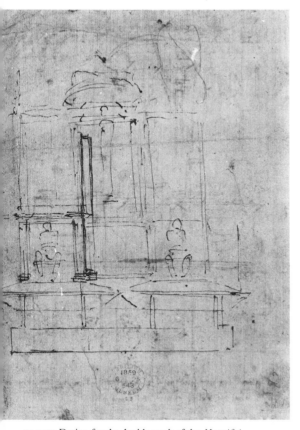

51 *verso* Design for the double tomb of the *Magnifici*

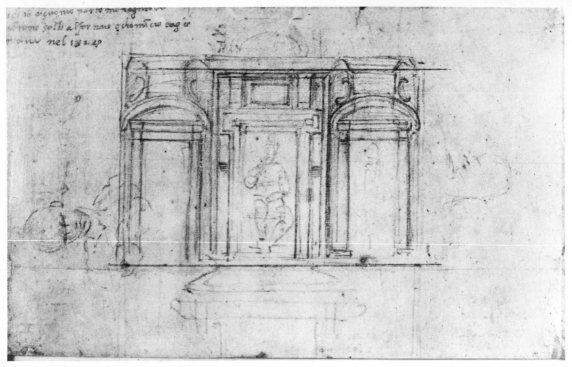

53 Study for the tomb of one of the Medici Popes

53 Study for the tomb of one of the Medici Popes

Ashmolean Museum (Parker 307)

Black chalk. 12·6 × 21·2 cm.

Lit.: Dussler 621; Portoghesi–Zevi, p. 154; Hartt 219

Thode was the first to connect this drawing with one in the Casa Buonarotti (52A; Barocchi 258, pl. ccclvi) which is an elaboration of the centre niche showing the seated figure wearing a papal tiara and making a gesture of benediction. This must therefore be a project for one of the papal tombs in S. Lorenzo (see no. 54). Wilde believed that the present design dates from the stage when it was proposed to place two single tombs in the side-rooms on either side of the altar niche of the New Sacristy.

54 Elevation and plan of a recess containing a wall-tomb

British Museum (Wilde 38)

Pen and ink. 42·7 × 25·8 cm.

Lit.: Dussler 180; Portoghesi–Zevi, p. 370; Hartt 280

A. E. Popp (*Münchner Jahrbuch*, N.S. iv (1927), p. 405) was the first to suggest that two drawings

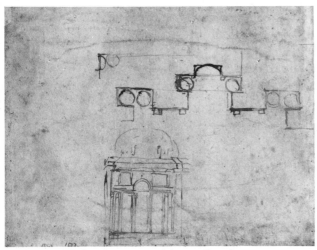

54 Elevation and plan of a recess containing a wall-tomb

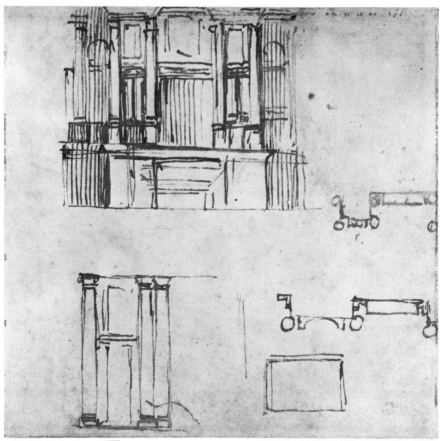

55 Studies for a wall-tomb

in the Casa Buonarroti which are clearly for the same project as nos. 54, 55 and 56, might be connected with the abortive proposal that the tombs of the two Medici Popes, Leo X and Clement VII, should be placed in the family church of S. Lorenzo. This proposal was put forward by Clement soon after his election in November 1523 and is referred to in Michelangelo's correspondence in the period 1524–6. It was out of the question to place the tombs in the New Sacristy itself since work on the tombs of the *Capitani* was by then too far advanced. Michelangelo's first idea was to place them in the two small side-rooms of the Sacristy, but this position was objected to as being insufficiently distinguished and he was instructed to look for a better one in the church itself. No. 56 is for a double tomb, which was intended at some stage of the scheme, as the iconography of no. 57 shows.

The choir would have been the most likely place, either with single tombs facing each other at the far end, beyond the high altar, or a double tomb in a recess in the centre of the end-wall. Wilde, while emphasizing that Popp's suggestion was entirely conjectural, was inclined to accept it for nos. 54 and 56 (no. 57 was unknown to him).

The proposal was never carried out, and the two Popes were eventually buried in the Roman church of S. Maria sopra Minerva; their tombs were executed by Baccio Bandinelli.

55 Studies for a wall-tomb

British Museum (Wilde 39)

Pen and ink. 17.5×18.2 cm.

Lit.: Dussler 330; Portoghesi–Zevi, p. 369; Hartt 318

See no. 54.

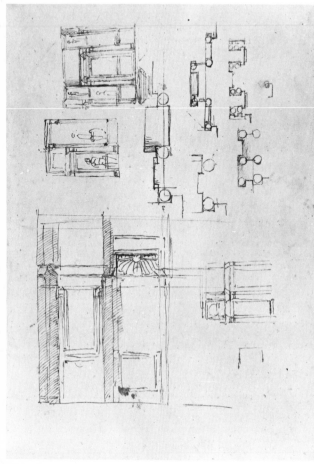

56 Studies for a double tomb

56 Studies for a double tomb

Ashmolean Museum (Parker 308)

Pen and ink. 26·3 × 38·3 cm.

Lit.: Dussler 345; Portoghesi–Zevi, pp. 372 f.; Hartt 222

About 1525–6. See no. 54.

57 Design for the upper part of the double tomb of the Medici Popes

Christ Church (0993)

Black chalk and brown wash. 19·3 × 25·4 cm.

Lit.: Dussler 639; C. de Tolnay, *Mitteilungen des Kunsthistorischen Institutes in Florenz*, xiii (1968), p. 348

1524–6. Tolnay (iii, p. 247) was the first to connect this drawing with the project of placing the tombs of the two Medici Popes in S. Lorenzo (see no. 54). The fact that both figures in the side-niches are wearing the papal tiara suggests that this must relate to a stage of the project in which a double tomb was envisaged. The circular relief in the centre of the upper storey seems to represent two scenes from papal history. Tolnay now accepts the drawing as by Michelangelo himself, a view shared by Michael Hirst, Paul Joannides and J. Byam Shaw.

58 A vase: male torso: head of a youth

British Museum (Wilde 30)

Black chalk, the torso partly gone over in pen and ink. 12·3 × 12·8 cm.

Lit.: Dussler 312; Portoghesi–Zevi, p. 162; Hartt 301

About 1521–4. The vase resembles those used as decoration in the Medici chapel which appear on the frames of the marble tabernacles. The figure-studies cannot be definitely connected with any known work, but their style suggests the same period.

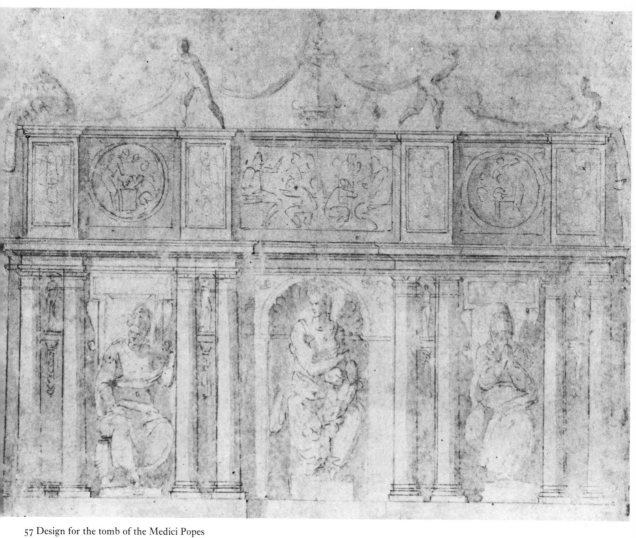

57 Design for the tomb of the Medici Popes

59 The Virgin and Child

59 The Virgin and Child

British Museum (Wilde 31)

Pen and ink, and red chalk. 39·6 × 27 cm.

Lit.: Dussler 149; Hartt 177

On the *verso* is an account of purchases of material for models of the figures in the Medici Chapel on which Michelangelo was working in 1524. Tolnay's contention that these are studies for the statue of the Virgin and Child in the chapel has much to recommend it. Wilde's reason for dismissing it—that "the groups appear to be complete, and it would hardly be possible to continue them downwards"—is less convincing. He went on to suggest that these studies are for the same composition as the famous black chalk drawing in the Casa Buonarotti (Barocchi cat. no. 121) in which the Virgin is represented as suckling the Child.

The red chalk drawings are copies by one of Michelangelo's pupils, to whom the exhortation, in Michelangelo's hand, is evidently addressed: '*Disegnia Antonio disegnia e no(n) p(er)der te(m)po*' ("Draw, Antonio! draw and don't waste time"); he has been identified as Antonio Mini (1506–33).

60 Study for the figure of Day

Ashmolean Museum (Parker 310)

Black chalk. 17·6 × 27 cm.

Lit.: Dussler 599; Hartt 227

A study, either from the life or from a wax or clay model, for the statue on the sarcophagus of Giuliano de' Medici in the Medici Chapel.

61 Study for the figure of Day

Ashmolean Museum (Parker 309)

Black chalk. 25·7 × 33·2 cm.

Lit.: Dussler 598; Hartt 228

Similar to no. 60. On the *verso* are studies in red chalk for the right arm of *Night*.

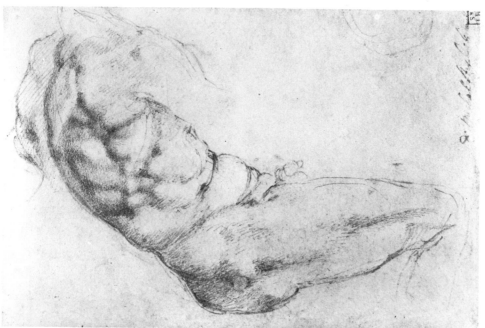

60 Study for the figure of Day

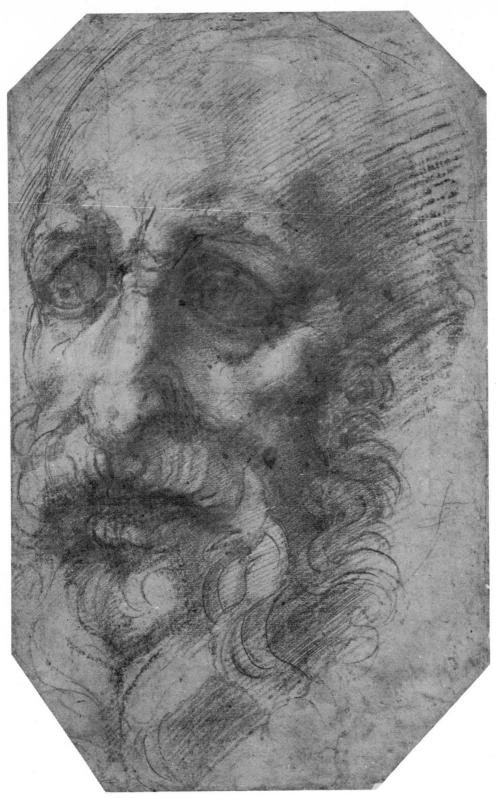

65 Head of a bearded man

62 Working drawings for a recumbent statue

British Museum (Wilde 35)

Pen and ink. 13·7 × 20·9 cm.

Lit.: Dussler 154; Hartt 252

Working drawings for one of the statues of River-Gods, which in Michelangelo's final plan were to be placed on the steps of the tombs in the Medici Chapel, but which were never executed. This particular figure was to be placed on the right side of the step of Giuliano's tomb. See no. 50, in which the River-Gods are indicated. A clay model for a River-God survives in the Accademia, Florence.

63 A left arm

British Museum (Wilde 49)

Black chalk and pen and ink, over stylus. 16 × 13·5 cm.

Lit.: Dussler 549; Hartt 392

Study from life for the figure of *Night* on the sarcophagus of Giuliano de' Medici.

64 Grotesque head

Windsor (Popham–Wilde 425)

Red and black chalk. 24·8 × 11·9 cm.

Lit.: Dussler 237; Hartt 497

Possibly connected with the head on the back of the armour of the statue of Giuliano de' Medici (cf. Tolnay, iii, fig. 330).

65 Head of a bearded man

British Museum (Wilde 57)

Black chalk. 38·8 × 24·7 cm.

Lit.: Dussler 575

Perhaps, as Wilde was the first to suggest, a study for the head of one of the statues of the patron saints of the Medici, St Cosmas and St Damian, which were intended for the side-niches of the (unexecuted) tomb of the *Magnifici* in the Medici Chapel. The statues were executed by assistants, after models by Michelangelo, in 1533 onwards.

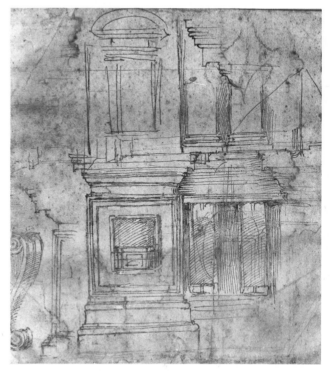

66 Architectural studies

66 Architectural studies

British Museum (Wilde 36)

Pen and brown ink. 28·2 × 25·8 cm.

Lit.: Dussler 173; Portoghesi–Zevi, p. 258; Hartt 265

1525. For the wall of the vestibule of the Biblioteca Laurenziana in Florence. For an analysis of the complex architecture of the vestibule see R. Wittkower, *The Art Bulletin*, xvi (1934), pp. 123 ff.

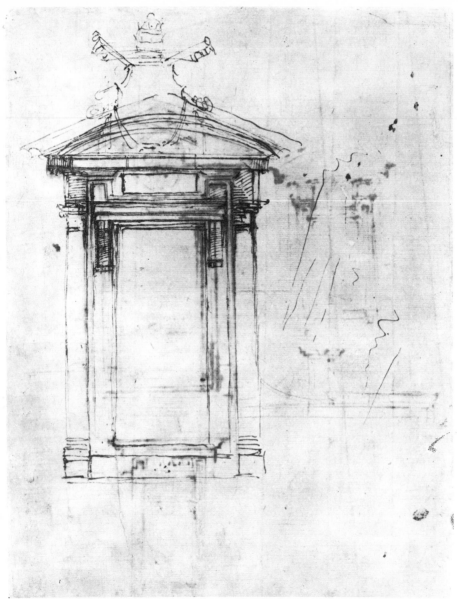

67 Study for a door

67 Study for a door

British Museum (Wilde 37)

Pen and ink. 28·4 × 20·9 cm.

Lit.: Dussler 157; Portoghesi–Zevi, p. 269; Hartt 275

1526. For the library side of the door between the vestibule and the library in the Biblioteca Laurenziana. See no. 66.

Nos. 68–111: DRAWINGS UNCONNECTED WITH MAJOR PROJECTS

68 Details of classical architecture

British Museum (Wilde 18)

Red chalk. 28·9 × 21·8 cm.

Lit.: Dussler 315; Portoghesi–Zevi, p. 50; Hartt 142

This drawing and no. 69 (originally forming a single folded sheet, as Wilde was the first to demonstrate) are part of a sketchbook of which other leaves are in the Casa Buonarroti. They are copies of details of Antique Roman architecture, made not directly from the original, but from copies in another sketchbook, the so-called 'Codex Coner' (Soane Museum), which were drawn in Rome by an unknown Florentine hand in about 1515. Michelangelo's interest was purely architectural, and he omitted inscriptions etc. of only archaeological significance.

69 Details of classical architecture

British Museum (Wilde 19)

Red chalk. 28·8 × 21·7 cm.

Lit.: Dussler 316; Portoghesi–Zevi, p. 50; Hartt 144

See no. 68.

70 Details of architecture

British Museum (Wilde 21)

Red chalk. 13·4 × 21·2 cm.

Lit.: Dussler 309; Portoghesi–Zevi, p. 53; Hartt 484

Though these sketches are closely similar in style to the red chalk sketches of details of Antique architecture on nos. 68 and 69, it has not been possible to trace their exact source.

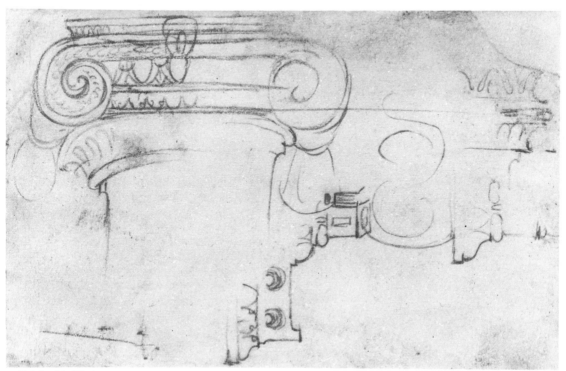

70 Details of architecture

71 **Capitals and profiles of bases**

British Museum (Wilde 20)

Pen and two different coloured inks, over stylus. 27·6 × 21·5 cm.

Lit.: Dussler 308; Portoghesi–Zevi, p. 53; Hartt 152

Dated by Wilde *c.* 1516–18, at about the same time, or a little later, as the similar drawings of architectural details, nos. 68, 69 and 70.

72 **Studies for a structure in the form of a triumphal arch**

British Museum (Wilde 22)

Black chalk and pen and brown ink. 22 × 29 cm.

Lit.: Dussler 160; Portoghesi–Zevi, p. 76; J. Ackerman, *The Architecture of Michelangelo*, 1961, ii, p. 2; Hartt 201.

These studies, which evidently lead up to the sketch at the bottom of the sheet, are a series of variations on the theme of the Antique triumphal arch. Tolnay connects them with the 1525–6 project for the Julius tomb, but Wilde is surely right in maintaining that the architectural style is considerably earlier. We agree with his dating, *c.* 1516. It should be noted that the bottom sketch is closely similar in essentials to his reconstruction of the upper part above the already completed lower storey of the 1516 project for the Julius tomb (see J. Wilde, *Michelangelo's 'Victory'*, Oxford (Charlton Lecture, 1954, p. 7); with which, however, it can hardly be connected, since it is for a complete single-storeyed structure with a low *basamento*—either a monumental altar or a tomb.

A sheet of similar sketches at Christ Church (no. 73) is generally connected with the present drawing, but here Michelangelo has departed still further from the original triumphal arch motif to emphasize instead the strength of the horizontal cornice. Furthermore the proportions of the bays have been changed and in one instance expanded to five. On the other side of the sheet is what appears to be a finished elaboration (repr. M. Weinberger, *Michelangelo, the Sculptor*, 1967, ii, pl. 66, 2), a design for an altar in three bays with a triangular pediment, in the central bay of which is represented the *Nativity* with the *Annunciation* above. Ackerman notes the resemblance between the *verso* studies and the façade of the little chapel of Leo X in the Castel Sant' Angelo, which was Michelangelo's first work in architecture (1514).

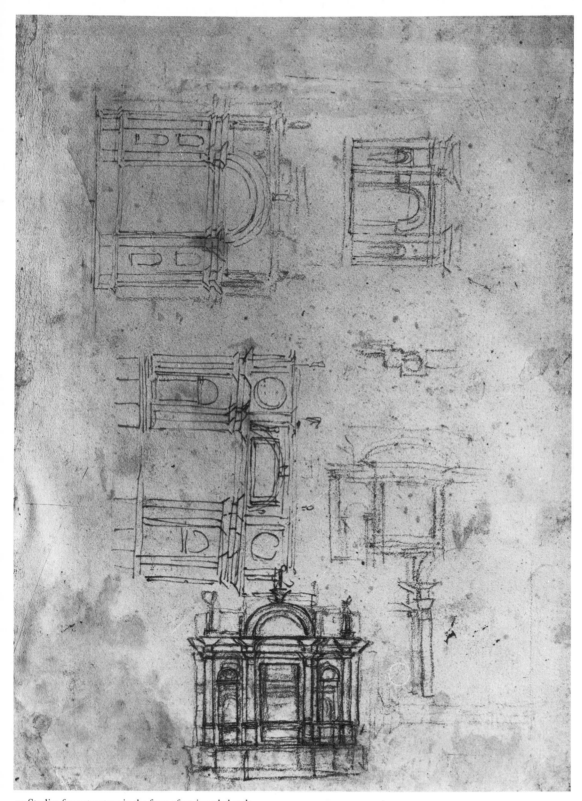

72 Studies for a structure in the form of a triumphal arch

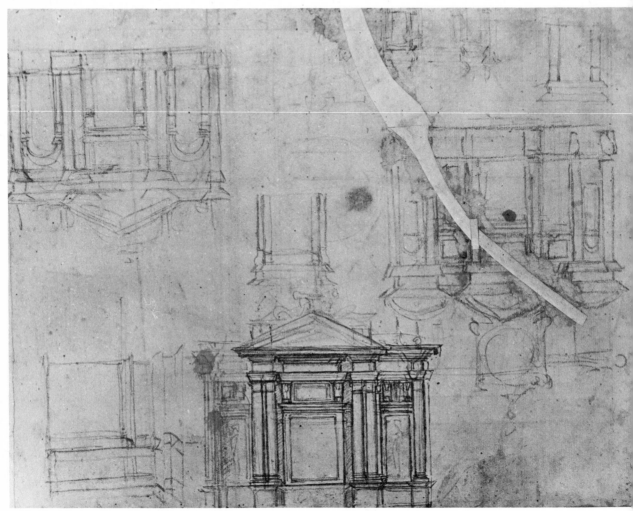

73 Studies for a monumental altar

73 Studies for a monumental altar

Christ Church, Oxford (0992 *verso*)
Black chalk and pen and ink. 25·9 × 34·1 cm.
Lit.: Dussler 638; Portoghesi–Zevi, p. 77; Hartt
403
About 1516. See no. 72.

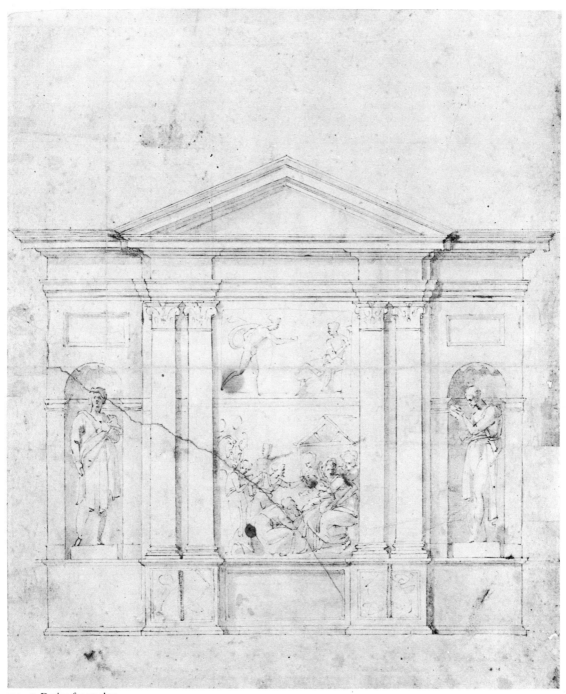

73 *recto* Design for an altar

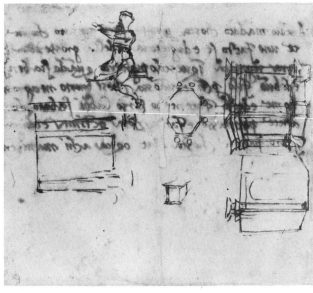

75 Studies for an octagonal structure: nude man

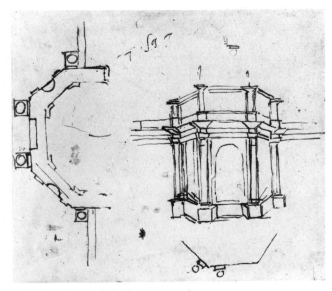

76 Sketch and ground plan for an octagonal structure

74 Two diagrams of blocks of marble with measurements

Anonymous lender

Pen and ink. 2·4 × 6·3 cm. 7·8 × 21 cm.

Lit.: Dussler 183 and 184

About 1516. The diagrams were drawn to enable quarrymen at Carrara or Pietrasanta to cut blocks of marble of the size required for some unspecified purpose, perhaps for parts of the tomb of Julius II. The longer fragment has on it Michelangelo's mark of three interlocking circles with the initial M.

75 Studies for an elongated octagonal structure: a seated nude man

Ashmolean Museum (Parker 312)

Pen and ink. 14·6 × 16·8 cm.

Lit.: Dussler 197; Portoghesi–Zevi, p. 374; Hartt 196

The writing on the *verso* refers to business transacted by Michelangelo in the summer of 1518. These studies and those on no. 76 are clearly connected, though on one the ground plan is of a complete freestanding octagon and on the other of a half octagon apparently piercing a lower curtain-wall. No convincing suggestion has yet been made about the nature or purpose of this structure. Wilde describes it as an 'ambo' but, as Kurz pointed out (*Burlington Magazine*, xcv (1953), p. 310), by the sixteenth century this would have been a liturgical anachronism.

76 Sketch and ground plan of a semi-octagonal structure

British Museum (Wilde 24)

Pen and ink. 14·6 × 17·8 cm.

Lit.: Dussler 156; Portoghesi–Zevi, p. 374; Hartt 197

See no. 75.

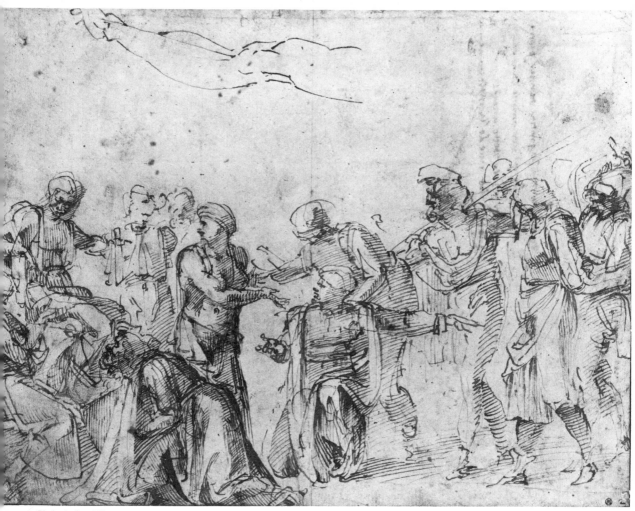

77 Christ before Pilate

77 Christ before Pilate

Count Antoine Seilern

Pen and ink, partly over red chalk. 21 × 28·2 cm.

Lit.: Dussler 216; Hartt 131

On the *verso* are four lines and two lines in Michelangelo's hand, parts of two sonnets which were never completed; also some rough sketches in pen. Most critics who have discussed the sheet have concentrated on the *verso* while rejecting the *recto*. Adolfo Venturi (*L'arte*, 1928, pp. 155 f.), Wilde (1953 exhibition catalogue) and Parker (under no. 324), on the other hand, maintain that the recto is also by Michelangelo himself.

The most complete of the *verso* sketches shows the upper part of the figure of a man standing with his arms behind him—they are apparently bound—and his head held sideways to the spectator's right. There is a *pentimento* for the right arm, which in the second position is raised above the head. The first position approximates closely to that of the Christ in the Borgherini Chapel *Flagellation*, as Tolnay and Dussler both recognized, but the alternative position of the right arm seems to exclude the possibility of one being a study for the other. Tolnay was no doubt right in considering this to be a sketch for one of the '*Slaves*' on the Julius Tomb.

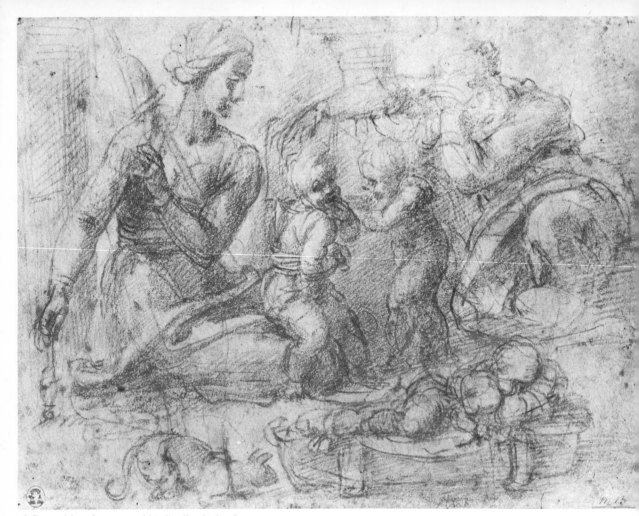

78 Composition of a woman with a distaff and other figures

That the subject of the *recto* drawing is Christ before Pilate is established by the presence of a female figure in the centre foreground, who must be Pilate's wife. It cannot be connected with any known or recorded work. Wilde, who dated the drawing *c.* 1516–20 (1953 exhibition catalogue no. 40), is said to have suggested (orally) that it might be a design for one of the reliefs planned for the never-executed façade of S. Lorenzo, but unfortunately no amplification of this idea could be found among his notes. Michelangelo received the commission for the façade in December 1516. The compression of the figures into a narrow plane in the foreground certainly suggests a relief; but no record has survived of the subjects of all the proposed reliefs, and in the absence of further evidence Wilde's suggestion must remain an attractive if unprovable conjecture.

78 Composition of a woman with a distaff, three children and a sleeping man

Christ Church, Oxford (0068)

Red chalk. 21·2 × 28·3 cm.

Lit.: Dussler 636

On the *verso* are studies of legs, universally accepted as by Michelangelo. In spite of this, the *recto* drawing is one of those that modern criticism has wrongly given to Sebastiano del Piombo (see p. 39).

Were it not for the presence of the third child asleep in the cradle in the foreground, one might be tempted to interpret the subject as a somewhat unconventional *Holy Family with the Infant Baptist*. It seems to be a scene of domestic *genre*, and as such unusual in Michelangelo's *œuvre*. Wilde dates it *c.* 1515–20.

79 'Écorché' of a male torso

Windsor (Popham–Wilde 439)

Red chalk. 18·2 × 20·6 cm.

Lit.: Dussler 710; Schilling–Blunt, p. 99

This drawing, together with two others in red chalk at Windsor (nos. 80 and 81) and a fourth in the Gathorne–Hardy Collection (no. 82), are part of a series of anatomical studies, the authenticity of which was questioned by Wilde in the Windsor catalogue. Later, in the 1953 exhibition catalogue, he revised his opinion and attributed them to Michelangelo himself, dating them *c.* 1515–20. Nos. 83 and 84, in pen and ink, were also questioned in the Windsor catalogue. Michael Hirst now believes that they too are by Michelangelo. (See Schilling–Blunt, *Windsor*, pp. 99f.).

80 'Écorché' of a male leg

Windsor (Popham–Wilde 441)

Red chalk. 28·2 × 20·7 cm.

Lit.: Dussler 712; Hartt 132E

See no. 79.

81 'Écorché' of a male torso

Windsor (Popham–Wilde 440)

Red chalk. 28·1 × 20·8 cm.

Lit.: Dussler 711

See no. 79.

82 'Écorchés' of legs

Gathorne–Hardy Collection

Red chalk. 27·5 × 20·4 cm.

Lit.: Dussler 592

See no. 79.

83 'Écorchés' of two male torsos and a male back

Windsor (Popham–Wilde 442)

Pen and brown ink. 28·3 × 19 cm.

Lit.: Dussler 708

See no. 79.

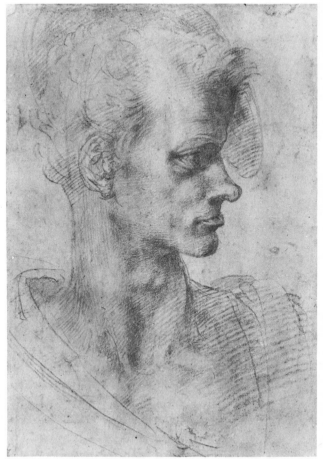

85 Man's head in profile

84 'Écorchés' of legs, knees, etc.

Windsor (Popham–Wilde 443)

Pen and brown ink. 27·8 × 20·3 cm.

Lit.: Dussler 709

See no. 79.

85 Man's head in profile

Ashmolean Museum (Parker 316)

Red chalk. 28·2 × 19·8 cm.

Lit.: Dussler 341; Tolnay, v, p. 170, no. 153; J. Q. van Regteren Altena, *Studi di storia dell'arte in onore di Antonio Morassi*, Venice, 1971, pp. 77 ff.; Hartt 161

Van Regteren Altena suggested that this is an idealized likeness of Lorenzo the Magnificent (1449–92), and that the drawing was made in

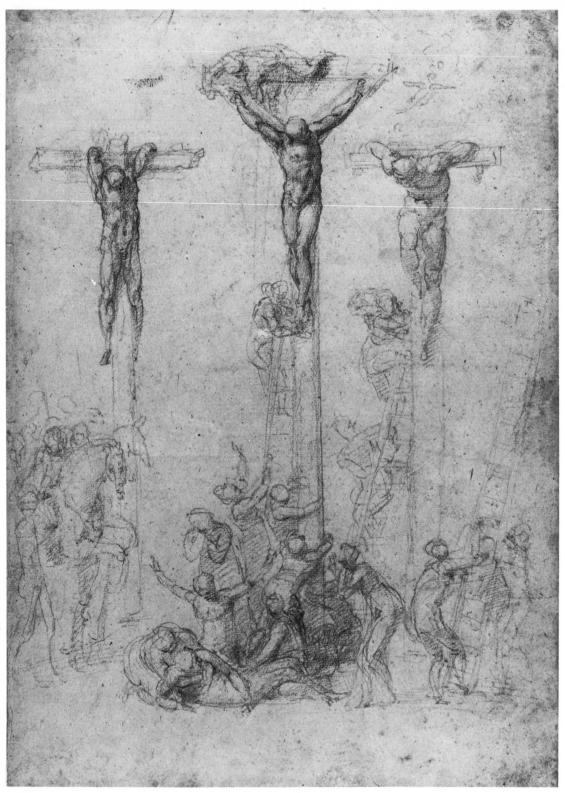

87 The Crucifixion

connexion with his proposed tomb in the Medici Chapel. But though there is a certain general resemblance, the drawing seems unduly grotesque —even to the point of caricature—in such details as the forelock and the bonnet worn absurdly at the very side of the head.

Dated by Berenson 'in the period of the Medici tombs' and by Wilde *c.* 1520–4. Parker is inclined to think that this is too late.

86 Nude male figure

Ashmolean Museum (Parker 313)

Pen and ink. 9·1 × 9·8 cm.

Lit.: Dussler 198; Hartt 166

Dated about 1520–4 by Wilde, with the comment 'perhaps for a mourning figure in a *Crucifixion* or *Descent from the Cross*'. Parker is surely right in doubting this interpretation.

87 The Crucifixion

British Museum (Wilde 32)

Red chalk. 39·4 × 28·1 cm.

Lit.: Dussler 559, Hartt 298

About 1521–4. This drawing—one of the few complete composition-studies by Michelangelo to have survived—cannot be definitely connected with any known work. Wilde dated it in the 1520s, and suggested a connexion with Michelangelo's undertaking, in 1523, to produce *uno quadretto per uno studiolo*, either a painting or a relief, for Cardinal Domenico Grimani. The Cardinal's death on 27 August 1523 put an end to the project. This drawing is one of those that some critics have wrongly attributed to Sebastiano del Piombo (see p. 39).

88 A Prophet or Sibyl: ground plan of a chapel: cornices

British Museum (Wilde 29)

Pen and brown ink. The ground-plan in red chalk. 41·4 × 28·1 cm.

Lit.: Dussler 323; Hartt 55

Most critics have connected the figure with the Sistine Ceiling, some seeing in it a study for

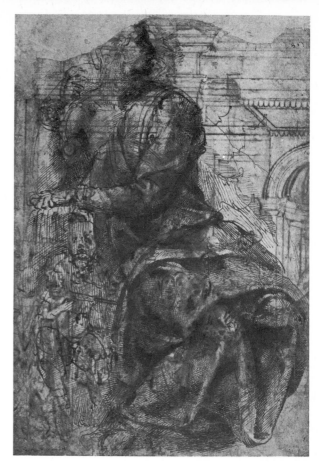

88 A Prophet or Sibyl

Isaiah, others a study for one of the Sibyls. Wilde, on the other hand, argued that 'the style is not consistent with that of Michelangelo's figure-drawing in the period 1508–12, as is shown by the rather elongated proportions, the tall body with the very small head and delicate hands and feet; the continuity of the movement; and the unity of the plastic mass, lacking any kind of sharp contrast'. He regarded it as a variant of the *Isaiah* rather than a preliminary study, and dated it, rightly, in the first half of the 1520s.

The ground-plan, drawn before the figure, is of an almost square room with niches on three sides, the fourth being open and framed by three-quarter pilasters. Wilde suggested that it might be connected with the choir of the Medici Chapel.

The figure also appears to be drawn over a complete architectural composition consisting of a canopied niche in a wall with square pilasters. This is a drawing, by another hand, showing through from the back of the sheet.

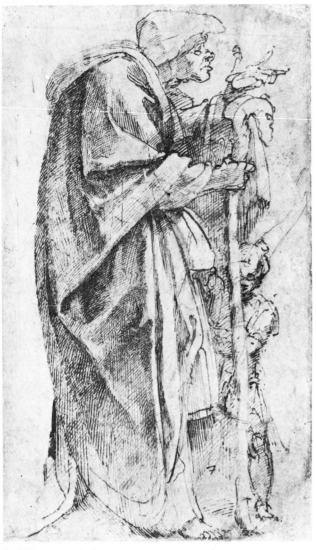

89 Old woman and a boy

89 Old woman and a boy

Ashmolean Museum (Parker 324)

Pen and ink, much rubbed. 32·8 × 19·3 cm.

Lit.: Dussler 514; Hartt 155

The critical fortune of this drawing is much the same as that of no. 99: traditionally attributed to Michelangelo, it was attributed by Wickhoff to Passarotti and by Berenson first to Passarotti and later to his 'Andrea di Michelangelo'. Parker agrees with Wilde that the drawing is by Michelangelo, but considers his suggested dating *c.* 1520–4 too late.

90 Christ on the Cross

Christ Church, Oxford (0094)

Black chalk. 16·6 × 10·3 cm.

Lit.: Dussler 353; Hartt 416

Dated by Wilde *c.* 1520–30.

91 Four grotesque masks: Hercules and Antaeus

British Museum (Wilde 33)

Black chalk and red chalk. 25·5 × 35 cm.

Lit.: Dussler 159; Portoghesi–Zevi, p. 162; Hartt 496

The style of these drawings suggests a dating in the mid-1520s rather than the early 1530s. It seems likely therefore that the small sketch of *Hercules and Antaeus* is connected, not with the group on the Windsor sheet (no. 120), but with Michelangelo's project of carving a marble statue of this subject or *Hercules and Cacus* as a *pendant* to his marble *David*. He first proposed this in 1508–12, and took it up again in 1524. In October 1525 Clement VII refused him the commission and gave it to Bandinelli.

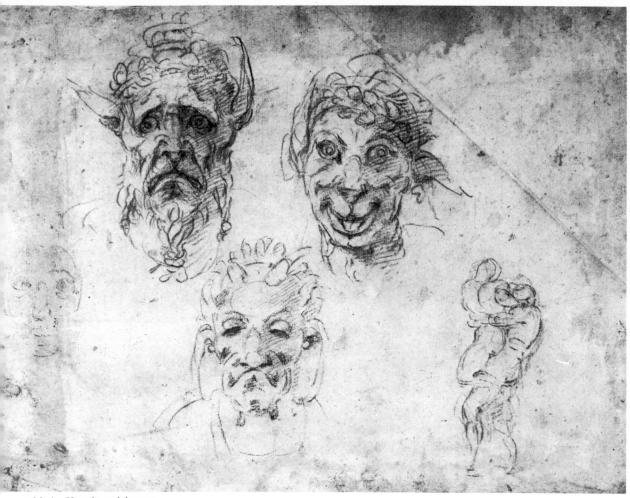

91 Masks: Hercules and Antaeus

93 Head of an old man shouting

92 Sheet with studies of Hercules and Antaeus

Ashmolean Museum (Parker 317)

Red chalk. 28·6 × 42·7 cm.

Lit.: Dussler 196; Hartt 302

About 1524–5. The studies of *Hercules and Antaeus* were no doubt made in connexion with the group projected in about 1524–5 (see no. 91) Not all the drawings on this side of the sheet and on the *verso* are by Michelangelo, though on the latter is a poem in his handwriting.

93 Head of an old man shouting

Ashmolean Museum (Parker 322)

Red chalk. 15·5 × 12·6 cm.

Lit.: Dussler 600; Hartt 156

Dated by Wilde *c.* 1525.

95 Torso of a statue of Venus

94 Torso of a statue of Venus

British Museum (Wilde 44)

Black chalk. 20·2 × 11 cm.

Lit.: Dussler 557; Hartt 242

About 1525. See no. 95.

95 Torso of a statue of Venus

British Museum (Wilde 43)

Black chalk. 25·6 × 18 cm.

Lit.: Dussler 556; Hartt 241

About 1525. No. 94 is another drawing of the same Antique torso. Others are in the Casa Buonarroti.

96 Girl holding a spindle

British Museum (Wilde 40)

Black chalk. 28·8 × 18·2 cm.

Lit.: Dussler 553; Hartt 368

Dated by Wilde *c.* 1525.

97 A right leg

British Museum (Wilde 45)

Pen and brown ink over lead-point. 28·5 × 25·5 cm.

Lit.: Dussler 305; Hartt 248

A study from the life of a type which Michelangelo made, in order to revive his knowledge of anatomy, in the course of his work on the figures in the Medici chapel. Dated by Wilde *c.* 1524–5.

98 Recumbent male figure and seated monk

Windsor (Popham–Wilde 422)

Red chalk and pen and ink. 26·6 × 16·6 cm.

Lit.: Dussler 714; Hartt 162

The three studies of the recumbent figure are probably after an antique relief of Cupid and Psyche known as *The Bed of Polycletus* which was in the possession of Vittorio Ghiberti, to whom it had descended from his great-grandfather Lorenzo, the sculptor. The drawing is dated *c.* 1525 by Wilde.

96 Girl holding a spindle

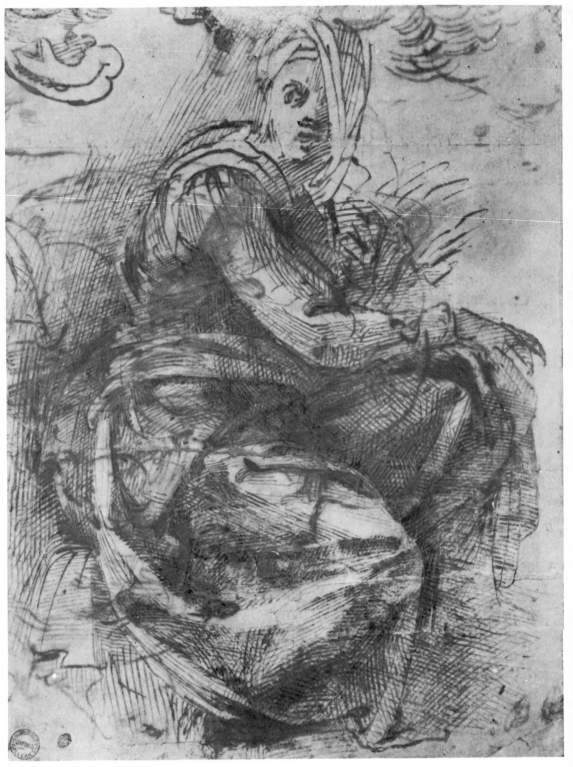

99 A Sibyl

100 Studies of shoulders

99 A Sibyl

Ashmolean Museum (Parker 325)

Pen and ink. 26·5 × 19·9 cm.

Lit.: Dussler 613; Hartt 160

About 1520–4. Regarded by Robinson as a discarded study for one of the Sistine Sibyls, by Wickhoff as a forgery by the Bolognese Bartolommeo Passarotti (1529–92), and by Berenson as the work of a pupil whom he named 'Andrea di Michelangelo'. This drawing is in fact one of Michelangelo's most brilliant studies, of later date than the Sistine Ceiling and contemporary with the drawing of a Prophet in the British Museum (no. 88).

100 Studies of shoulders

British Museum (Wilde 46)

Black chalk. 27·5 × 35·9 cm.

Lit.: Dussler 554; Hartt 230

Datable about 1525–8.

101 Male nude

102 Three men in conversation

Ashmolean Museum (Parker 326)

Pen and ink. 37·8 × 25 cm.

Lit.: Dussler 596

Inscriptions in Michelangelo's hand on the *verso* refer to events of the year 1526. Many doubts have been expressed about the authorship of this brilliant if unusual sketch. Berenson (who calls it 'the most troublesome of drawings') finally attributed it to his 'Andrea di Michelangelo'. Parker was inclined on balance to accept the attribution to Michelangelo himself, but pointed out that there is a copy by Battista Franco in the Cottonian Collection, Plymouth, and that the group occurs in a painting by Franco of about 1537 in the Palazzo Pitti, Florence (Venturi, ix, 6, fig. 156). This painting also includes adaptations from Michelangelo's *Dream of Human Life* (cf. no. 128) and *Rape of Ganymede* (cf. no. 124), and Wilde was surely right in his emphatic acceptance of the traditional attribution of the drawing. The superficial resemblance of the graphic technique to Franco's can be accounted for by his intense admiration for Michelangelo; it is in fact fully compatible with that of Michelangelo's rough pen sketches (e.g. no. 103).

103 Two draped male figures

Ashmolean Museum (Parker 327 *verso*)

Pen and ink. 26·2 × 16·3 cm.

Lit.: Dussler 597

Close in style and handling to no. 102 and evidently dating from the same period, *c.* 1526.

101 Male nude with notes of proportion

Windsor (Popham–Wilde 421)

Red chalk. 28·9 × 18 cm.

Lit.: Dussler 716

Dated by Wilde *c.* 1525–8. Probably made by Michelangelo to demonstrate to some pupil the proportions of the human body. In style, and technique it recalls the drawings with which Michelangelo supplied his protégé, Sebastiano del Piombo (e.g. nos. 37 to 41).

102 Three men in conversation

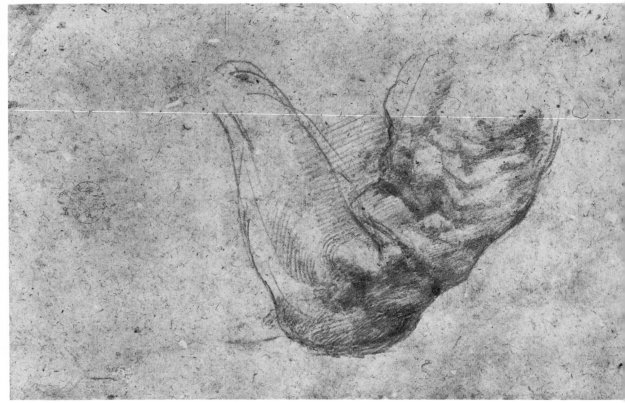

104 Reclining male nude

104 Reclining male nude

British Museum (Wilde 48 *verso*)

Black chalk. 17·8 × 29·6 cm.

Lit.: Dussler 555; Hartt 235

Considered by Berenson (B.B. 1498) as a study for the statue of *Night* in the Medici Chapel. Wilde saw a stylistic difference between this drawing and the studies for the arms of *Night* on the *verso* of no. 61, and connected it with the lost painting of *Leda*, commissioned from Michelangelo by the Duke of Ferrara and completed by October 1530.

It should be noted, however, that though the pose of the left leg and torso is closely similar in the two figures (both are in fact derived from the same prototype, an Antique statue of *Leda*), in the *Leda* the torso is twisted further away from the spectator so that the right buttock is visible. In these respects the drawing corresponds more closely with the figure of *Night*.

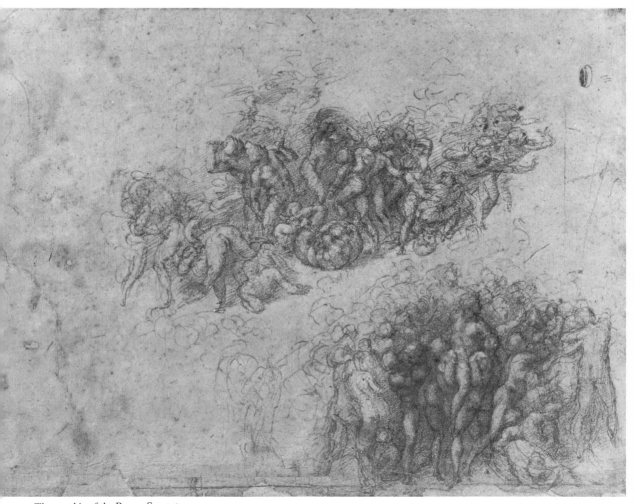

105 The worship of the Brazen Serpent

105 The worship of the Brazen Serpent

Ashmolean Museum (Parker 318)

Red chalk. 24·4 × 33·6 cm.

Lit.: Dussler 195; Hartt 257

Connected by Robinson and Berenson with the
fresco of the subject on the Sistine Ceiling, but
its style points to a much later date, around 1530.
Its purpose is unknown.

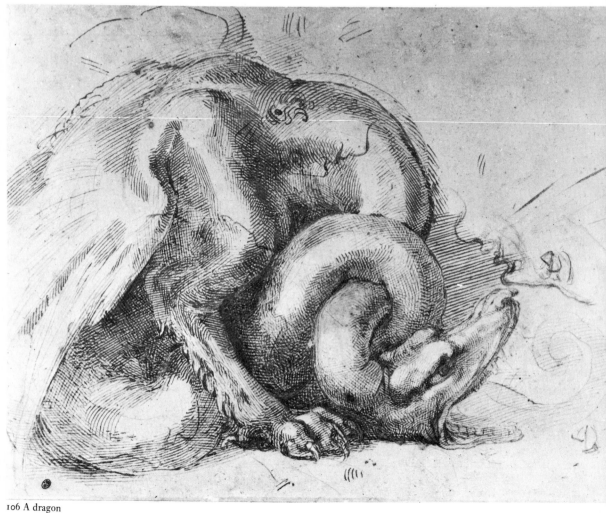

106 A dragon

106 A dragon

Ashmolean Museum (Parker 323)

Pen and ink. 25·4 × 33·7 cm.

Lit.: Dussler 343; Hartt 191

Berenson's suggestion that this might be a study for the dragons in the panels on the bases of the two candelabra on the altar of the Medici Chapel is hardly convincing; the dragons on the candelabra are conventionalized and reduced almost to decorative arabesques, whereas the creature in the drawing is treated with the greatest possible degree of plastic realism.

On the *verso* are studies by Michelangelo of a profile, locks of hair and eyes, together with copies of these by a childish hand, evidently that of a pupil. The dragon was drawn over some other profiles by the same hand. An inscription on the *verso*, beginning *Andrea abbi patientia*, has been interpreted as an exhortation to this pupil, whom Berenson named 'Andrea di Michelangelo'; but he is now generally assumed

to be Antonio Mini (1506–33). A more likely explanation of the inscription is that it is a draft of the beginning of a letter to Michelangelo's young friend Andrea Quaratesi (cf. no. 119), whose name is also inscribed on the *verso* in an abbreviated form. The period of Michelangelo's friendship with Quaratesi was the late 1520s and early 1530s; Mini was a member of his household from 1522 to 1531.

107 A salamander

Ashmolean Museum (Parker 320)

Black chalk. 13·3 × 21 cm.

Lit.: Dussler 346; Hartt 188

107 A salamander

Wilde was the first to connect this drawing with no. 108. The generally accepted identification of the animal as a salamander seems to be based on the fact that it is represented amid flames. Otherwise one would have little hesitation in seeing it as a cringing hound. On the other hand, the rather similar creature in no. 108; though its body is that of a hound, has an impossibly elongated neck; and in this combination it resembles some of the salamanders above the painted panels in the Galerie François I at Fontainebleau (e.g. K. Kusenberg, *Le Rosso*, Paris, 1931, pl. xliv).

Though the salamander was the well-known device of François I, it does not necessarily follow that these drawings were made in con- nexion with Antonio Mini's journey to France in 1531. The figures on either side of no. 107 seem certainly to be connected with the central motif, in spite of the discrepancy in scale: on the left a zephyr blowing on the flames, and on the right a figure apparently recoiling from them. Is this perhaps some kind of complicated allegory in the manner of Leonardo?

The two sheets are generally dated *c.* 1530.

108 A salamander

British Museum (Wilde 50)

Black chalk. 9·2 × 12·7 cm.

Lit.: Dussler 332; Hartt 189

See no. 107.

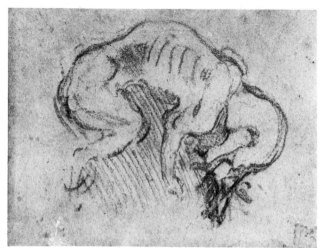

108 A salamander

109 Venus and Cupid

British Museum (Wilde 56)

Pen and ink. 8·5 × 12·1 cm.

Lit.: Dussler 158; Hartt 307

A sketch for a cartoon made in 1532–3 for the Florentine painter Jacopo Pontormo (1494–1556), who had been asked for a painting of this subject. What is either the cartoon itself or an exact contemporary copy is in the Naples Museum (Tolnay, iii, fig. 287), but its bad condition makes it difficult to judge. There are various painted versions, that in the Florence Accademia being generally regarded as the original (Berenson, *Italian Pictures of the Renaissance, Florentine School*, 1963 edn., pl. 1224).

110 Three figures in violent movement

Ashmolean Museum (Parker 321)

Pen and ink over lead-point. 10·4 × 10·4 cm.

Lit.: Dussler 350; Hartt 170

Parker follows Wilde in accepting without qualification Thode's tentative suggestion that this drawing and five similar sketches in the Casa Buonarroti were made in the early 1530s for the benefit of the Florentine painter Giuliano Bugiardini (1475–1554), who was experiencing particular difficulty over the design of the row of startled soldiers in the foreground of his altarpiece of the *Martyrdom of St Catherine* (Florence, S. Maria Novella; Venturi ix, i, fig. 303). Wilde's reference to Michelangelo's 'lost outline drawing', though literally correct, is somewhat misleading. In this case Michelangelo did not produce the same kind of carefully pondered study that he made for Sebastiano del Piombo. Vasari, in his very circumstantial account of the episode (vi, pp. 207 f.), relates how Michelangelo, when appealed to by Bugiardini for advice in front of the unfinished picture, took a piece of chalk and then and there sketched in the outlines of the foreground figures directly onto the panel, indicating them so roughly that Bugiardini was even then incapable of rendering the chiaroscuro and had

to ask the sculptor Tribolo to make clay models of the figures. If Vasari's account is to be believed, this was a casual gesture on Michelangelo's part, made on the spur of the moment and not necessarily preceded by any preparatory drawings (though if any had been made they would presumably have been very rough sketches of this kind). It should also be noted that there is no correspondence between any of the figures in the painting and any of those in the drawings of which complete reproductions exist (there are at least six figures on Casa Buonarroti 38F drawn so faintly in black chalk as to defy reproduction), or in the two other drawings which Wilde groups with them (no. 111 and B.B. 1471 at Haarlem). Figures of this kind would be equally in place in a composition of the *Resurrection* (e.g. no. 46).

111 A man in violent movement

British Museum (Wilde 51)

Lead point. 9·1 × 4 cm.

Lit.: Dussler 310; Hartt 167

See no. 110.

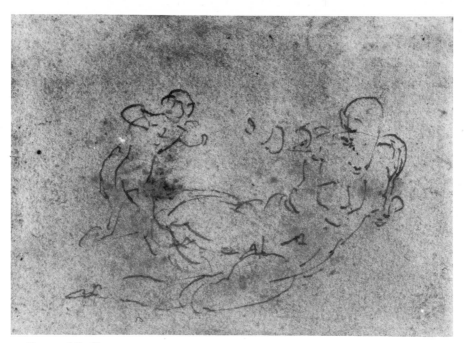

109 Venus and Cupid

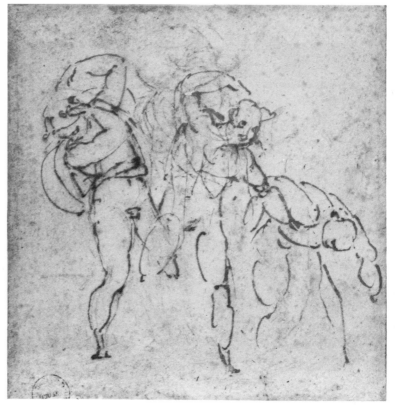

110 Three figures in violent movement

VI 'PRESENTATION DRAWINGS'

This term was coined by Wilde to define a group of highly finished chalk drawings, devotional or allegorical in theme, which Michelangelo made as gifts for his particular friends. One such friend whose acquaintance he made in the early 1530s, and to whom he was passionately attached, was a young Roman nobleman, Tommaso de' Cavalieri. For him, Vasari relates, Michelangelo made the drawings of the *Rape of Ganymede* (lost: see no. 124), *Tityus* (no. 123), the *Fall of Phaethon* (no. 126) and the *Bacchanal of Children* (no. 122). He also drew a life-size half-length portrait of Cavalieri in black chalk. This is lost, but its general appearance may be inferred from the black chalk portrait, datable *c.* 1532, of another young friend, Andrea Quaratesi (no. 119).

For such drawings, which were intended as works of art complete in themselves, Michelangelo evolved a complex and laborious technique of fine parallel strokes and stippling. Their high degree of finish caused some critics to dismiss them as copies; but as Wilde wrote apropos of the *Archers* (no. 127): 'The gradations of light and shade are infinite. The figures on the left which are exposed to the full light show the same fineness of surface modelling as the highly polished statues of *Night* and *Dawn* in the Medici Chapel. That contemporaries should have studied a work of this kind under the magnifying glass was thoroughly justified (see Vittoria Colonna's letter to Michelangelo). We do well to follow their example, and by so doing are enabled to discover a series of characteristic *pentimenti* which may serve to satisfy those who desire manifest proofs as an argument for originality.' (Vittoria Colonna's letter is no. 200 in the present exhibition.)

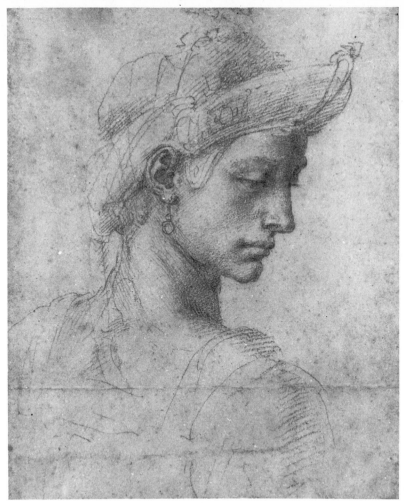

112 Ideal head

THE IDEAL HEADS, *PORTRAIT OF ANDREA QUARATESI*

Nos. 112–30: *THREE EXPLOITS OF HERCULES*, THE *BACCHANAL OF CHILDREN*, *TITYUS*, THE *FALL OF PHAETON*, *ARCHERS SHOOTING AT A HERM* AND *CHRIST ON THE CROSS*

112 Ideal head

Ashmolean Museum (Parker 315)

Red chalk. 20·5 × 16·5 cm.

Lit.: Dussler 342; Tolnay, v, p. 170, no. 152; Hartt 363

Critics have proposed dates for this drawing ranging from before 1500 to *c.* 1530, but the general view is that it can hardly be earlier than the period of the Sistine Ceiling (1508–12) or later than about 1525. Whether the head, usually referred to as that of a young woman, is male or female is not altogether clear. The features resemble those of some of the *ignudi* on the Sistine Ceiling, but it is also true that Michelangelo's female types tend towards the androgynous, as these were frequently drawn from male models. The costume is ambiguous: the ear-ring might suggest a woman, but the head-dress is not so much 'turban-like' (Parker) as a kind of fantastic helmet with cheek lappets.

The purpose of the drawing is unknown. Wilde (who dated it *c.* 1516) may well be correct in suggesting that it was made for presentation.

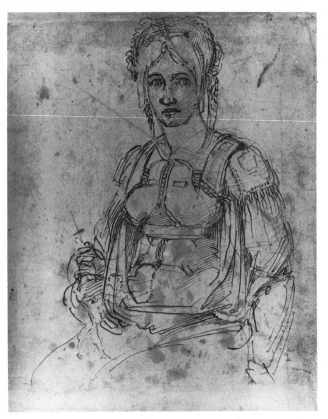

113 Figure of a woman

113 Half-length figure of a woman

British Museum (Wilde 41)

Pen and ink over red and black chalk.

32·3 × 25·8 cm.

Lit.: Dussler 307; Hartt 366

Wilde accepts the suggested dating *c.* 1525. He describes this as a 'presentation drawing'—one of the *'teste divine'* that, according to Vasari, Michelangelo made for his friends. The known 'presentation drawings' are highly finished, and it is perhaps more likely that this is a preliminary sketch for one.

114 Ideal head of a woman

British Museum (Wilde 42)

Black chalk. 28·7 × 23·5 cm.

Lit.: Dussler 568; Tolnay, v, p. 168, no. 148; Hartt 365

This drawing has always been considered in connexion with no. 115. Most critics have rejected them both, considering them to be either copies after lost drawings by Michelangelo, or products of his studio, or independent works by some other Florentine artist; the present drawing for example has been attributed to Bacchiacca. Thode was the first to observe that no. 114 is an original drawing by Michelangelo and no. 115 a contemporary copy, a judgement with which Wilde agreed. This head and the lost original of no. 115 were no doubt two of the *'teste divine'* which Michelangelo is recorded by Vasari as having made for his friends. Wilde considers it somewhat earlier than the presentation drawings made for Tommaso de' Cavalieri and suggests a date *c.* 1525–8.

The traditional title of the drawing, *Marchesa di Pescara*, is a romantic invention: this is clearly an ideal head, which there is no reason to connect with Vittoria Colonna.

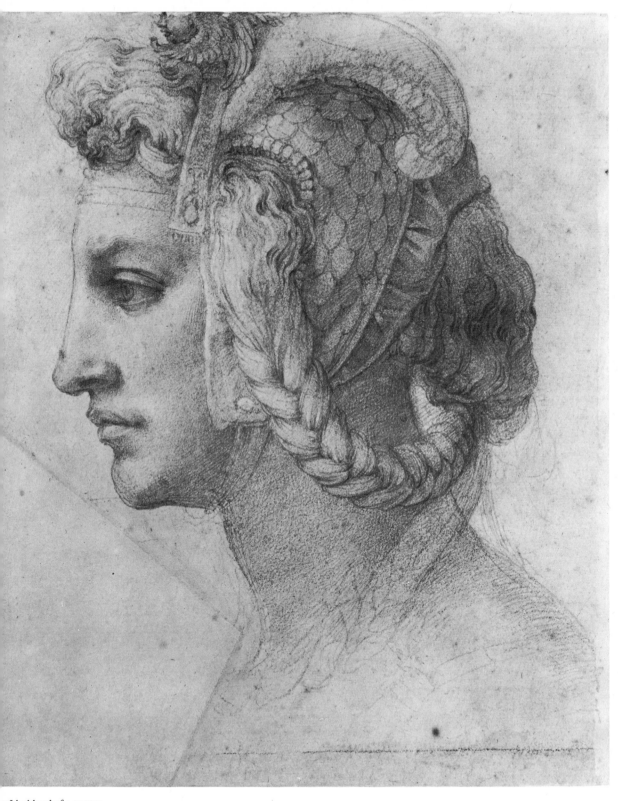

4 Ideal head of a woman

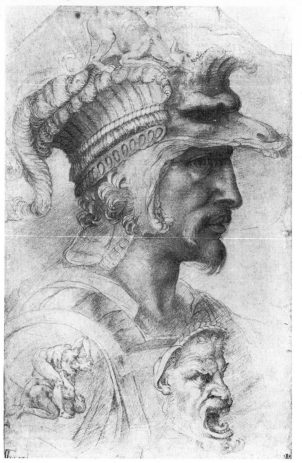

115 'The Count of Canossa' (after Michelangelo)

(*cane*) gnawing a bone (*osso*), could be construed as a punning, or 'canting', allusion to the name Canossa. He described the drawing as 'an ideal portrait of a Count of Canossa, from whom Michelangelo supposed himself to be descended', an explanation which may well be correct. Condivi describes Michelangelo's descent from this family as a fact, and their arms, as given by Rietstap in his *Armorial Général*, were *Gules a greyhound rampant argent collared and chained or holding in its mouth a bone proper*, with the same animal *issuant* as crest. The lost original, presumably drawn about the same time as no. 114, which Wilde dates *c.* 1525–8, might have been made for presentation to Count Alessandro da Canossa, with whom Michelangelo was acquainted and who wrote to him on 8 October 1520, addressing him as 'kinsman' ('*parente on.*') and inviting him to come and visit his relatives (see the letter, no 197 in the exhibition).

116 Christ on the Cross

Count Antoine Seilern

Black chalk. 42·5 × 39·8 cm.

This drawing was formerly in the Lawrence Collection—the source of most of the Michelangelo drawings in this country—and came originally from the Buonarroti family. It was one of the thirty by Michelangelo selected by Samuel Woodburn for lithographic reproduction in his facsimile publication *The Lawrence Gallery* (1853). James Byam Shaw was responsible for its rediscovery.

At some time it was covered with varnish (now removed), and the surface has suffered considerably so that the drawing is somewhat difficult to judge; but such passages as the modelling of the chest and stomach, the drawing of the lower part of the legs and the feet, and the contours of the right arm could only be by Michelangelo himself. The style suggests a dating in the 1530s. The high degree of finish makes it possible that this was made for presentation.

115 'The Count of Canossa' (after Michelangelo)

British Museum (Wilde 87)

Black chalk. 41 × 26·3 cm.

Lit.: Dussler 567; Tolnay, v, p. 167, no. 147

The lost original is generally considered to have been a companion drawing to no. 114, but the two are not so alike as necessarily to have been conceived as a pair. The two heads were, however, etched as a pair by Antonio Tempesta in 1613 (Bartsch xvii, p. 180, 1371 and 1372). The etching of no. 114 bears no title, but on the other is inscribed, according to Bartsch, '*Canossiae familiae nobilissimo stipiti*'. The drawing is traditionally known as '*The Count of Canossa*', an identification dismissed by all critics but Robinson as being no less fanciful than that of no. 114 as a portrait of Michelangelo's friend Vittoria Colonna, Marchesa di Pescara. Robinson pointed out that the crest on the helmet, a dog

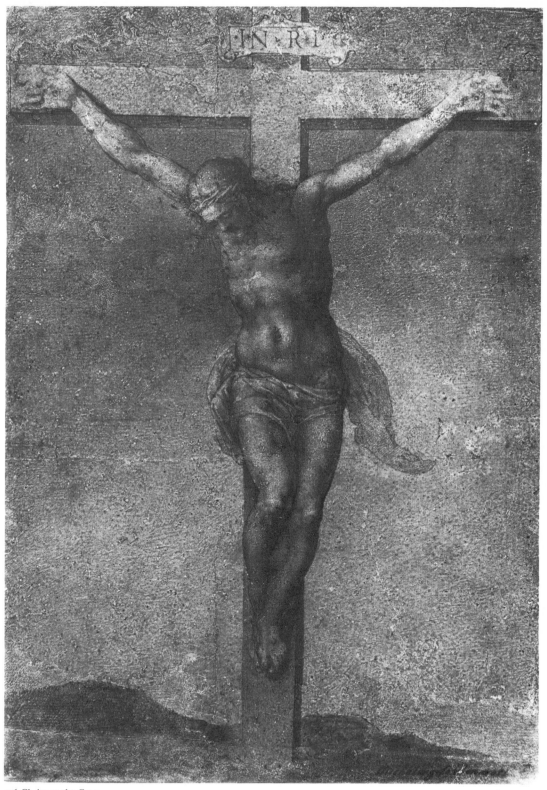

116 Christ on the Cross

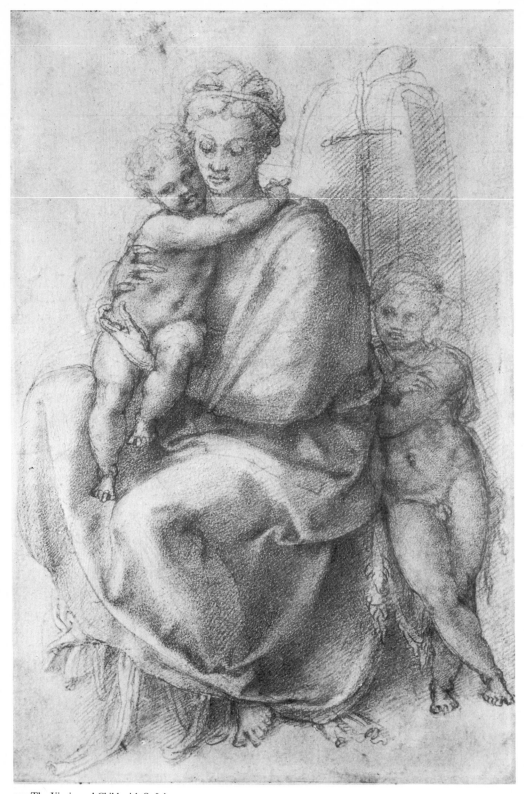

117 The Virgin and Child with St John

117 The Virgin and Child with St John

Windsor (Popham–Wilde 426)

Black chalk. 31·7 × 21 cm.

Lit.: Dussler 719

Dated by Wilde *c.* 1532. Possibly, as he suggested (1953 exh.) a presentation drawing.

118 The Virgin and Child with St John

British Museum (Wilde 58)

Black chalk. 31·4 × 20 cm.

Lit.: Dussler 558; Tolnay, v, p. 165, under no. 143

Dated *c.* 1532–3 by Wilde, who pointed out resemblances in style and handling to drawings by Michelangelo datable in that period (e.g. nos. 122 and 128). He thought that it was either a presentation drawing or one made for the use of a fellow artist, perhaps Sebastiano del Piombo.

This is one of the drawings that some recent critics have given to Sebastiano himself, an opinion still maintained by Tolnay, who describes the drawing as 'cotton-like'. It should, however, as Wilde argued, be compared with the study, undoubtedly by Sebastiano, for his *Madonna del Velo* at Naples (*Old Master Drawings*, xiv, pl. 30). An even more instructive contrast is with the finished study of the *Virgin and Child* by Sebastiano, also datable in the early 1530s, which has recently come to light and which the Museum has acquired.

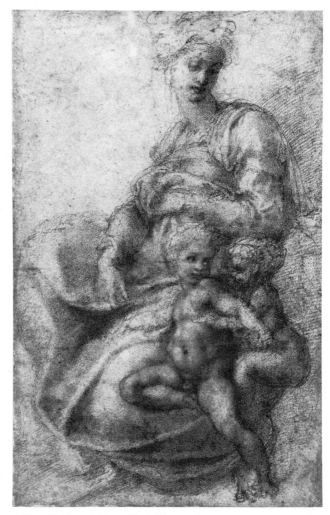

118 The Virgin and Child with St John

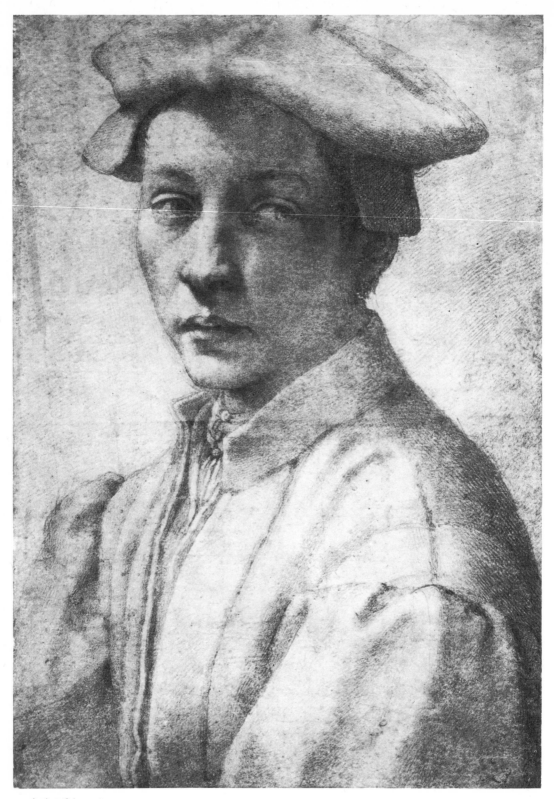

119 Andrea Quaratesi

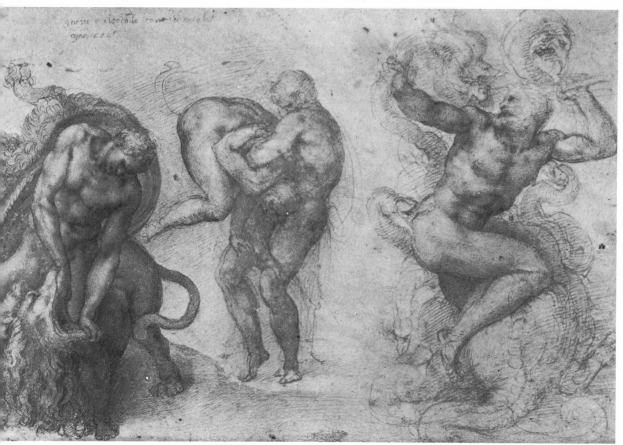

120 Three exploits of Hercules

119 Andrea Quaratesi

British Museum (Wilde 59)

Black chalk. 41·1 × 29·2 cm.

Lit.: Dussler 577

Three other versions of this subject are known, one, in the Uffizi, described on an old label as a copy made in 1645 by Carlo Dolci after a portrait drawing by Michelangelo of Andrea di Rinieri Quaratesi which was then in the possession of Giorgio Quaratesi. The Quaratesi were a noble Florentine family with which Michelangelo was on friendly terms, and his correspondence shows that it was this Andrea Quaratesi to whom he was particularly attached.

Wilde was the first to point out that the British Museum version—'the only one in which there is complete harmony between form and graphic style'—must be the original. It was presumably made as a presentation drawing. The date *c.* 1532 proposed by Wilde agrees with the apparent age of the subject, who was born in 1512.

Finished portrait drawings of this kind were unusual in Michelangelo's *œuvre*, and this is the only one now known. The lost half-length, life-size, black chalk portrait of Tommaso de' Cavalieri which Vasari refers to, and which was probably drawn at about the same time, no doubt resembled it in technique and degree of finish.

120 Three exploits of Hercules

Windsor (Popham–Wilde 423)

Red chalk. 27·2 × 42·2 cm.

Lit.: Dussler 363a; Hartt 360

Inscribed in red chalk by Michelangelo above the left-hand group: '*questo e il seco(n)do leone ch(e) ercole | am(m)azzo*' ('This is the second lion that Hercules killed').

Of the three exploits of Hercules here represented, the *Killing of the Nemean Lion* and the *Killing of the Lernaean Hydra*, form part of the traditional Twelve Labours; the fight with

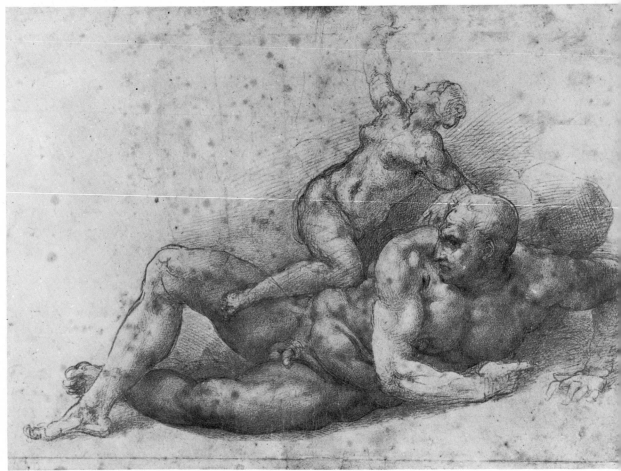

121 Samson and Delilah

Antaeus represented in the centre does not. The inscription explains why he is already wearing a lion-skin while fighting the Nemean Lion: this is the skin of the Citheronian Lion which he had killed in his youth. The action of rending the lion's jaws is taken from the traditional representation of Samson: according to the legend, Hercules first fought the Nemean Lion with his club and then strangled it.

Wilde, who once again reasserted the traditional attribution to Michelangelo, was surely right in describing this as a finished presentation drawing datable *c.* 1530, at about the same time as those drawn for Tommaso de' Cavalieri.

121 Samson and Delilah

Ashmolean Museum (Parker 319)

Red chalk. 27·2 × 39·5 cm.

Lit.: Dussler 624; Hartt 466

This drawing has been rejected by some critics, but Wilde (1953 exh.) convincingly reasserted the traditional attribution. He dated it *c.* 1530 on the strength of its technical and stylistic resemblance to some of the presentation drawings (e.g. no. 127), and suggested it could have been made for the same purpose. The subject would certainly lend itself to symbolical or allegorical interpretation.

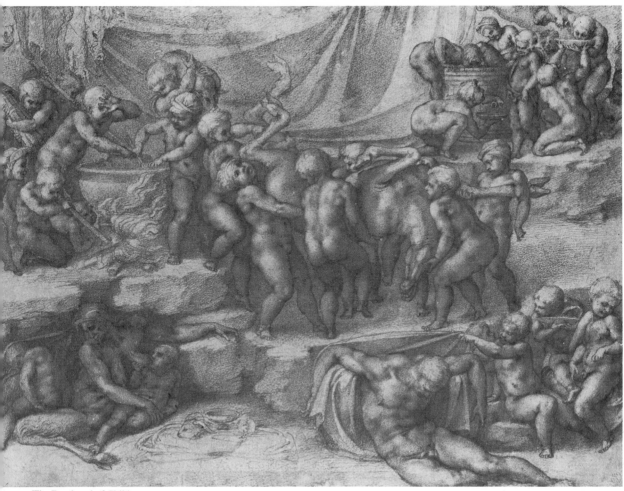

122 The Bacchanal of Children

Parker pointed out the parallel between this composition and that of the lost *Venus and Cupid* (see no. 109), also datable in the early 1530s. Both consist of two figures of disparate size, the smaller balanced on the hip of the larger reclining one.

122 'The Bacchanal of Children'

Windsor (Popham–Wilde 431)
Red chalk. 27·4 × 38·8 cm.
Lit.: Dussler 365; Hartt 361

One of the presentation drawings which Vasari describes as having been made for Tommaso de' Cavalieri. From external evidence it can be dated 1533.

The subject is not derived from any known literary source. Its meaning however, is obvious: the functions of life at their lowest and least spiritual level, as opposed to the lost drawing of *Ganymede*, also made for Cavalieri (see no. 124), which symbolizes the ecstasy of Platonic love by which the soul is freed from all physical bondage.

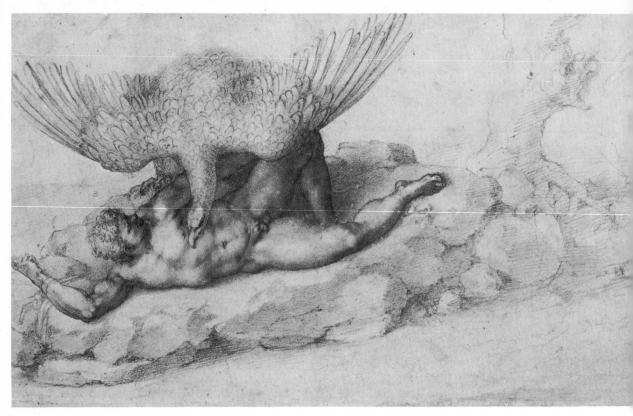

123 Tityus

123 Tityus

Windsor (Popham–Wilde 429)

Black chalk. 19 × 33 cm.

Lit.: Dussler 241; Hartt 353

Tityus was a giant who, having assaulted Latona, the mother of Apollo and Diana, was punished in Hades by having his liver perpetually torn out by a vulture. The drawing was made for Tommaso de' Cavalieri in 1532 as a *pendant* to the *Ganymede* (see no. 124). The two drawings taken together constitute an allegory on the theme of *Sacred and Profane Love*; Ganymede symbolizing the ecstasy of ideal love, Tityus the agony of sensual passion.

124 The Rape of Ganymede (after Michelangelo)

Windsor (Popham–Wilde 457)

Black chalk. 19·2 × 26 cm.

Lit.: Dussler 722

At one time this was believed to be the actual drawing which Michelangelo gave to Tommaso de' Cavalieri towards the end of 1532. Brinck-mann was the first to put forward the view that it is definitely a copy, a judgment with which Wilde agrees.

The group was engraved by Beatrizet (Passavant, vi, no. 111) with a landscape below in which is sitting the dog of the shepherd Ganymede. That this represents Michelangelo's

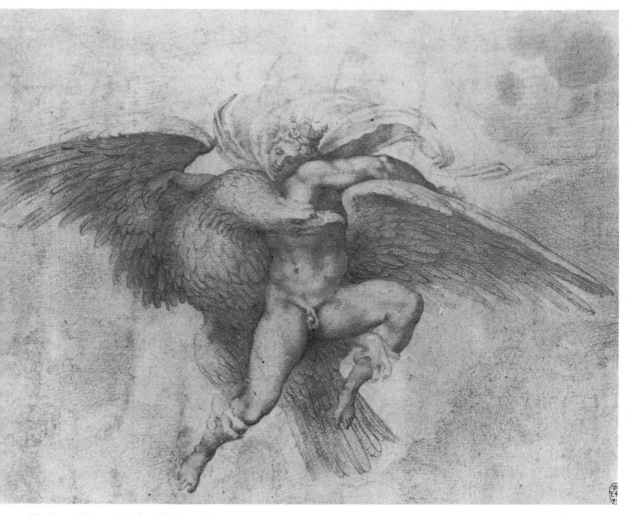

124 The Rape of Ganymede (after Michelangelo)

intention is shown by a black chalk drawing in the Fogg Museum, Harvard (1955–75) in which the principal group is exactly as in the Windsor copy, but which differs from the engraving in showing the dog accompanied by a group of sheep. If this drawing is not by Michelangelo himself, it can only be a faithful old copy. Michael Hirst, who first drew attention to it, is convinced that it is an autograph *modello*;

perhaps, like the British Museum version of the *Fall of Phaethon* (no. 125), made to be submitted to Cavalieri for his approval. Mr Hirst also attributes to Michelangelo himself another neglected drawing, in red chalk, in which the subject is treated in a different way but which also includes the dog, in the Uffizi (611$^{\mathrm{E}}$; Barocchi 277, pl. ccclxix). He hopes to publish both drawings in the near future.

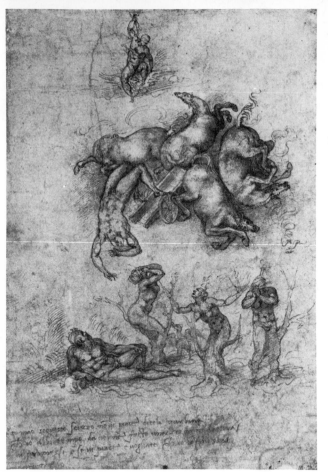

125 The Fall of Phaethon

126 The Fall of Phaethon

Windsor (Popham–Wilde 430)

Black chalk. 41·3 × 23·4 cm.

Lit.: Dussler 238; Hartt 358

Phaethon tried to drive the chariot of the Sun but was unable to control the horses and nearly set the Earth on fire. He was killed by a thunderbolt from Jupiter, and fell into the River Eridanus (the Po), typified in the drawing by the River-God and the swan. His sisters, who had harnessed the horses, were punished by being transformed into poplar trees.

Phaethon symbolizes presumptuous ambition. The drawing, which was made for Tommaso de' Cavalieri in 1533, has been interpreted as an expression of Michelangelo's feelings of temerity and presumptuousness in venturing to love him. The trouble that he took over it is shown by the existence of two trial *modelli*, one in the Venice Accademia (177; B.B. 1601) and another in the British Museum (no. 125).

The Windsor drawing was much admired by Michelangelo's contemporaries: it was copied in bronze and crystal, in drawings, engravings and paintings.

125 The Fall of Phaethon

British Museum (Wilde 55)

Black chalk. 31·3 × 21·7 cm.

Lit.: Dussler 177; Hartt 355

Inscribed in Michelangelo's hand: [*Mess*]*er toma(s)o se questo scizzo no(n) ui piace dietelo a urbino/ [acci]o ch(e) io abbi tempo dauerne facto un altro doma(n)dassera/ [co]me ui promessi e se ui piace e uogliate ch(e) io lo finisca/ [rim]andate me lo'* ('Messer Tommaso, if you don't like this sketch tell Urbino [i.e. Michelangelo's servant] in time for me to make another by tomorrow evening as I promised; and if you do like it and want me to finish it, send it back to me'). As the inscription makes clear, this was a trial *modello* for the drawing which Michelangelo made for Tomasso de' Cavalieri in 1533. The final version was the even more elaborately finished and somewhat larger drawing at Windsor (no. 126).

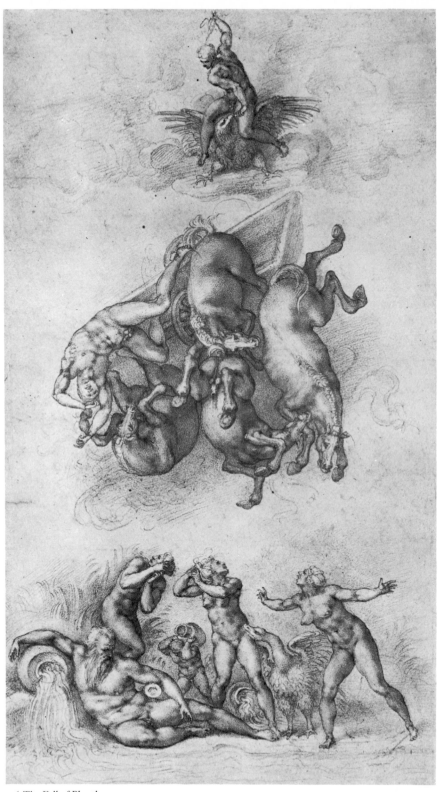

126 The Fall of Phaethon

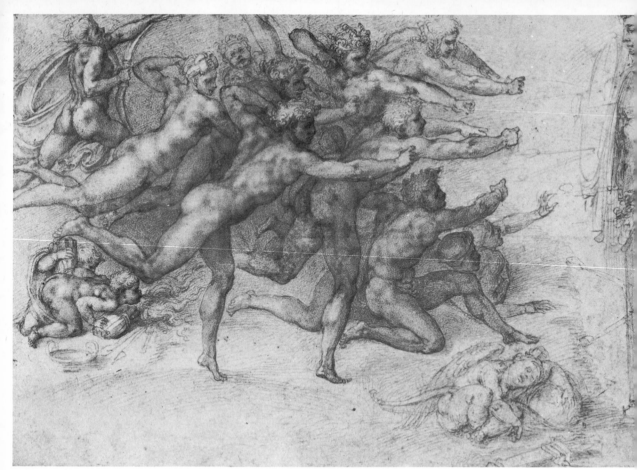

127 Archers shooting at a herm

127 Archers shooting at a herm

Windsor (Popham–Wilde 424)

Red chalk. 21·9 × 32·3 cm.

Lit.: Dussler 721; Hartt 362

In spite of the old inscription on the back, *D. Giulio Clovio copia di | Michiel Angelo*, which can only mean that this drawing was at some time believed to be one of the copies by Clovio (e.g. no. 39), the doubts as to its authenticity are surely ill-founded, as Wilde maintained.

Evidently a 'presentation drawing' which from its style and technique must date from about the same time as those made for Tommaso de' Cavalieri. The motif seems to have been inspired by the Antique (cf. the small painting of figures shooting at a herm which is a detail of a ceiling in the Golden House of Nero) but its allegorical significance has never been satisfactorily ex-

plained, though attempts to do so have been made notably by Panofsky (*Studies in Iconology*, New York, 1939, pp. 225 ff.).

128 'The Dream of Human Life'

Count Antoine Seilern

Black chalk. 39·6 × 27·9 cm.

Lit.: Dussler 589; Tolnay, v, p. 181, no. 169; Hartt 359

A famous composition, known from the engraving by Beatrizet (Passavant, vi, 112) and various drawn and painted copies (one in the National Gallery). The present version has in the past been dismissed as yet another drawn copy, but Wilde was undoubtedly right in maintaining that it is Michelangelo's original. It must be a 'presentation drawing', made at about the same time as those drawn for Tommaso

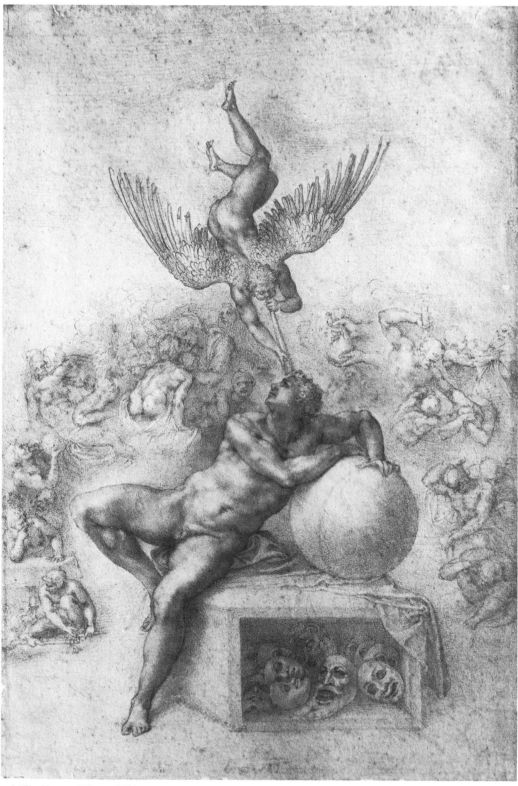

128 'The Dream of Human Life'

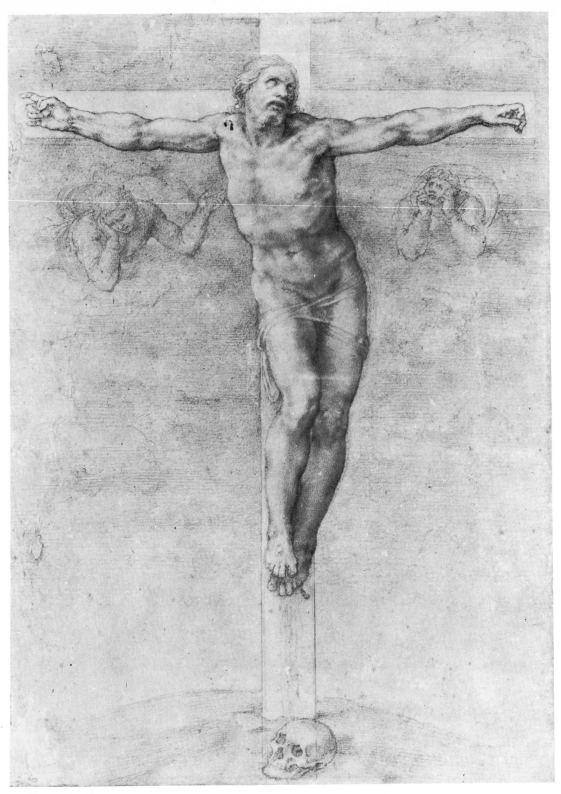

129 Christ on the Cross

de' Cavalieri. The identity of the recipient is not recorded.

The general significance of the allegory is clear. The small-scale groups in the background represent six of the Seven Deadly Sins, clockwise from the lower left *Gluttony*, *Lust*, *Avarice*, *Anger*, *Envy* and *Sloth*. These are the subject of the young man's dream, from which he is aroused by the trumpet of the flying figure of *Fame* or *Emulation*. The masks are symbols of untruth and deceit. The moral is that he who would achieve fame must not let himself be diverted by worldly and sensual preoccupations.

129 Christ on the Cross

British Museum (Wilde 67)

Black chalk. 37 × 27 cm.

Lit.: Dussler 329; Hartt 408

This drawing corresponds exactly with Condivi's description (so far as it goes) of one made by Michelangelo for Vittoria Colonna. This identification has been generally accepted, though some critics have considered the drawing a copy of the lost original. These doubts are surely unfounded, as Wilde argued.

Vittoria Colonna, Marchesa di Pescara (1492–1547), was a poetess of note and one of the leaders of the movement which aimed at reforming the Church from within. In the last years of her life she and Michelangelo became intimate friends, and he is known to have made at least three 'presentation drawings' for her: the *Christ on the Cross*, the *Pietà with Angels* (Fenway Court, Boston) and the *Christ and the Woman of Samaria* (lost).

The drawing of *Christ on the Cross* is referred to in the correspondence between Michelangelo and Vittoria Colonna (see the letter, no. 200). These letters bear no dates, but can be assigned on internal evidence either to 1536 or to 1539–40. The style of the drawing suggests the later date. The letter from her to Michelangelo about the drawing of *Christ and the Woman of Samaria* is dated 20 July 1541.

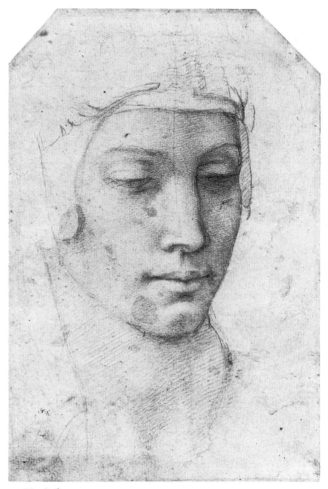

130 Head of a young woman

130 Head of a young woman

Windsor (Popham–Wilde 434)

Black chalk. 21·2 × 14·2 cm.

Lit.: Dussler 715; Tolnay, v, p. 171, no. 154; Hartt 364

Dated by Wilde *c.* 1540–2, with the suggestion that this may have been one of the '*teste-divine*' which, according to Vasari, Michelangelo made for Tommaso de' Cavalieri.

VII THE THIRD ROMAN PERIOD
1534–64

The early 1530s marked a crisis in Michelangelo's life and in his art. The failure of Clement VII's diplomatic policy resulted in 1527 in the disastrous Sack of Rome, which in its turn brought about the expulsion from Florence of the ruling Medici dynasty and the setting up of a republican government of which Michelangelo was a supporter. In 1529 Clement was reconciled with the Emperor Charles V, who agreed to restore the Medici and laid siege to Florence. Michelangelo, who was given charge of the fortifications by the Republican government, did much to improve them, but when Florence eventually capitulated in August 1530 he was given immunity by the Pope on condition that he continued work on the Medici Chapel. From 1532 he began spending long periods in Rome and in September 1534 moved there for good. He never returned to Florence and the chapel was left unfinished. The first work that he undertook in Rome was the *Last Judgement* (1536–41) on the altar-wall of the Sistine Chapel. This was originally commissioned by Clement, probably in 1533, and after his death in September 1534 the project was enthusiastically taken up by his successor, Paul III. The altar-wall was previously decorated with a number of separate frescoes at different levels, including an *Assumption of the Virgin* by Perugino above the altar and, at the very top, two lunettes by Michelangelo himself which were part of his earlier ceiling decoration. The *Last Judgement* as finally carried out occupies the entire area of the wall including the lunettes, but, as Wilde was the first to point out (*Die Graphischen Künste*, N.S. i (1936), pp. 7 ff.), an early project for it in the Casa Buonarroti shows the whole composition not only occupying a smaller area but also incorporating Perugino's altarpiece. Like the ceiling decoration, which can be seen as the pictorial equivalent of the first project for the tomb of Julius II, the *Last Judgement* is likewise conceived in sculptural terms, as a vast high relief; but the contrast between the two shows that Michelangelo had in the interval undergone a profound spiritual crisis. By the 1530s, the disaster of 1527 and the changed attitude of mind that was to lead to the Counter-Reformation had combined to make a radical change in the intellectual climate of Rome. In the *Last Judgement* the pictorial subtlety and grace of the ceiling decoration and the humanist Neoplatonic emphasis on the ordered structure of the universe have been, as it were, burnt away, and the human figure is now used as a vehicle for a direct and highly personal expression of mystical emotion—so personal indeed, that the later Counter-Reformation popes failed to understand the intensely spiritual quality of the *Last Judgement*, one of them (Paul IV) even ordering the nudities to be painted over. The contrast is apparent in drawings: the fine black chalk technique that Michelangelo developed for the studies for individual figures in the *Last Judgement* seems to have an almost deliberate lack of charm, when compared with some of the ceiling studies (e.g. no. 20). The same kind of 'expressionism' characterizes the frescoes of the *Conversion of St Paul* and the *Martyrdom of St Peter* which he painted in the Cappella Paolina in the Vatican between 1546 and 1550, and the series of drawings of religious themes, particularly *Crucifixions*, which he drew at the very end of his life. The religious mysticism of this period is also present in two late *Pietà* sculptures (Florence, Cathedral and Milan, Castello Sforzesco), both of which Michelangelo laboriously worked and reworked during the later

part of his life. They are the sculptural equivalents to the *Crucifixion* drawings, which pulsate with corrected and cancelled lines, showing likewise the abandonment of the conventional notion of finish.

The Cappella Paolina frescoes were Michelangelo's last paintings. For the rest of his life he was chiefly active as an architect, though he continued to make drawings for himself and to help other artists. The most distinguished of these was Daniele Ricciarelli da Volterra (1512/5–79) whom he seems to have helped in much the same way as he formerly did Sebastiano del Piombo, and whose response was, in its own way, as creative (see nos. 165 and 166). He is also recorded as having on at least one occasion made drawings for Marcello Venusti (1509–66); Venusti made a speciality of small-scale paintings based on designs by Michelangelo (e.g. the much-repeated *Agony in the Garden*; see no. 170), but he was less capable than Daniele of understanding the implications of Michelangelo's style, so that his pictures tend to be mere repetitions. (It is not always clear whether the drawings used by Venusti were necessarily always made expressly for him.)

In 1546 Michelangelo succeeded Giuliano da San Gallo as Architect of St Peter's. He brilliantly simplified and concentrated San Gallo's somewhat diffuse plan, and his inspired conception of the building as an organic whole survives in the exterior of the lateral arms in combination with the dome. But the latter was not executed entirely in accordance with his final design (see no. 172), and his Greek Cross plan had, for liturgical reasons, to be transformed into a Latin Cross by the addition in the early seventeenth century of three bays to the fourth arm to form a nave. Other architectural works in Rome were: the replanning of the Capitol begun in 1538 (two lateral palaces and the design of the oval pavement are after his designs); the upper storey of the Palazzo Farnese begun in 1546 (see no. 149); the Sforza Chapel in S. Maria Maggiore, begun *c.* 1560 (see no. 173); the Porta Pia, begun in 1561; the transformation of the tepidarium of the Baths of Diocletian into the church of S. Maria degli Angeli, begun 1561. The designs he made for what would have been one of his most remarkable works in architecture, the centrally planned church of S. Giovanni de' Fiorentini, were never executed, but they exercized a fundamental influence on Bernini and Borromini in the middle of the following century.

Nos. 131–83: DRAWINGS FOR THE
LAST JUDGEMENT,
THE *CRUCIFIXION OF
ST PETER*;
ARCHITECTURAL DESIGNS
FOR THE PALAZZO FARNESE,
THE CUPOLA OF ST PETER'S
AND THE SFORZA CHAPEL;
THE 'EPIFANIA' CARTOON
AND LATE STUDIES FOR
A *CRUCIFIXION*

131 Studies for the Last Judgement

British Museum (Wilde 60)

Black chalk. 38·4 × 25·3 cm.

Lit.: Dussler 333; Tolnay, v, p. 186, no. 178;
Hartt 374

The three studies of figure-groups are for
separate groups in the finished painting. There
are many differences of detail and the groups
are not placed in the same relation as on the wall.
The uppermost is probably, as Wilde suggests,
for the one with the Baptist, in the upper register
to the left of Christ; the central one is identified
by the sheaf of arrows held by the kneeling
figure (St Sebastian) and the broken wheel
grasped by the crouching figure on the extreme
right (St Catherine), as for the group of martyrs
in the lower part of the upper register on the
extreme right; the lowest is for the group of the
Seven Deadly Sins immediately below the
Martyrs. Most of the other studies are details
of single figures. The pose of the large-scale
figure seated in the lower centre is that of the
ignudo above and to the right of the *Delphic Sibyl*.
Its presence on this sheet may be explained by
the similarity of the pose, in reverse, to that of
the St Lawrence in the *Last Judgement* who
appears immediately below Christ to the left.

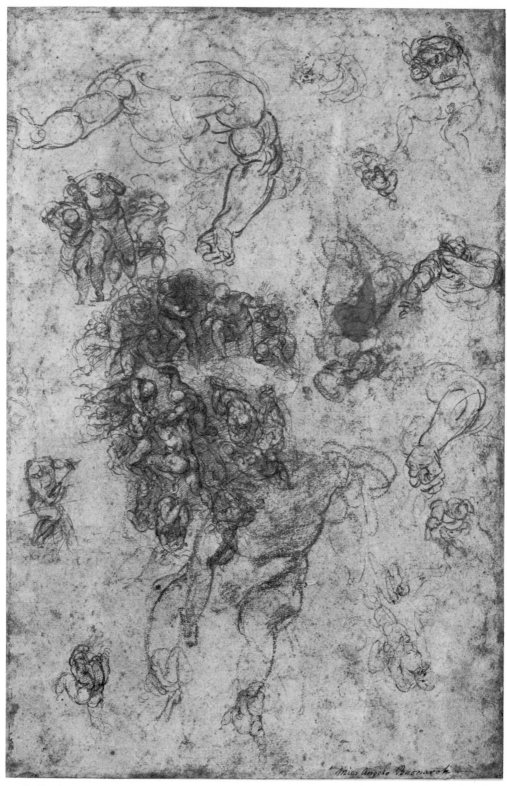

131 Studies for the Last Judgement

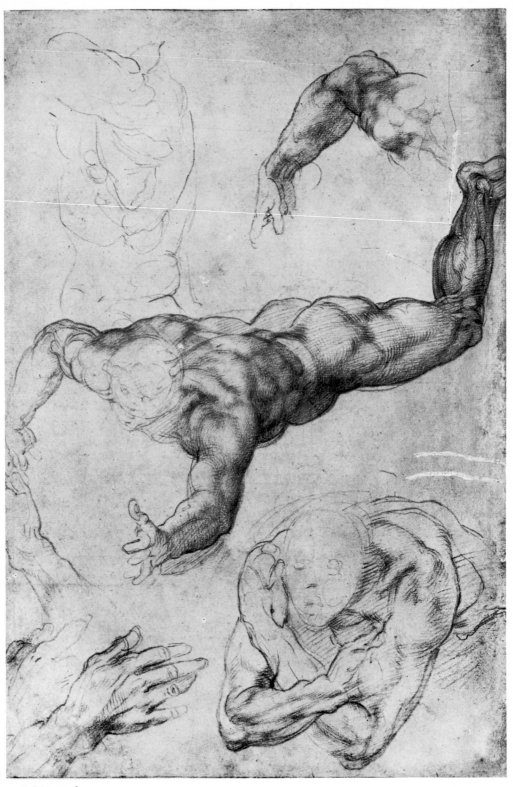

132 A flying angel

132 A flying angel and other studies

British Museum (Wilde 61)

Black chalk. 40·7 × 27·2 cm.

Lit.: Dussler 560; Tolnay, v, p. 192, no. 191; Hartt 379

A study for the angel to the right above the Column in the right-hand lunette at the top of the *Last Judgement*. The figure with arms crossed at the bottom right of the sheet does not appear in the fresco.

133 Studies of a seated nude man

British Museum (Wilde 62)

Black chalk. 34·2 × 26·3 cm.

Lit.: Dussler 551; Tolnay, v, p. 178, no. 123; Hartt 385

Wilde, who interprets the object held in the right hand as a knife, considered this drawing to be a study for the St Bartholomew to the right immediately below Christ in the *Last Judgement*. The position of the legs and arms in the two figures is entirely different, the only point of correspondence being the angle of the torso. Tolnay interprets the object in the hand as the end of a baton (the rest of which was not drawn in order that the figure's anatomy could be fully realized) and connects the drawing with the statue of Giuliano de' Medici in the Medici Chapel. As between these two suggestions Wilde's seems the more likely: the style of the drawing is certainly more suggestive of a dating in the mid-1530s than of one in the mid-1520s.

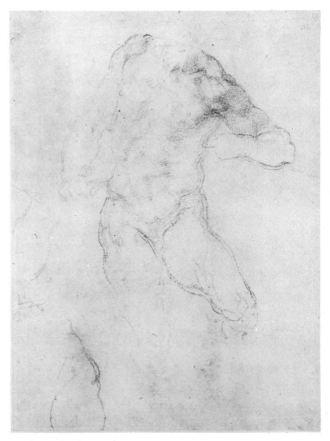

133 A seated nude man

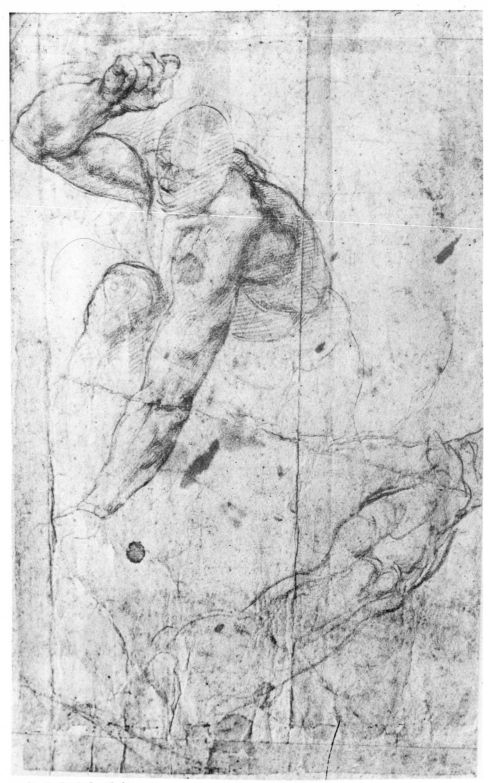

134 Studies for the Last Judgement

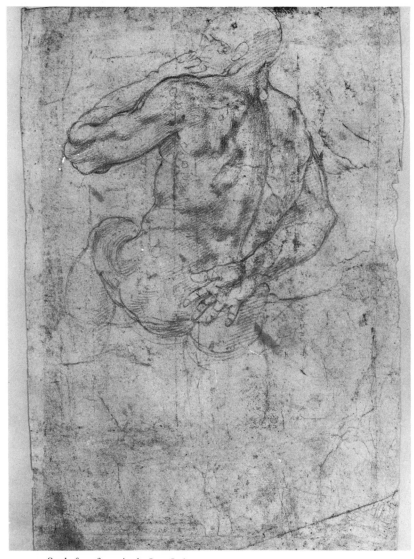

134 *verso* Study for a figure in the Last Judgement

34 Studies for figures in the Last Judgement

Methuen Collection

Black chalk. 26·4 × 18·2 cm.

Lit.: M. Hirst, *Burlington Magazine*, cxi (1969), pp. 27 f.

Attributed to Michelangelo by Hirst and identified by him as a sheet of studies for the angel in the *Last Judgement* who occurs, striking one of the damned, at the top left of the group of the Seven Deadly Sins, and for the right arm of his victim; the drawing on the *verso* is a study for the figure identified as *Lust* on the far right of the same group.

135 A man rising from the tomb

Ashmolean Museum (Parker 330)

Black chalk. 21·4 × 25·8 cm.

Lit.: Dussler 625; Tolany, v, p. 191, no. 187; Hartt 380

Study for the man rising from the tomb in the extreme bottom left-hand corner of the *Last Judgement*.

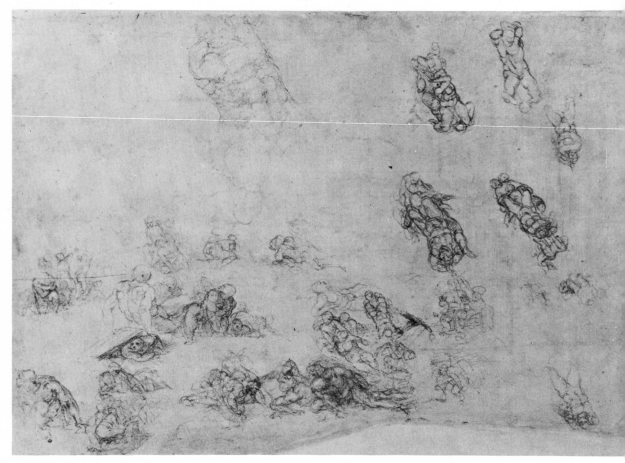

136 Studies for the Last Judgement

136 Studies for the Last Judgement

Windsor (Popham–Wilde 432)

Black chalk. 27·7 × 41·9 cm.

Lit.: Dussler 364; Tolnay v, p. 187, no. 80; Hartt 376

Studies for figures and groups of figures in the left and centre part of the lower zone, representing the resurrection of the dead and the mouth of Hell.

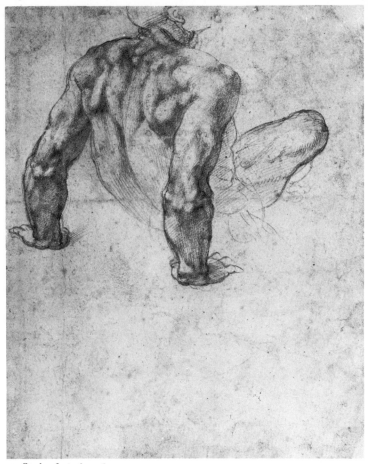

137 Study of a male nude

137 Study of a male nude

British Museum (Wilde 63)

Black chalk. 29·3 × 23·3 cm.

Lit.: Dussler 563; Tolnay, v, p. 190, no. 185; Hartt 390

For one of the figures rising from the tomb in the lower left corner of the *Last Judgement*.

138 Christ on the Cross

British Museum (Wilde 68)

Red chalk. 9·4 × 6 cm.

Lit.: Dussler 311; Tolnay, v, p. 172, no. 155; Hartt 253

Dated by Wilde in the period of the *Last Judgement*, *c*. 1534–40, and by Tolnay *c*. 1530.

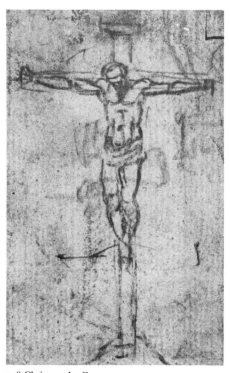

138 Christ on the Cross

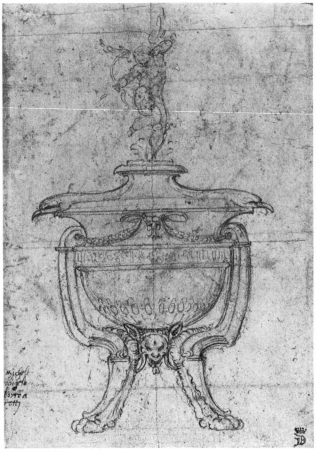

139 Design for a salt cellar

139 Design for a salt-cellar

British Museum (Wilde 66)

Black chalk. 21·7 × 15·5 cm.

Lit.: Dussler 582; Hartt 532

Robinson, who possessed another drawing of the same subject, a copy (now in the Victoria and Albert Museum, E. 1322–1927), was the first to recognize its close correspondence with the contemporary description of the silver salt-cellar which Michelangelo designed in 1537 for the Duke of Urbino. The present version had been lost sight of, and it was Wilde who first identified it as Michelangelo's original.

Michelangelo's uncharacteristic readiness to undertake a small commission of this kind can be explained by his need to conciliate the Duke of Urbino who, as the principal heir of Julius II, was pressing him to complete the Pope's tomb.

140 The Holy Family with the infant St John

British Museum (Wilde 65)

Black chalk. 31·7 × 19·1 cm.

Lit.: Dussler 583

Wilde, who saw a resemblance in style and technique to studies for the *Last Judgement*, dated this drawing in the mid-1530s.

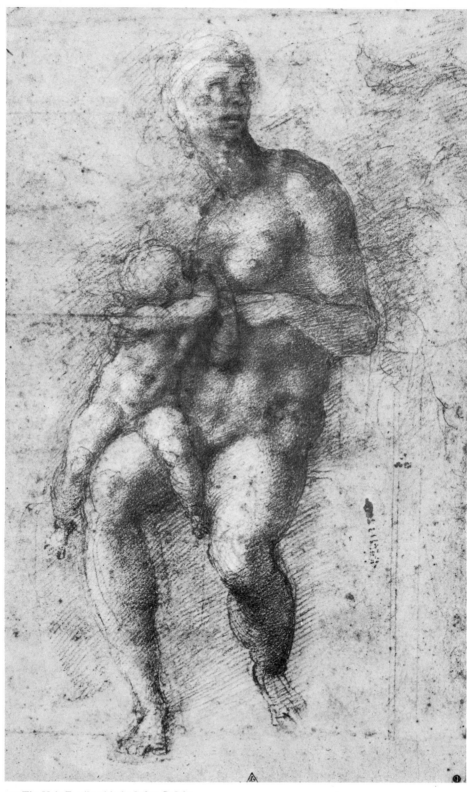

140 The Holy Family with the Infant St John

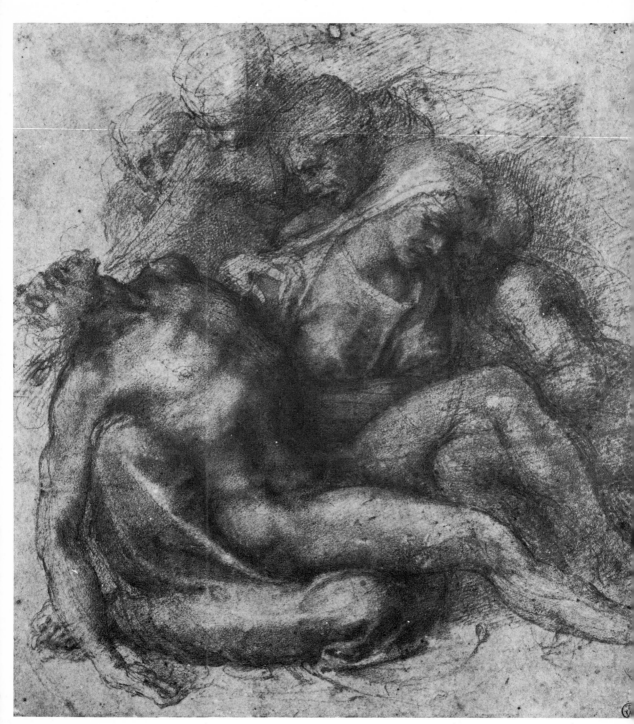

141 The Lamentation

141 Lamentation over the dead Christ

British Museum (Wilde 64)

Black chalk. 28·2 × 26·2 cm.

Lit.: Dussler 578

This drawing, sometimes referred to as the 'Warwick Pietà' from having once been in the collection of the Earl of Warwick, is one of those that modern critics have attributed to Sebastiano del Piombo. Wilde is certainly right in returning to the traditional attribution to Michelangelo. He dates it *c.* 1534–8. See no. 142.

142 Kneeling figure

Windsor (Popham–Wilde 433)

Black and red chalk. 25·7 × 22·1 cm.

Lit.: Dussler 718

On the left-hand side of the sheet, partly cut away, is a lightly drawn composition sketch of a *Pietà* which Wilde connects with no. 141. The arrangement of the figures is in no way similar, but that they are in some way connected is shown by the principal study on the Windsor sheet, of a kneeling man whose pose is identical with that of the figure supporting the swooning Virgin on the extreme right of the other.

143 The Virgin and Child

Windsor (Popham–Wilde 435)

Black chalk, over a preliminary sketch in red chalk: the background was covered at some time with gold paint. 22·5 × 19·4 cm.

Lit.: Dussler 242; Tolnay, v, p. 215, no. 237; Hartt 439

Wilde pointed out that this group occurs, in an interior setting, in a painting believed to be by Marcello Venusti when in the collection of Richard Cosway, which is referred to, and illustrated by an outline engraving, in Richard Duppa's *Life of Michelangelo*, 1807, p. 331. Wilde dates the drawing *c.* 1545.

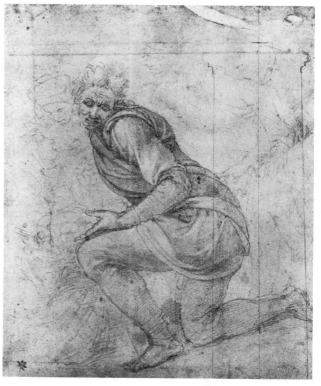

142 Kneeling figure

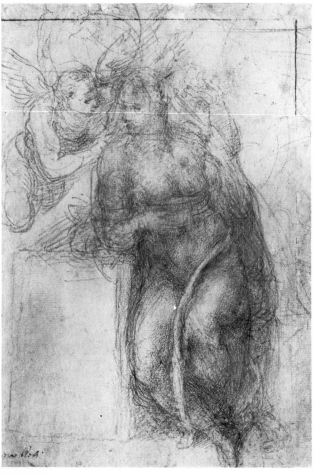

144 The Annunciation

144 The Annunciation

British Museum (Wilde 72)

Black chalk. 28·3 × 19·6 cm.

Lit.: Dussler 176; Tolnay, v, p. 207, no. 221;
A. Perrig, *Wallraf-Richartz-Jahrbuch*, xxiv
(1962), pp. 279 ff.; Hartt 436

This drawing and no. 145 were originally on the
same sheet. On the *verso* is a study of an angel
which forms the right-hand part of the same
drawing as the *Virgin Annunciate* on no. 145.
Wilde connected them with the two altarpieces
of the *Annunciation* by Marcello Venusti, one
painted for the Cesi Chapel in S. Maria della
Pace and the other for S. Giovanni in Laterano,
for both of which, according to Vasari, Michel-
angelo was persuaded by Tommaso de' Cavalieri
to provide designs. There is no point of exact
resemblance between either of the drawings and
either the Cesi altarpiece (now Galleria
Nazionale; Tolnay, v, fig. 313) or the other (S.
Giovanni in Laterano; Tolnay, v, fig. 314) but
the suggestion is a plausible one and has been
generally accepted.

Wilde's dating of 1545–7 for the Cesi altar-
piece, arrived at on external grounds, fits well
with the style of the two drawings.

145 Virgin Annunciate

British Museum (Wilde 71)

Black chalk. 34·8 × 22·4 cm.

Lit.: Dussler 179; Tolnay, v, p. 206, no. 220;
Hartt 431

See no. 144.

144 *verso* Angel of the Annunciation

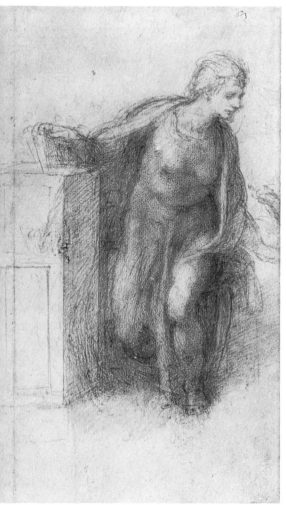

145 Virgin Annunciate

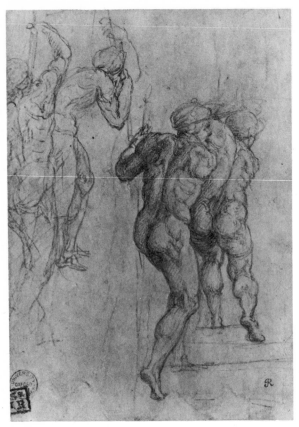

147 Studies of two figures

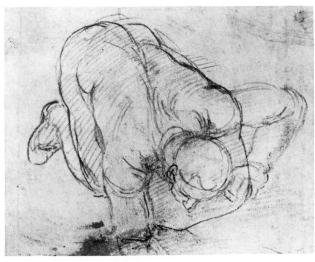

148 A kneeling man

146 Studies of arms and legs

Ashmolean Museum (Parker 329)

Black chalk. 24 × 14.5 cm.

Lit.: Dussler 629; Tolnay, v, p. 198, no. 204; Hartt 382

These studies cannot be connected with any known work. Parker dates them in the later 1530s; Wilde *c.* 1545–50.

147 Variant studies of two figures seen from the back

Ashmolean Museum (Parker 331)

Black chalk. 15 × 10.6 cm.

Lit.: Dussler 631; Hartt 400

Generally, and probably rightly, considered to be studies for the group of soldiers ascending the steps in the lower left-hand corner of the *Crucifixion of St Peter* in the Cappella Paolina in the Vatican.

148 A kneeling man

British Museum (Wilde 70)

Black chalk. 14 × 18 cm.

Lit.: Dussler 572; Tolnay, v, p. 191, no. 189; Hartt 405

The darker chalk outline indicates a change of mind on the part of the draughtsman. The second position corresponds very closely in reverse with that of the kneeling figure scooping out the hole for the Cross in the *Crucifixion of St Peter* in the Cappella Paolina in the Vatican, for which Wilde, very reasonably, considers the drawing a study.

149 Design for a window

Ashmolean Museum (Parker 333)

Black chalk and wash. 42 × 27·8 cm.

Lit.: Dussler 634; Portoghesi–Zevi, p. 621; J. Ackerman, *The Architecture of Michelangelo*, 1961, ii, p. 77; Hartt 495

For the windows in the upper storey of the courtyard of the Palazzo Farnese in Rome, which Michelangelo designed in 1547–9. There are many differences in detail from the windows as finally executed. Ackerman claims that this may be the only surviving drawing by Michelangelo himself that can be definitely connected with the palace.

150 Design for a window

Ashmolean Museum (Parker 332)

Black chalk and wash. 41·1 × 25·6 cm.

Lit.: Dussler 633; Hartt 494

While this drawing must date from about the same period as no. 149, it is not necessarily connected with the Palazzo Farnese, as has often been suggested.

151 Nude man in violent motion

British Museum (Wilde 73)

Black chalk. 10·2 × 6 cm.

Lit.: Dussler 321; Tolnay, p. 208, no. 223; A. Perrig, *Wallraf-Richartz-Jahrbuch*, xxiv (1962), pp. 285 ff.; Hartt 434

The arms were first drawn in a lower position, with the right arm extended and the left arm held behind the figure and slightly bent. This drawing has been seen as a discarded sketch for an ascending figure in the *Last Judgement*; but Wilde argued that the style of drawing suggests rather a dating in the second half of the 1540s. He pointed out that the figure is represented as running forward, and that it resembles, in the first lightly sketched position, the angel in the *Annunciation* in S. Giovanni in Laterano (see no. 144).

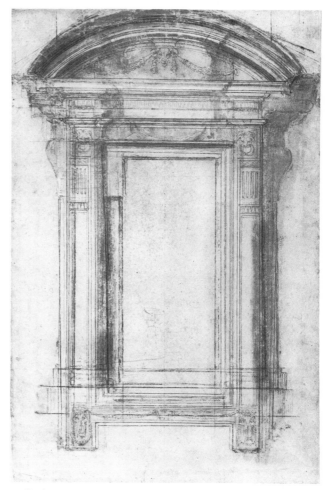

149 Design for a window

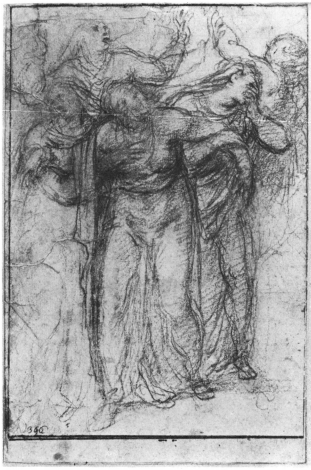

152 The holy women at the Cross

152 The Holy Women at the foot of the Cross

British Museum (Wilde 69)

Black chalk. 21·1 × 14·2 cm.

Lit.: Dussler 320; Hartt 451

This cannot be definitely connected with any known work. Wilde, who dates it *c.* 1542–50, suggests that it might possibly be a later variant of a group in a composition of the *Descent from the Cross* in Haarlem closely connected with the *Crucifixion* (no. 87) and dating from the same period.

153 'Epifania'

British Museum (Wilde 75)

Black chalk. 232·7 × 165·6 cm.

Lit.: Dussler 178; Tolnay, v, p. 213, no. 236; Hartt 440

Made for Michelangelo's friend and biographer Ascanio Condivi, whose painting after it is in the Casa Buonarroti (Tolnay, v, fig. 333). The cartoon was given the title '*Epifania*' in Michelangelo's posthumous inventory. Its subject is obscure. Professor Gombrich (who will discuss the question more fully elsewhere) suggests that it represents the Virgin and St Joseph with the brothers and sisters of Christ, whose existence is referred to in the Gospels; and that the traditional title alludes to the fourth-century theologian St Epiphanias, who held that these were the children not of the Virgin but of St Joseph by a previous marriage, and that the Virgin's marriage to him was never consummated. This would explain her gesture in the cartoon, where she seems to be pushing him away.

154 Draped male figure

Ashmolean Museum (Parker 334)

Black chalk. 20 × 11·9 cm.

Lit.: Dussler 347; Tolnay, v, p. 205, no. 217; Hartt 506

See no. 157.

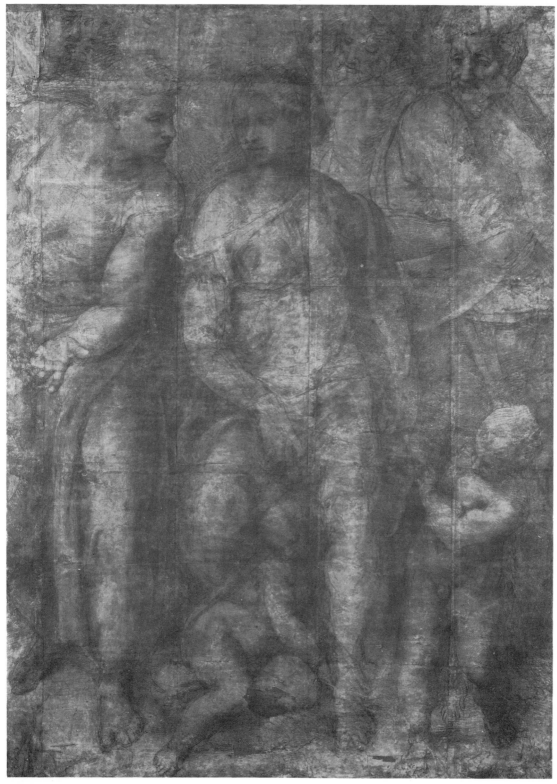

153 'Epifania'

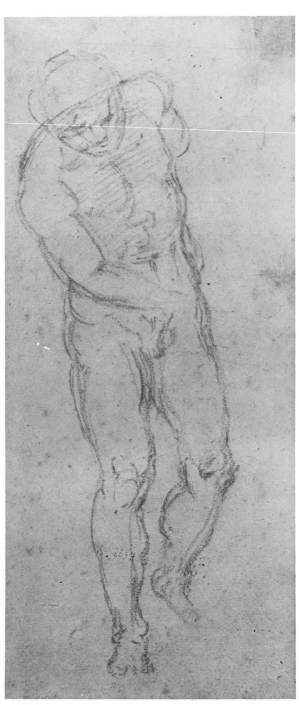

156 Male nude

155 Sketch of a male nude

Ashmolean Museum (Parker 335)

Black chalk. 18·1 × 8·7 cm.

Lit.: Dussler 348; Tolnay, v, p. 205, no. 218; Hartt 508

See no. 157.

156 Male nude

Gathorne-Hardy Collection

Black chalk. 23 × 10 cm.

Lit.: Dussler 338; Tolnay, v, p. 106, no. 219; Hartt 509

See no. 157.

157 Sketches of two male nudes

Ashmolean Museum (Parker 336)

Black chalk. 20·1 × 11·9 cm.

Lit.: Dussler 349; Tolnay, v, p. 205, no. 216; Hartt 507

It has been suggested that this drawing and nos. 154, 155 and 156 are studies for the figure on the extreme right of the *Epifania* cartoon (no. 153). The resemblance is not sufficiently close to make this definite, but the drawings are certainly of the same period.

158 Studies for a Pietà and for a group of the Dead Christ supported by two men

Ashmolean Museum (Parker 339)

Black chalk. 10·8 × 28·1 cm.

Lit.: Dussler 201; Tolnay, v, p. 219, no. 246; Hartt 459

Robinson was the first to recognize that the *Pietà* studies are for the Rondanini *Pietà*, now in Milan, generally agreed to be a late work begun probably after 1552 and altered extensively by Michelangelo himself in the 1560s. The other studies on the sheet, of the Dead Christ with his feet raised from the ground supported by two disciples, are presumably also for a sculptural group, and might have been the germ of the *Pietà*.

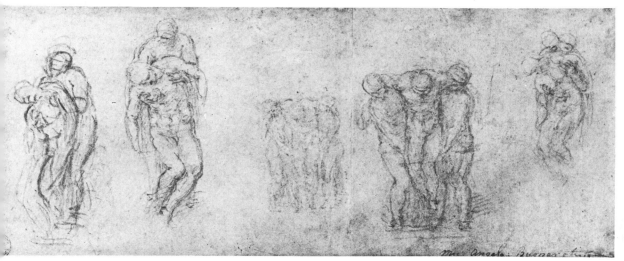

158 Studies for a Pieta

159 The Descent from the Cross

Ashmolean Museum (Parker 342)

Red chalk. 37·5 × 28·1 cm.

Lit.: Dussler 616; Tolnay, v, p. 217, no. 242; Hartt 456

Parker points out that the drawing has been reworked by another hand, using a chalk of a more crimson shade. Though the drawing is difficult to judge in its present state, Wilde was surely correct in rejecting the attribution to Sebastiano del Piombo proposed by Berenson, in favour of the traditional one to Michelangelo. Parker agrees with him that this must be a late work, though perhaps somewhat earlier than his suggested dating *c*. 1555.

The purpose of the drawing is not known, unless it is a study for the large unfinished cartoon of a *Pietà with nine figures* listed in the posthumous inventory of Michelangelo's effects.

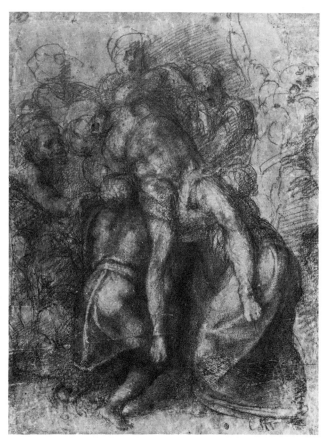

159 The Descent from the Cross

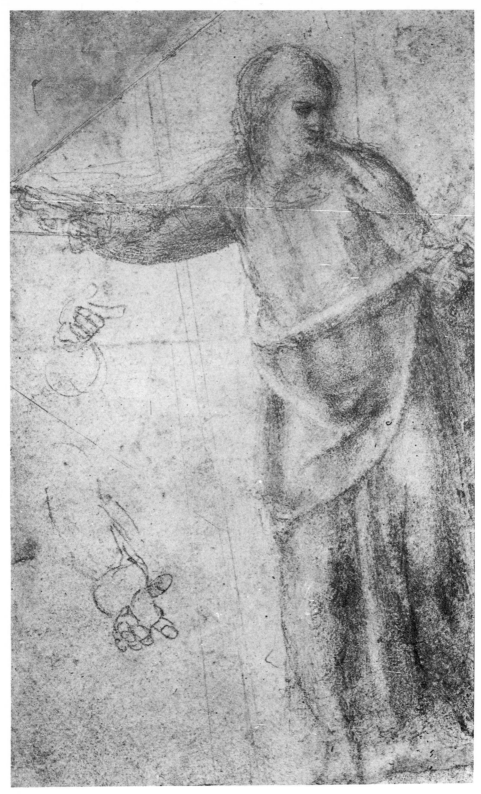

160 Standing figure of Christ

160 Standing figure of Christ

Fitzwilliam Museum

Black chalk. 27 × 16 cm.

Lit.: Dussler 3; Tolnay, v, p. 208, no. 224; Hartt 462

The style suggests a date not earlier than *c.* 1550. This has been generally supposed to be a study for one of the figures in a composition of *Christ taking leave of his Mother*, a cartoon which is recorded in Michelangelo's posthumous inventory. But since the cartoon is lost and there is no record of the composition, this hypothesis is unverifiable.

161 Head of a young man

Ashmolean Museum (Parker 337)

Black chalk. 23·1 × 20·1 cm.

Lit.: Dussler 351; Hartt 397

On the *verso* is a sketch of a capital decorated with a grotesque mask, which is generally considered to be of the period of the Medici Chapel; but the style and technique of the drawing of a head point to a much later date, perhaps even after 1550 as Wilde suggested. In its youthful type and with its pensive downward gaze this could be the head of a St John in a *Crucifixion* or *Lamentation*, as Parker remarks. There is also a close resemblance, in reverse, to the head of St Dysmas, the Penitent Thief, in the group of martyrs below and to the right of Christ in the *Last Judgement* (Goldscheider, *Michelangelo: Paintings, Sculpture, Architecture*, 1953, pl. 185).

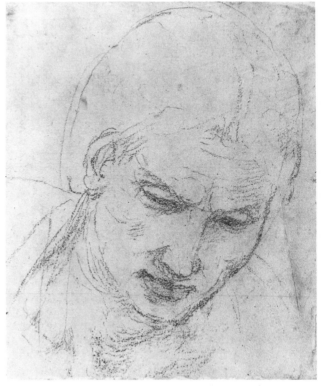

161 Head of a young man

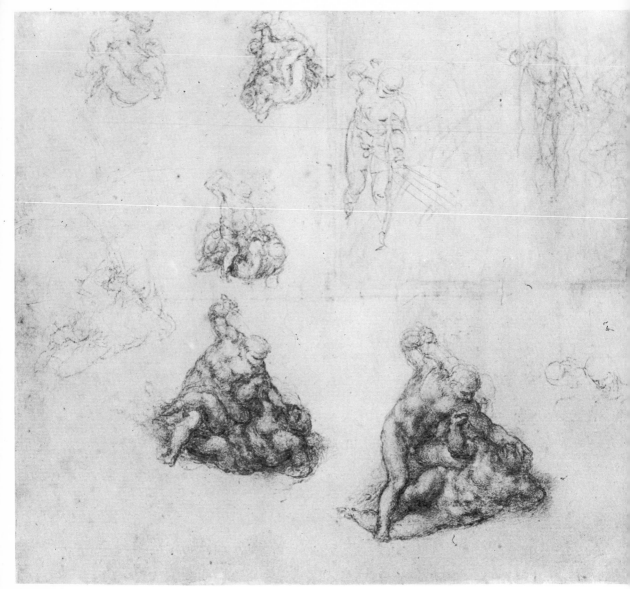

164 Studies of a group of two fighting men

162 Male nude standing

British Museum (Wilde 74)

Black chalk. 17 × 5·5 cm.

Lit.: Dussler 331; Tolnay, v, p. 204, no. 214; Hartt 510

The abbreviation of form in this summary sketch is characteristic of Michelangelo's late style of draughtsmanship, after 1550.

163 A right arm

British Museum (Wilde 80)

Black chalk. 11·3 × 15·6 cm.

Lit.: Dussler 303; Tolnay, v, p. 199, no. 206; Hartt 479

Dated by Wilde *c.* 1556–60.

164 Studies of a group of two fighting men

Ashmolean Museum (Parker 328)

Black chalk. 20·9 × 24·5 cm.

Lit.: Dussler 200; Tolnay, v, p. 201, no. 211;
Hartt 473

The two fighting men are generally identified
as Samson and a Philistine, but the weapon held
by the standing figure is not clearly distinguish-
able as a jaw-bone. Indeed, in the lower right
study it appears to be a club. The purpose of these
sketches is unknown, but from their style they
probably date from *c.* 1550–5. The group in its
final form on the sheet (lower right) could have
been developed *pari passu* with one of the studies
for the group of *David and Goliath* (Pierpont
Morgan Library; Tolnay, v, fig. 182) in which
the two figures are similarly conceived as a solid
pyramidal mass.

On the insertion in the top right corner of the
sheet are two sketches for the figure of Christ
in the composition of *Christ expelling the money-
changers* (see no. 167).

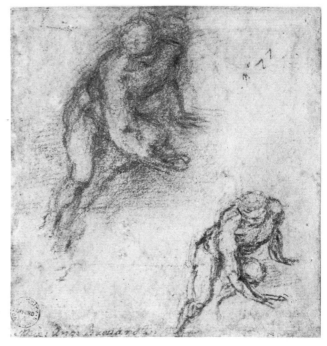

165 St John the Baptist

165 St John the Baptist in the desert

Ashmolean Museum (Parker 338)

Black chalk. 11·5 × 11 cm.

Lit.: Dussler 203; Hartt 469

The pose of the figure is close to that of the
Baptist in the Desert in a lost painting by Daniele
da Volterra known from a copy at Munich
(Tolnay, v, fig. 190), and it has been reasonably
supposed that the drawing was made by Michel-
angelo in this connexion. Vasari mentions what
is presumably this painting among those com-
missioned from Daniele by Giovanni della Casa,
possibly in 1555–6 (see no. 166).

This late dating provides a further argument
against the suggestion that this study is for the
angel below and to the left of St Lawrence in
the *Last Judgement*. Not only is there no point
of exact correspondence, but the action of the
two figures is different, since one is sitting and
the other standing.

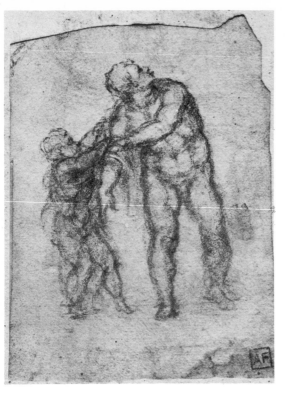

166 A nude man and a boy

166 A nude man and a boy

Count Antoine Seilern

Black chalk. 9·9 × 7·4 cm.

Lit.: Dussler 334; Tolnay, v, p. 201, no. 210; Hartt 475

A study, made to help Daniele da Volterra, of the Group of Aeneas and his attendant in a painting of *Mercury urging Aeneas to leave the couch of Dido*, which according to Vasari was commissioned from Daniele by Monsignor Giovanni della Casa. Such evidence as there is suggests that Daniele received this commission between June 1555, when Della Casa returned to Rome after a long absence, and November 1556, when he died.

A version of the painting was in a private collection in Sweden in 1922 (repr. *Kunstchronik*, N.F. xxxiv (1922–3), p. 376). Another drawing by Michelangelo for the same group is in Haarlem (B.B. 1470 *verso*). There are also several rough sketches for it by Daniele (one in the British Museum: 1956–10–13–13) and a highly finished black chalk study in the Albertina (497; S.R. 590).

167 Christ expelling the money-changers

167 Christ expelling the money-changers

British Museum (Wilde 78)

Black chalk. 17·8 × 37·2 cm.

Lit.: Dussler 167; Tolnay, v, p. 212, no. 235;
Hartt 447

The group of figures for which this drawing and
nos. 168, 169 and the fragment inserted into
no. 164 are studies appears, clothed and in an
architectural setting, in a small painting in the
National Gallery attributed to Marcello Venusti.
The group in its block-like cohesion seems
incongruous in its spacious setting in the paint-
ing, which may not necessarily have been the
end-product of the series of studies. Wilde dates
them *c.* 1555–60.

Tolnay's observation, that the curved shape
of the upper part of the group suggests a design
for a shallow lunette, is certainly true of the
group in the painting and in no. 167, which
corresponds exactly with it; but it should be
noted that in the sketch for the same composition
on no. 168 *verso* the group is set against an
architectural background, more in scale with it
than the one in the painting, and consisting of
a pair of arched openings.

168 Christ expelling the money-changers

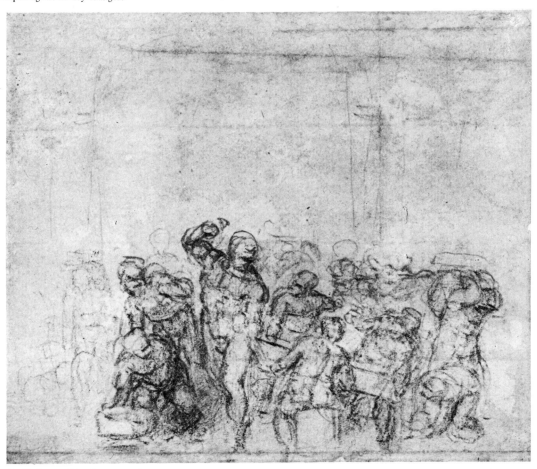

169 Christ expelling the money-changers

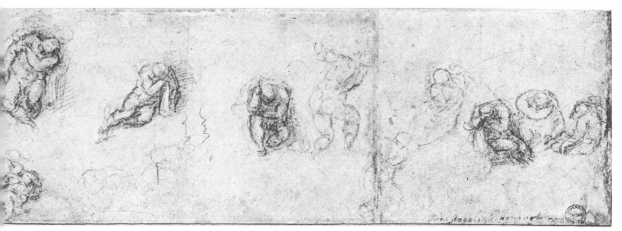

170 Studies of sleeping figures

168 Christ expelling the money-changers

British Museum (Wilde 76)

Black chalk. 14·8 × 27·6 cm.

Lit.: Dussler 166; Tolnay, v, p. 211, no. 231; Hartt 446

See no. 167.

169 Christ expelling the money-changers

British Museum (Wilde 77)

Black chalk. 13·9 × 16·7 cm.

Lit.: Dussler 165; Tolnay, v, p. 211, no. 233; Hartt 445

See no. 167.

170 Studies of sleeping figures

Ashmolean Museum (Parker 340)

Black chalk. 10·6 × 32·5 cm.

Lit.: Dussler 202; Tolnay, v, p. 209, no. 227; A. Perrig, *Wallraf-Richartz-Jahrbuch*, xxiv (1962), p. 291; Hartt 448

The studies on this sheet and on no. 171 are presumably for sleeping apostles in a composition of the *Agony in the Garden* which was carried out as a small painting by Marcello Venusti. Many versions exist, the best being that in the Doria Gallery in Rome (Tolnay, v, fig. 323). Wilde dates these studies 1555–60 on external evidence.

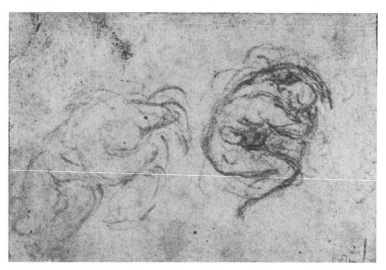

171 Studies of a sleeping figure

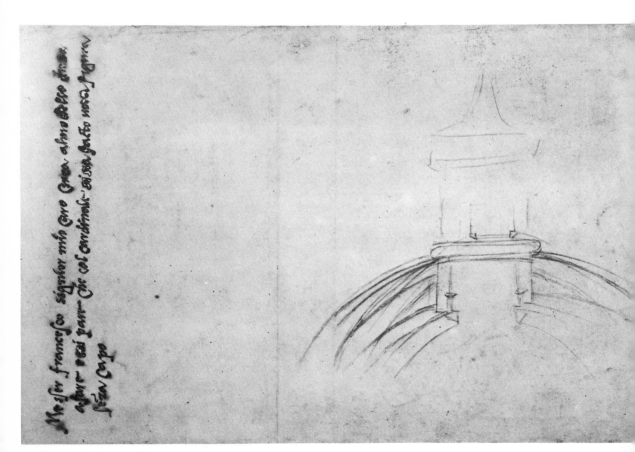

172 Study for the lantern of St Peter's

171 Two studies of a sleeping figure

British Museum (Wilde 79)

Black chalk. 6·6 × 10·1 cm.

Lit.: Dussler 322; Tolnay, v, p. 210, no. 228; A. Perrig, *Wallraf-Richartz-Jahrbuch*, xxiv (1962), p. 291; Hartt 449

See no. 170.

172 Study for the lantern of St Peter's

Ashmolean Museum (Parker 344)

Black chalk. 39·4 × 24·2 cm.

Lit.: Dussler 207; Portoghesi–Zevi, p. 514; J. Ackerman, *The Architecture of Michelangelo*, 1961, ii, pp. 109 f.; R. Wittkower, *La cupola di San Pietro di Michelangelo*, Florence, 1964, p. 46 (previously printed in *Arte antica e moderna*, v (1962), pp. 390 ff.); Hartt 501

The inscription, in Michelangelo's hand, is the beginning of a draft of a letter referring to the construction of the model of the dome, which was made in 1558–61. The divergent strokes indicating the curve of the dome show him even at this late date hesitating between his two fundamental solutions: a low hemispherical dome and a higher, more steeply curved one modelled on Brunelleschi's in Florence. As he does in the drawing, he chose the hemispherical solution (shown in its final form in the elevation and section engraved by Duperac), in which the lower height of the dome itself was to be compensated for by a larger lantern, as indicated in this drawing. The dome was completed after his death by Giacomo della Porta, who reverted to the earlier, Brunelleschian, design with some modifications.

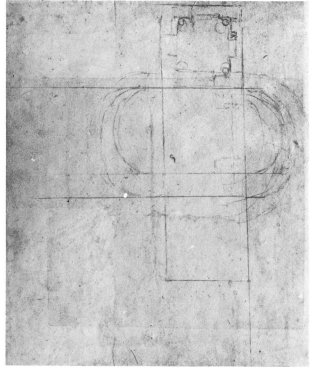

173 Ground plan of a chapel

173 Ground plan of a chapel

British Museum (Wilde 84)

Black chalk. 24·1 × 21 cm.

Lit.: Dussler 181; Portoghesi–Zevi, p. 695; J. Ackerman, *The Architecture of Michelangelo*, 1961, ii, p. 123

Ackerman accepts Wilde's suggestion that this is an early sketch from the Sforza Chapel in S. Maria Maggiore, designed by Michelangelo in his last years and completed after his death. In the drawing the side-arms are semi-circular in plan, whereas in the chapel as built they are reduced to shallow segmental recesses.

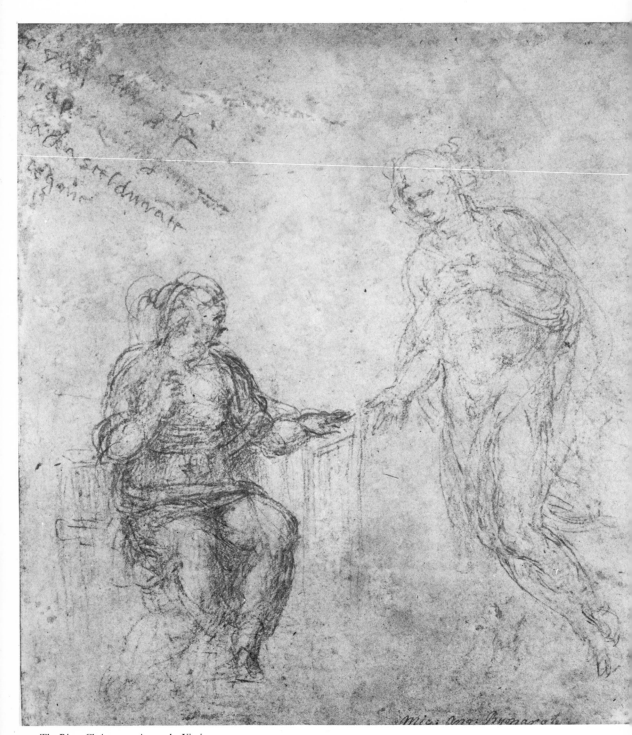

174 The Risen Christ appearing to the Virgin

174 The Risen Christ appearing to the Virgin

Ashmolean Museum (Parker 345)

Black chalk. 22 × 20 cm.

Lit.: Dussler 205; Tolnay, v, p. 228, no. 264; H. Pfeiffer, *Art Bulletin*, xlviii (1966), p. 227; Hartt 435

The subject has been generally interpreted as the Annunciation, but Pfeiffer has convincingly argued that it is, rather, the less usual one of the Risen Christ appearing to his Mother on the morning of the Resurrection. He points out that the Virgin is represented as a mature woman, not a young girl, and that she is pointing towards the other figure's right hand in which the nail-hole appears to be indicated. This gesture would be meaningless in an *Annunciation*. He could also have added, in further support of his contention, that the right-hand figure is clearly a man, naked but for a loose garment thrown round the shoulders.

The style is that of Michelangelo's last drawings. The words *Pasquino* and *Chastel-durante* in the inscription refer to the correspondence between Michelangelo and the widow of his servant Urbino, who had settled in Casteldurante after her husband's death at the end of 1555 and to whom Michelangelo sent messages by the muleteer Pasquino. The messages ceased in 1561.

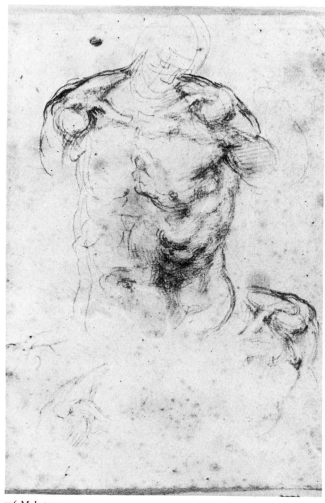

176 Male torso

175 Studies of a man's chest and shoulders and of his left knee

Ashmolean Museum (Parker 341)

Black chalk. 25·7 × 16 cm.

Lit.: Dussler 189; Tolnay, v, p. 226, no. 261; Hartt 401

In the position of both arms, so far as they go, this drawing resembles the marble *David* of 1501–4, for which Robinson believed it to be a study. But, as Wilde pointed out, the style excludes an early dating. He considered the drawing to be very late, *c.* 1555–60.

176 Male torso

Gathorne-Hardy Collection

Black chalk. 24 × 17·5 cm.

Lit.: Dussler 337; Hartt 477

A very late drawing, dated by Wilde *c.* 1560.

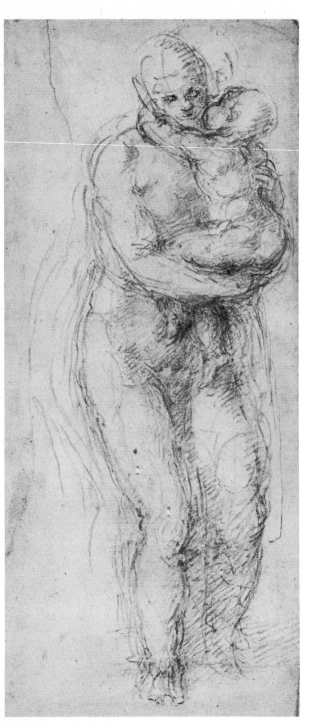

177 The Virgin and Child

177 The Virgin and Child

British Museum (Wilde 83)

Black chalk. 26·6 × 11·7 cm.

Lit.: Dussler 161; Hartt 441

A very late drawing, datable *c.* 1560. The Virgin's figure is closely related to that in no. 178; in both the final form is achieved by a process of narrowing down.

The strokes of chalk made by the old artist's shaking hand produce an incomparable effect of form, rhythm and colour.

178 Christ on the Cross between the Virgin and St John

Windsor (Popham–Wilde 437)

Black chalk. 40·5 × 21·8 cm.

Lit.: Dussler 236; Tolnay, v, p. 223, no. 252; Hartt 425

See no. 183.

In making the drawing Michelangelo shifted the paper so that the Cross now seems not quite vertical. The longer sides of the sheet were later trimmed and made parallel to the first position of the Cross.

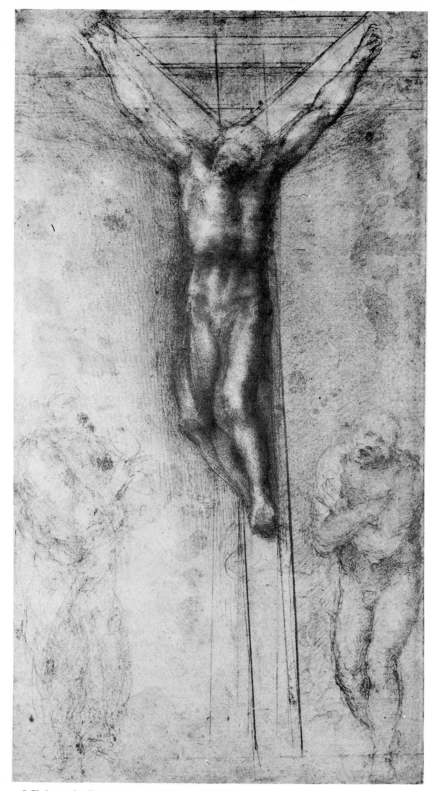

178 Christ on the Cross between the Virgin and St John

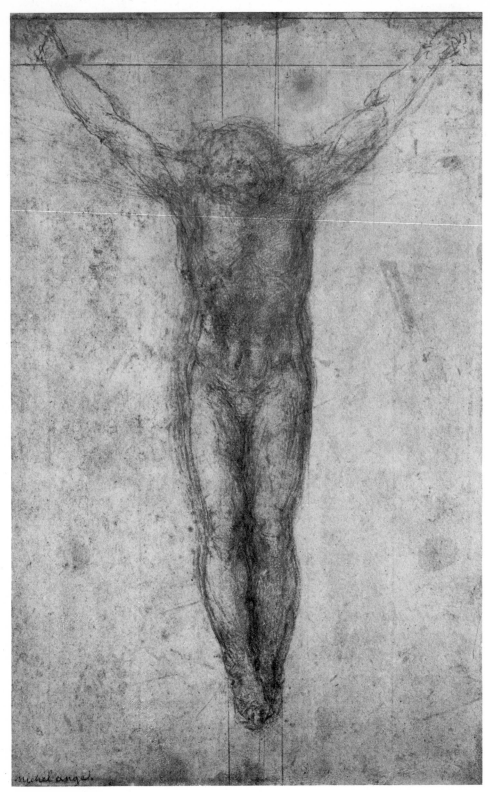

179 Christ on the Cross

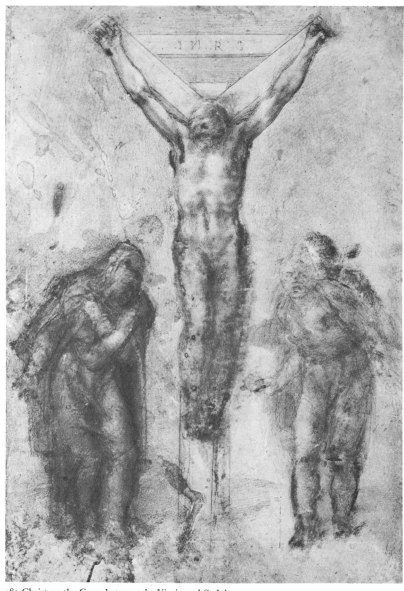

180 Christ on the Cross between the Virgin and St John

179 Christ on the Cross

Count Antoine Seilern

Black chalk. 27·5 × 23·4 cm.

Lit.: Dussler 185; Tolnay, v, p. 225, no. 257; Hartt 430

See no. 183. This may be a study for no. 180 in which the figure of Christ is in an identical pose.

180 Christ on the Cross between the Virgin and St John

British Museum (Wilde 81)

Black chalk (with white paint used for corrections). 41·3 × 28·6 cm.

Lit.: Dussler 174; Tolnay, v, p. 222, no. 25; Hartt 424

See no. 183.

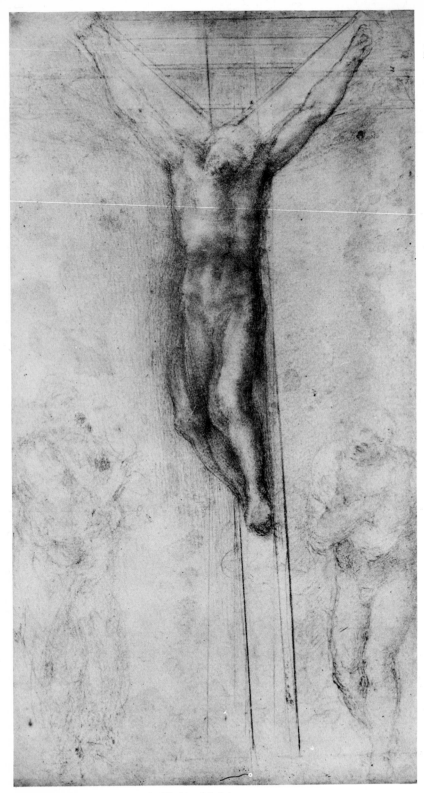

181 Christ on the Cross between the Virgin and St John

181 Christ on the Cross between the Virgin and St John

Windsor (Popham–Wilde 436)

Black chalk. 38·2 × 21 cm.

Lit.: Dussler 243; Tolnay, v, p. 222, no. 250; Hartt 423

See no. 183.

182 Christ on the Cross between the Virgin and St John

Ashmolean Museum (Parker 343)

Black chalk. 27·5 × 23·4 cm.

Lit.: Dussler 204; Tolnay, v, p. 223, no. 254; Hartt 426

See no. 183.

183 Christ on the Cross between the Virgin and St John

British Museum (Wilde 82)

Black chalk (with white paint used for corrections). 41·2 × 27·9 cm.

Lit.: Dussler 175; Tolnay, v, p. 224, no. 256; Hartt 429

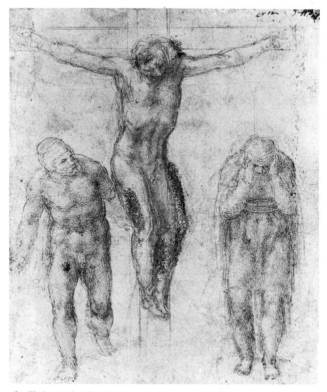

182 Christ on the Cross between the Virgin and St John

This drawing and nos. 178 to 182 clearly form a series, of which no. 183 is probably the last. Their purpose is unknown. It is possible, as Wilde suggests, that they were in the nature of 'presentation drawings'. Tolnay pointed out that Michelangelo held no. 178 up to the light and drew on the *verso* a roughly triangular outline circumscribing the figure of Christ on the other side. This he interprets, with good reason, as a diagram of a marble block; and he concludes that the drawings must have been made as studies for a projected sculptural group of the Crucifixion which was never executed. (Only part of the *verso* of no. 178, with a sketch of a left leg, is reproduced in the Windsor catalogue: for the entire *verso* see Tolnay, v, fig. 228.)

These drawings reveal the almost obsessive mystical devotion of Michelangelo at the end of his life. The graphic style of the Crucifixion series is characterized by frequent corrections and repetitions of outline so that the forms become more and more simplified. In the case of nos. 180 and 183 Michelangelo has used white paint to conceal these corrections and in conjunction with black chalk a richness of grey tone is produced not present in the earlier black chalk drawings of the 1530s and 1540s. It is these subtle gradations which reinforce the sculptural quality of the drawing.

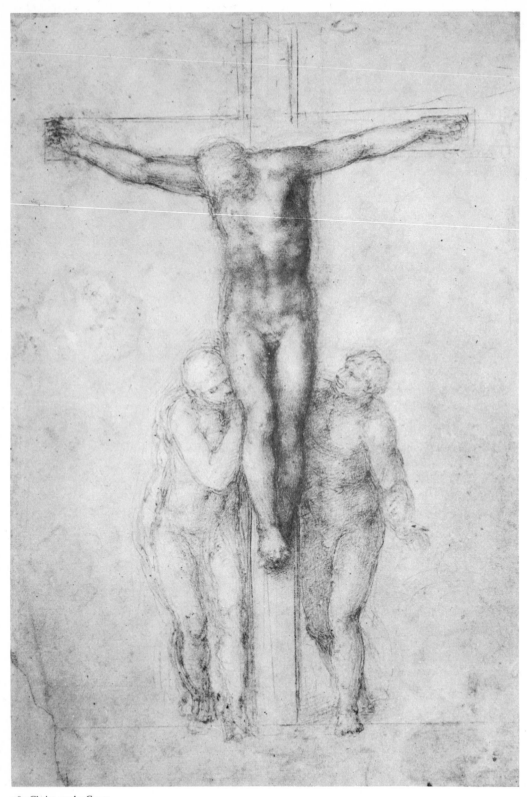

183 Christ on the Cross

184 Jan 31, 1506. Letter of Michelangelo in Rome to his father Lodovico in Florence. (The earliest of Michelangelo's letters in the British Museum.) Writes about the purchase of an estate. Complains that he has not been able to begin work on the tomb of Julius II because of difficulties in transporting the marble: '. . . all would be well if my marbles were to come, but as far as this goes I seem to be most unfortunate, for since I arrived here there have not been two days of fine weather. A barge which had the greatest luck not to come to grief owing to the bad weather, managed to put in with some of them a few days ago; and then, when I unloaded them, the river suddenly overflowed its banks and submerged them, so as yet I haven't been able to begin anything; however, I am making promises to the Pope and keeping him in a state of agreeable expectation so that he may not be angry with me . . .' Michelangelo also asks for his drawings to be sent to him from Florence: '. . . Please will you take all those drawings . . . and make a small parcel of them and send it to me by carrier . . .' Requests that a marble, possibly the *Bruges Madonna* which was transported to Flanders in August of 1506, be carefully stored: '. . . that marble of Our Lady; I want you to have it moved into the house . . . and not to let anyone see it.'

Printed: Milanesi, *Lettere di Michelangelo*, 1875, pp. 6 f., No. III; Ramsden, I, pp. 11 f. No. 6; Barrochi, *Il Carteggio di Michelangelo*, I, 1965, pp. 11 f, No. VII

Dept. of MSS. (Add 23140, f. 2)

185 May 10, 1508. *Ricordo* of the receipt of the first payment for the Sistine Ceiling and of beginning work on this commission: '. . . I Michelangelo, sculptor, have received 500 ducats from His Holiness Julius II . . . on account, for the painting of the ceiling of the chapel of Pope Sixtus, on which I begin work today following the conditions and agreements which appear in a contract made by the most Reverend Monsignor of Pavia [Cardinal Francesco Alidosi, Bishop of Pavia] . . .'

Printed: Maurenbrecher, *Aufzeichnungen des Michelangelo*, 1938, p. 5, repr. pl. I; Barocchi, *Ricordi*, pp. 1 f., No. II

Dept. of MSS. (Add. 23208, f. 4)

186 [October 1512]. Letter of Michelangelo in Rome to his father in Florence. Gives the news that he has finished the frescoes on the Sistine Ceiling and that the Pope is very much satisfied. 'Other things' which have not been going so well probably signify his work on the tomb of Julius II: '. . . I have finished the chapel I have been painting; the Pope is very well satisfied. But other things have not turned out for me as I'd hoped. For this I blame the times, which are very unfavourable to our art . . .'

Printed: Milanesi, *op. cit.*, p. 23, No. XV; Ramsden, I, pp. 75 f., No. 83; Barocchi, *Carteggio*, I. p. 138, No. CV

Dept. of MSS. (Add. 23140, f. 37)

187 [July 1516]. Michelangelo's description of the design stipulated in the third contract for the Julius monument which was concluded July 8, 1516. The form of the tomb is described as follows: 'The front face of the design is about 11 Florentine braccia wide. Within this breadth there is a base at ground level with four plinths or cubes and their moulding binding it right round. On these there are four marble figures in the round, each of them $3\frac{1}{2}$ braccia high . . .' There are said to be twelve figures and one history in the lower zone below the first cornice. Above: '. . . there are more decorated bases; and on these are half columns going up as far as the last cornice . . . On one side, between the two columns, there is an opening in which a sitting figure goes, $3\frac{1}{2}$ Florentine braccia high as it sits . . .' An opening, 'a small tribune', contains: '. . . the figure of the deceased, that is of the Pope Julius . . . with two more figures on each side of

him; and above these there is a marble Madonna, 4 braccia high . . .'

Printed: Maurenbrecher, *op. cit.*, pp. 6 ff., repr. pl. 3; Pope-Hennessey, *Italian High Renaissance and Baroque Sculpture*, catalogue, 1963, pp. 18 f. (from Milanesi, *op. cit.*, pp. 644–51)

Dept. of MSS. (Add. 23208, f. 6)

188 October 26, 1521. *Ricordo* of a payment of seven crowns into the bank of Giovanni de' Servi. A further money transaction is recorded: seven gold ducats being given by Giovanni de' Servi '. . . to the said Leonardo [Leonardo Sellaio] so that he should send four to Federigo called Frizzi, Florentine sculptor in Rome, on account of a marble figure of Christ which he had finished for me in Rome for Messer Metello Vari, and erected in the Minerva'. The *Risen Christ* of S. Maria sopra Minerva was commissioned in 1514 by Metello Vari. Almost complete, it was sent from Florence to Rome in 1520 in the care of Pietro Urbano, who was to supervise its final execution and erection. Urbano's failure to carry out this work caused him to be replaced by the sculptor Federigo Frizzi who is referred to in this document.

See no. 32.

Printed: Barocchi, *Ricordi*, pp. 108 f., No. CVIII

English private collection

189 [About Dec. 25/27, 1523]. Draft of a letter of Michelangelo in Florence to be sent to Giovan Francesco Fattucci in Rome, a complete account of the work undertaken by the artist for Julius II between 1505 and 1513. His friend Canon Fattucci was at this time negotiating a settlement between Michelangelo and the Pope's heirs. Michelangelo explains how, soon after entering the Pope's service, he contracted to make the tomb of Julius II for the sum of 10,000 ducats. He says how the Pope grew tired of the project: '. . . at the end of eight or nine months the Pope changed his mind and did not want to go on with

it [the tomb], and when I complained to him, because I found myself involved in heavy expenses, His Holiness, not wishing to pay for the said work, got tired of it and had me turned away from the audience chamber. I immediately left Rome in a rage and all the preparations I had made for a work on this scale were upset . . .' Explains how he went into hiding: '. . . After about seven or eight months which I spent practically in hiding through fear, for the Pope was furious with me, I was forced, not being able to remain in Florence, to go and sue to him for mercy at Bologna . . . he kept me for about two years to execute his statue in bronze, which was six braccia in height . . .' Even after he returned to Rome, Michelangelo states that he was not allowed to continue with the Julius tomb but was asked to paint the ceiling of the Sistine chapel, for which he was inadequately paid: '. . . when I had done some designs [for the ceiling] it seemed to me that it would turn out a poor affair: Thereupon he gave me a fresh commission down to the Histories below and said that I should do what I liked in the vault, which amounted to about as much again. And thus we were agreed. Then when the vault was finished and it came to the emolument, it was not increased, so that I reckon I am owed several hundreds of ducats . . .'

Printed: Maurenbrecher, *op. cit.*, pp. 68 f., repr. pl. 8., Ramsden, I, pp. 191 f., Draft 2; Barocchi, *Carteggio*, II. pp. 10 f., No. DXCV

Dept. of MSS. (Add. 23208, f. 1)

190 [Oct. 18, 1524]. Draft of a letter referring to an allowance of 50 ducats a month to be made to Michelangelo by Pope Clement VII and his use of a house in Florence, while he was at work on the Medici tombs. The first part of the letter is lacking and the lines of the second part have been shortened at both ends because of the trimming of the sheet. The *recto* shows a drawing of two men wrestling, by a weak hand which Wilde identified as that of Antonio Mini.

Printed: Barocchi, *Carteggio*, III, p. 110, No. DCLXVIII

Dept. of Prints and Drawings (Wilde 34 *verso*); Dussler 573

191 [Oct. 1524]. Draft of a letter on the same subject as no. 190, but written at a later stage of the transaction. A drawing by the same weak hand is on the *recto*.

Ashmolean Museum (Parker 378* *verso*); Dussler 623

192 Oct. 19 1524. Autograph copy of a receipt of allowances for work on the Medici tombs: 'I Michelagniolo of Ludovicho Simoni today, this day of the nineteenth of October one thousand fifteen hundred and twenty-four, have received from Giovanni Spina, four hundred gold ducats . . . according to the agreement reached with Pope Clement [for a payment] of fifty ducats a months for the figures of the tombs of the sacristy of S. Lorenzo and for any other thing that His Holiness wishes me to do . . .'

Printed: Milanesi, *op. cit.*, p. 596; Barocchi, *Ricordi*, pp. 158 f., No. CL

Dept. of MSS. (Add. 46473 E)

193 [About 1540?]. Draft of a poem. Michelangelo begins with an overture to his loved-one: 'Everything that I see counsels me, begs me and forces me to follow and love you so that whatever is not you is not good for me. Every wonder, every marvel of the universe seems to call me to you . . .' The poem ends on a more bitter note; Michelangelo asks the god of Love to help him fight off the impediments which prevent his union with his loved-one, for he believes this god is against him.

See Wilde, p. x, note.

Printed: Frey, *Dichtungen des Michelangelo*, 1897, pp. 402 f., Michelangiolo Buonarroti,

Rime, ed. E. Girardi, Bari 1960, p. 45, No. 81 and p. 251, No. III

Dept. of MSS. (Add. 21907)

194 July 18, 1561. Letter of Michelangelo in Rome to his nephew Lionardo in Florence. (The latest of Michelangelo's letters in the British Museum.) Conveys the artist's intention to spend about 300 ducats on alms in Florence: '. . . because I am an old man, as you know, I should like to do something in Florence for the welfare of my soul, that is to say, to give alms, since there is nothing else one can do that I know of. For this purpose I wish to have a certain number of *scudi* made payable in Florence, so that you can go and pay, or rather give in charity where there is most need. The said *scudi* will amount to about three hundred . . .'

Milanesi, *op. cit.*, p. 361, No. CCCXXX; Ramsden, II, p. 200 f., No. 468

Dept. of MSS. (Add. 13142, f. 83)

195 1563. *Ricordi* of salaries paid out by Michelangelo to his household servants from January 1 to October 1 in that year. (The latest of Michelangelo's autographs in the British Museum.) Three servants are mentioned, Antonio, Benedetta and Agatha: Antonio was paid two gold *scudi* a month; Benedetta and Agatha were paid only one.

Maurenbrecher, *op. cit.*, p. 258, repr. pl. 24; Barocchi, *Ricordi*, p. 325, No. CCLXXVIII

Dept. of MSS. (Add. 23209, f. 37)

196 Oct. 22, 1530. Letter of Duke Alfonso d'Este in Ferrara to Michelangelo in Florence. Introducing the agent who was to receive, and to transport to Ferrara, the picture of *Leda* which was executed by Michelangelo for the Duke in that year. The Duke flatters Michelangelo and then raises the question of payment: '. . . since it is already a long time that I have wanted to have an example of your work in my house, as I

have told you with my own mouth, it seems that every hour is a year until I can see this [painting of the *Leda*] . . . I am sending my servant called Pisanello and I beg you if you please to send it [the painting] to me through him, giving him advice and direction as to how he should carry his load. And don't be scandalized if through him I do not send you any payment now, because I have not even heard from you what you want for it nor do I myself know how to judge not having yet seen it, but I certainly promise you that you have not wasted that labour which you have endured for love of me; and you would be doing me a most welcome pleasure if you would write to me how much you would like me to send to you as I shall be much more certain of your judgement in valuing it than in mine . . .'

Printed: Steinmann–Wittkower, *Michelangelo–Bibliographie*, 1927, pp. 445 f., and pl. XI

Dept. of MSS. (Add. 23139, f. 4)

197 October 8, 1520. Letter of Count Alessandro da Canossa to Michelangelo. Invitation to the artist to come and see his relatives. The letter is addressed to '. . . My much loved and good kinsman ("parente") . . . Michelle Angelo Bonarroto from . . . [Cano]ssa most worthy sculptor of Rome . . .' The Count suggests that Michelangelo should come to meet his family ('casa') signing the letter '. . . Your good kinsman Alexander of Canossa, Count E. c.'

See no. 115.

Printed: A. Gotti, *Vita di Michelangelo*, Florence, 1871, i, p. 4. Michelangelo's descent from the Canossa family is discussed by Frey, *Michelagniolos Jugendjahre*, I, Berlin, 1907, p. 6

Dept. of MSS. (Egerton 1977, f. 8)

198 Vittoria Colonna. *Tutte le Rime della illustris. et eccellentiss. Signora Vittoria Colonna Marchesana di Pescara.* Venetia, 1558. Michelangelo's copy

with his autograph *Michlagniolo schultore* on p. 392 (shown).

Lit.: E. Steinmann, *Michelangelo im Spiegel seiner Zeit*, Leipzig, 1930, p. 100 pl. xix

Dept. of Printed Books

199 April 21, 1516. Letter of Cardinal Leonardo della Rovere in Rome to Michelangelo in Rome. The Cardinal, one of the executors of Julius II's will, conveys to the artist the wish of the Duchess of Urbino, one of the heirs of the Pope, to inspect the Julius monument then in course of execution in Michelangelo's workshop: '. . . because her Excellency Madame Duchess of Urbino greatly wishes to see your work on the tomb of the good memory of pope Julius: and as you know what is there . . . you will do me a most singular pleasure by showing the said illustrious Madame the said work. And we ask you not to let her leave Rome with the disappointment of not seeing this work of yours . . .' See Wilde, p. 45.

Printed and repr.: Steinmann–Wittkower, *op. cit.*, p. 440, pl. III

Dept. of MSS. (Egerton 1977, f. 5)

200 [About 1538–41]. Letter of Vittoria Colonna in Rome to Michelangelo in Rome. Acknowledgement of the drawing of *Christ on the Cross* here exhibited (no. 129): 'Unique master Michelangelo and my most singular friend. I have received yours [Michelangelo's letter] and have seen the crucifixion which has certainly crucified in my memory how many other paintings I have never seen. It is not possible to see an image better made, more alive and more finished and certainly I could never explain how subtly and marvellously wrought it is . . . I have looked at it carefully in the light, with the glass, and with the mirror and I have never seen a more finished thing.'

Printed and repr.: Steinmann–Wittkower, *op. cit.*, p. 447, pl. XIV

Dept. of MSS. (Add. 23139, f. 10)

201 March 14, 1560 [st. c.]. Letter of Benvenuto
Cellini in Florence to Michelangelo in Rome.
One of the numerous attempts at persuading
Michelangelo to return to Florence. The letter
is headed 'Most excellent and divine preceptor,
my Master Michelangelo . . .' Cellini's invitation
is most persuasive: '. . . you must come here and
settle down, as the whole of this city [Florence]
greatly desires this and even more does our most
glorious Duke who is such a great admirer of
your marvellous virtues and who is the most
benign and courteous *Signor* ever made . . .' He
further presses Michelangelo: '. . . to finish here
these happy years in your own country ('patria')
with so much pleasure and with so much of your
glory . . .'

Dept. of MSS. (Add. 23139, f. 12)

IX PORTRAIT RELIEF OF MICHELANGELO BY LEONE LEONI AND TWO EXAMPLES OF HIS MEDAL OF MICHELANGELO

202, 203 Two examples of a medal of Michelangelo by Leone Leoni (1509–90)

Obverse (Lead, no reverse). 59·5 mm. Bust of Michelangelo in profile to r., Inscr.: MICHAEL-ANGELVS. BONARROTVS. FLOR :[entinus]. AE[tatis]. s[uae]. ANN[o]. 88. Signed LEO.

Dept. of Coins and Medals (296).

Reverse (Silver). An old blind man led by a dog. Inscr.: DOCEBO. INIQVOS. V[ias]. T[uas]. ET. IMPII. AD. TE. CONVER[tentur]. Psalm li, 13. 'Then will I teach transgressors thy ways; and sinners shall be converted unto thee.'

Victoria and Albert Museum (4569–1857).

Lit.: E. Plon, *Leone Leoni et Pompeo Leoni*, Paris, 1887, p. 270; G. F. Hill, *Portrait medals of Italian artists of the Renaissance*, 1912, no. 40; E. Steinmann, *Die Portraitdarstellungen des Michelangelo*, 1913, pp. 51 f.

According to Vasari, the subject on the reverse was suggested by Michelangelo himself. The medal was completed by March 1561 (when Michelangelo would have been 86, not, as the inscription on the obverse claims, 88). See nos. 28–31 for the motif on the reverse, fifty years earlier, lightly sketched by Michelangelo in black chalk, and then transformed into one of the figures of the *Ancestors* (Antenati) in the lunettes of the Sistine chapel.

204 Portrait-relief in wax of Michelangelo

43 × 32 mm.

Lit.: E. Plon, *op. cit.*, pp. 270 f.; G. F. Hill, *op. cit.*, no. 40 f.; the same, *Burlington Magazine*, XV (1909), p. 31; El Steinmann, *op. cit.*, p. 51

Incr. on reverse: *Ritratto di Michelangiolo Buonaroti fatto dal Naturale da Leone Aretino suo Amico.*

The attribution of this relief to Leoni is confirmed by its resemblance to the head on his signed medal (no. 203), for which it has been supposed to be a study. It is more likely, however, to have been executed independently as a portrait-medallion.

Dept. of British and Medieval Antiquities

CONCORDANCES

Popham-Wilde (Windsor)	London Exhibition 1975
421	101
422	98
423	120
424	127
425	64
426	117
427	46
428	44
429	123
430	126
431	122
432	136
433	142
434	130
435	143
436	181
437	178
439	79
440	81
441	80
442	83
443	84
448	11
451	39
457	124

Wilde (B.M.)	London Exhibition 1975
1	1
2	2
3	3
4	8
5	6
6	4
7	14
8v	15
9	16
10	17
11	18
12	22
13	23
14	21
15	37
16	40
17	41
18	68
19	69
20	71
21	70
22	72

Wilde (B.M.)	London Exhibition 1975
23	36
24	76
25	48
26	49
27	50
28	51
29	88
30	58
31	59
32	87
33	91
34v.	190
35	62
36	66
37	67
38	54
39	55
40	96
41	113
42	114
43	95
44	94
45	97
46	100
47	34
48v	104
49	63
50	108
51	111
52	42
53	45
54	47
55	125
56	109
57	65
58	118
59	119
60	131
61	132
62	133
63	137
64	141
65	140
66	139
67	129
68	138
69	152
70	148
71	145
72	144
73	151
74	162
75	153
76	168

Wilde (B.M.)	London Exhibition 1975
77	169
78	167
79	171
80	163
81	180
82	183
83	177
84	173
87	115

Parker	London Exhibition 1975
291	12
292v	13
293	7
294	9
295	5
296v	10
297	19
299	24
300	25
301	26
302	27
303	28
304	29
305	30
306	31
307	53
308	56
309	61
310	60
311v	43
312	75
313	86
314	35
315	112
316	85
317	92
318	105
319	121
320	107
321	110
322	93
323	106
324	89
325	99
326	102
327v	103
328	164
329	146

Parker	London Exhibition 1975
330	135
331	147
332	150
333	149
334	154
335	155
336	157
337	161
338	165
339	158
340	170
341	175
342	159
343	182
344	172
345	174
349	52
378*	191

London Exhibition 1953	London Exhibition 1975
1	1
2	2
3	3
4	4
5	5
6	6
7	—
8	7
9	8
10	9
11	10v
12	12
13	13
14	22
15	16
16	14
17	21
18	19
19	24–27
20	18
21	23
22	28–31
23	17
24	32
25	15
26	—
27	91
28	85
29	101

London Exhibition 1953	London Exhibition 1975
30	92
31	93
32	37
33	87
34	112
35	78
36	40
37	41
38	99
39	88
40	77
41	89
42	61
43	60
44	34
45	114
46	96
47	104
48	100
49	102
50	97
51	59
52	106
53	98
54	63
55	113
56	103
57	129
58	148
59	130
60	65
61	141
62	152
63	142
64	140
65	137
66	131
67	136
68	133
69	132
70	135
71	125
72	119
73	120
74	128
75	117
76	—
77	42
78	118
79	145
80	144
81A	158
81B	170
82	153

London Exhibition 1953	London Exhibition 1975	London Exhibition 1953	London Exhibition 1975	Dussler	London Exhibition 1975	Dussler	London Exhibition 1975	Dussler	London Exhibition 1975
83A	168	128	156	164	15	311	138	566	17
83B	169	129	165	165	169	312	58	567	115
84	43	130	166	166	168	313	22	568	114
85	167	131	—	167	167	314	16	569	23
86	44	132	68	168	42	315	68	570	37
87	45	133	70	169	8	316	69	572	148
88	46	134	69	170	3	317	34	573	190
89	47	135	72	171	1	320	152	575	65
90	127	136	73	173	66	321	151	577	119
91	126	137	71	174	180	322	171	578	141
92	123	138	36	175	183	323	88	580	18
93	122	139	76	176	144	324	4	582	139
94	147	140A	191	177	125	326	45	583	140
95	159	140B	75	178	153	327	2	589	128
96	143	140C	86	179	145	328	47	592	82
97	121	141	48	180	54	329	129	596	102
98	105	142	53	181	173	330	55	597	103
99	182	143	50	182	32	331	162	598	61
100	183	144	51	183	74	332	108	599	60
101	178	145	56	184	74	333	131	600	93
102	164	146	49	185	179	334	166	603	5
103	181	147	66	189	175	337	176	604	24
104	179	148	67	190	9	338	156	605	25
105	177	149	54	191	7	339	20	606	26
106	180	150	55	192	13	340	35	607	27
107	161	151	62	193	12	341	85	608	28
108	174	152	74	194	19	342	112	609	29
109	176	153	173	195	105	343	106	610	30
110	90	154	149	196	92	344	10	611	31
111	64	155	172	197	75	345	56	613	99
112	58	186	150	198	86	346	188	616	159
113	94			199	43	347	154	621	53
114	139			200	164	348	155	623	191
115	95			201	158	349	157	624	121
116	79			202	170	350	110	625	135
117	80	Dussler	London Exhibition 1975	203	165	351	161	629	146
118	82			204	182	353	90	631	147
119	81	3	160	205	174	363	44	633	150
120	175	149	59	207	172	363a	120	634	149
121	35	150	49	216	77	364	136	636	78
122	146	151	50	236	178	365	122	638	73
123	110	152	36	237	64	514	89	639	57
124	107	153	51	238	126	551	133	708	83
125A	111	154	62	239	46	553	96	709	84
125B	109	155	48	241	123	554	100	710	79
125C	108	156	76	242	143	555	104	711	81
126A	171	157	67	243	181	556	95	712	80
126B	138	158	109	303	163	557	94	714	98
126C	162	159	91	304	21	558	118	715	130
126D	151	170	72	305	97	559	87	716	101
126E	163	161	177	307	113	560	132	718	142
127A	154	162	6	308	71	561	41	719	117
127B	155	163	14	309	70	562	40	721	127
127C	157			310	111	563	137	722	124